IMAGES
of America

BOURBONNAIS

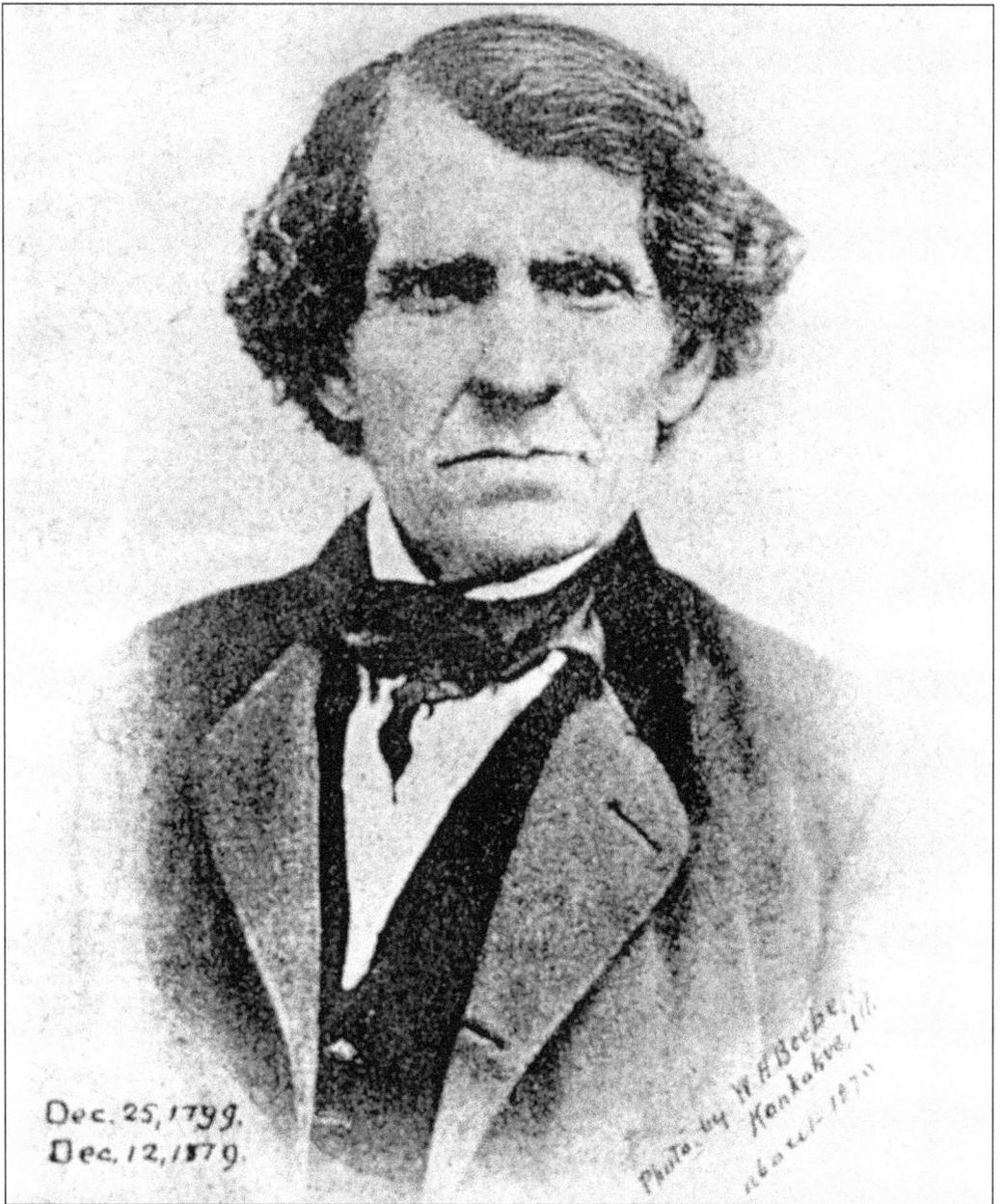

Dec. 25, 1799.
Dec. 12, 1879.

Photo by W. H. Beebe, Kankakee, Ill. about 1870

This is the earliest known image of Noel LeVasseur. He is the founder of a French Canadian settlement later know as the village of Bourbonnais. The photograph was taken about 1870 by William H. Beebe, who had a studio on Court Street in Kankakee. (Courtesy of Bourbonnais Grove Historical Society.)

On the cover: Please see page 110. (Courtesy of Adrien M. Richard.)

IMAGES
of *America*

BOURBONNAIS

Vic Johnson and the
Bourbonnais Grove Historical Society

ARCADIA
PUBLISHING

Published by Arcadia Publishing
Charleston, South Carolina

Library of Congress Catalog Card Number: 2006929371

For all general information contact Arcadia Publishing at:
Telephone 843-853-2070
Fax 843-853-0044
E-mail sales@arcadiapublishing.com
For customer service and orders:
Toll-Free 1-888-313-2665

Visit us on the Internet at www.arcadiapublishing.com

To Adrien M. and Anne Richard, who generously contributed time and substance to the founding and support of the Bourbonnais Grove Historical Society. This book would not have been possible without Adrien's research and the written record he created in various publications.

CONTENTS

ACKNOWLEDGMENTS

To the following people and organizations who have participated in this exciting journey into the history of Bourbonnais we express our sincere appreciation and most profound thank you!

It would not have been possible to author this book without the years of research and writing by village historian Adrien M. Richard. Adrien is no longer with us, but his enthusiasm and diligence in recording and preserving the history of his beloved village in numerous *Le Journal du Village* newsletter stories and books, *The Village: A Story of Bourbonnais*, *Notre Dame Centennial: A Century of Devotion*, and *Tales of Another Day*, (also booklets *A Concise History of the Maternity of the Blessed Virgin Mary Parish* and *Milestones in the History of the Village of Bourbonnais*), have inspired others to continue the task he so generously left us. His wife, Anne, has loaned the collection of photographs and documents from Adrien's files for our use.

Mary Ann and Daniel Kirsch, cochairmen of the Bourbonnais Centennial Pageant, Hooray Bourbonnais, organized an engaging stage presentation with live performers, music, dances, and a collection of slides that were projected into the background of various scenes. Those slides copied from hundreds of pictures collected from village residents in 1975 are today an irreplaceable archive. A note of thanks to all the committee members and performers of "Hooray Bourbonnais," far too many to list individually here.

Many photographs have been loaned by the Kankakee County Museum through the courtesy of executive director Norman Stevens. Special thanks to Jory Walters and other members of Steven's staff for searching through the museum archives.

Olivet Nazarene University's Brenner Library director Kathy Bowyens, information technologist Craighton Hippenhammer, and archivist Tina Simmons have been most helpful in finding and contributing photographs from their collection to this project.

Back in 1974, Thomas J. Lindsay of Lindsay Publications copied photographs and images for Adrien's book *The Village*. Lindsay has graciously shared copies of those images with us.

Of course, the board of directors and officers of the Bourbonnais Grove Historical Society are behind this project 100 percent under the leadership of board chairman Nick Allen, past president Carl Moran, and newly elected president Nancy Arseneau.

Others contributing in various ways over the years to the Bourbonnais Grove Historical Society archives from whom information in this book has been accessed are Prof. Emeritus Linford Marquart; Prof. James Paul of Kankakee Community College; Eric A. Derr (who discovered Fr. Isadore Antoine Lebel's grave beneath Maternity Blessed Virgin Mary Church); Fr. Wayne Dupuis, C.S.V.; Fr. George Auger, C.S.V., the Viatorian Order of Arlington Heights, Illinois; Bourbonnais mayor Robert Latham; Suzanne Smith-Pruchnicki (for her contribution on Acadia); Dave King (for his information on Petit Canada); Theresa Dupuis Johnson; Evelyn Dupuis LeBeau; Glenna Benoit; Robert Pallissard; Joseph Berard Fitzpatrick; Sr. Mary Therese Sweeny of the Congregation of Sisters of St. Joseph of Orange; James Fortier; Cecile LaMarre Enright; Mary Louise Bertrand; Peg Paschke; Ken Ponton; Bernice Bissaillon; George L. Godfrey; Gary Soper; Toby Olszewski, publisher of the *Bourbonnais Herald*; and the Small Publishing Group, Inc., of Kankakee, publishers of the *Kankakee Daily Journal*.

The photographs in this book are courtesy of the following sources: Adrien M. Richard (AMR), Bourbonnais Grove Historical Society (BGHS), Chicago Historical Society (CHS), Kankakee County Museum (KCM), Olivet Nazarene University (ONU), Theakiki Heritage Collection (THC), and Thomas J. Lindsay (TJL).

INTRODUCTION

"Is Illinois in Bourbonnais?"

For over 100 years, a small enclave of French Canadians in north-central Illinois, descendants of immigrants, who arrived during the first half of the 19th century, flourished in the bosom of their Gallic culture and their Roman Catholic religion. Nuns, priests, and brothers from Canada came to teach the children, establish a girls' school, and later found a boys' school that blossomed into a college. By 1900, a reporter for the *Chicago Sunday Chronicle* would write, "Almost all the Bourbonnais residents, of whom there are some 300 families, have large farms, which are worked by their sons. Thus there are no poor in Bourbonnais, but all are thrifty, economical and comfortably well off. And they are a hospitable people and full of courtesy, especially at the college." "Bourbonnais became so well known to the Canadians," said Peter Granger, son of one of the first settlers, "that many would inquire, 'Well, and where is Illinois? Is Illinois in Bourbonnais?'"

The name of our community, Bourbonnais, has its origin in the venerable French province of Bourbonnois (original spelling). Brovo is the name of the Gallic god of the waters and is the root word for the name of the province. In that province, at least 100 springs are found, places of pilgrimage since Roman times, and also the Tronçais Forest, 25,000 acres of ancient oaks. This woodland was the last refuge of the Druids.

Around 1668, a French immigrant, François Brunet, arrived in Villa Marie (Montreal) from near Bourges in the French countryside of Bourbonnais. In the tradition of adopting "dit" nicknames among soldiers and the transient sojourners in the wilderness of North America (*coureuse de bois*), this ambitious young man became known as François Brunet, "Le Bourbonnais."

Brunet was an associate of the explorer Réné-Robert Cavelier Sieur de La Salle and lived on La Salle's estate at Cöte, Saint-Sulpice (later called Lachine). He transported supplies to Lake Ontario, where La Salle was building Fort Frontenac. It is said by one student of the Bourbonnais family that Brunet accompanied La Salle on one of his expeditions of exploration and later engaged in fur trading ventures in the Illinois country.

Eventually most members of the growing families of Brunets (François and his wife, Barbe Beauvais, raised seven daughters; three sons out of five survived to adulthood) adopted Bourbonnais as their surname.

In 1688, Brunet, in partnership with four other citizens of Lachine, bought merchandise for 1,706 livres and promised to repay the debt the next year "in good beaver hides at the price of the bureau of Quebec."

Fr. M. A. C. Dugas writes that François Brunet dit Bourbonnais died at Lachine on June 24, 1702. It is said he succumbed to pleurisy.

During the 1700s, there are numerous entries in *Canadian Passports—1681–1752* of *congé de trait* (permission to trade) that were issued to members of the Bourbonnais family. These passports or licenses allowed them to engage in legitimate trade in the upper Great Lakes region.

In 1832, some 166 years after François Brunet arrived in Montreal, François Bourbonnais Sr., a great-great-grandson and free trader among the Native Americans and client of the American Fur Company, settled with his Potawatomi wife and family in a grove of timber on the north bank of the Kankakee River, 54 miles south of Chicago's Fort Dearborn. The timber tract became known as Bourbonnais Grove, or, in the vernacular of the early pioneer settlers of the region, "Bullbonus" Grove.

In October 1832, the Potawatomi of the Prairie and the Kankakee treated away their claim to land in north-central Illinois. Removal of the Potawatomi to western Missouri and eastern Kansas began.

According to the 1832 treaty of Camp Tippecanoe, François Bourbonnais's wife, Catherine "Catish" Bourbonnais (née Chevalier in church records), son Washington, and granddaughter Mawteno each were granted contiguous sections of land (1,920 acres) adjacent to the north bend of the Kankakee River. Bourbonnais and his family removed to western Missouri in 1836 along with most of the Potawatomi of the Prairie and the Kankakee.

Sale of the Bourbonnais estate in Illinois to speculators took place in the late 1840s. In 1853, when the Chicago branch of the Illinois Central Railroad was being built, the Associates Land Company platted the city of Kankakee on the two sections of land once owned by Catish and Mawteno. Curiously, Associates labeled the first plat "Bourbonnais," although the village of Bourbonnais Grove was a well-established community two miles to the north. Soon the name of the new settlement was changed to Kankakee City, and a couple of years later to simply Kankakee.

From pioneer times, the Anglo-American settlers had difficulty with the name Bourbonnais. Aside from "Bullbonus," possibly a derivation that came about because the native Potawatomi had no r sound in their language, the name was generally pronounced "Burr-bóne-us."

The village of Bourbonnais held a centennial celebration of its incorporation in 1975. The village board proclaimed that from then on, in remembrance of the first French Canadian settlers, the official pronunciation would be "Boor-bon-náy," even though some of the descendants of the French Canadians suggest the correct pronunciation is "Boor-bon-náh." (This contradiction might be because in old French a was pronounced "ah.") Today the village is called "Boor-bon-náy," but the name of the township in which it is located is still pronounced "Burr-bóne-us."

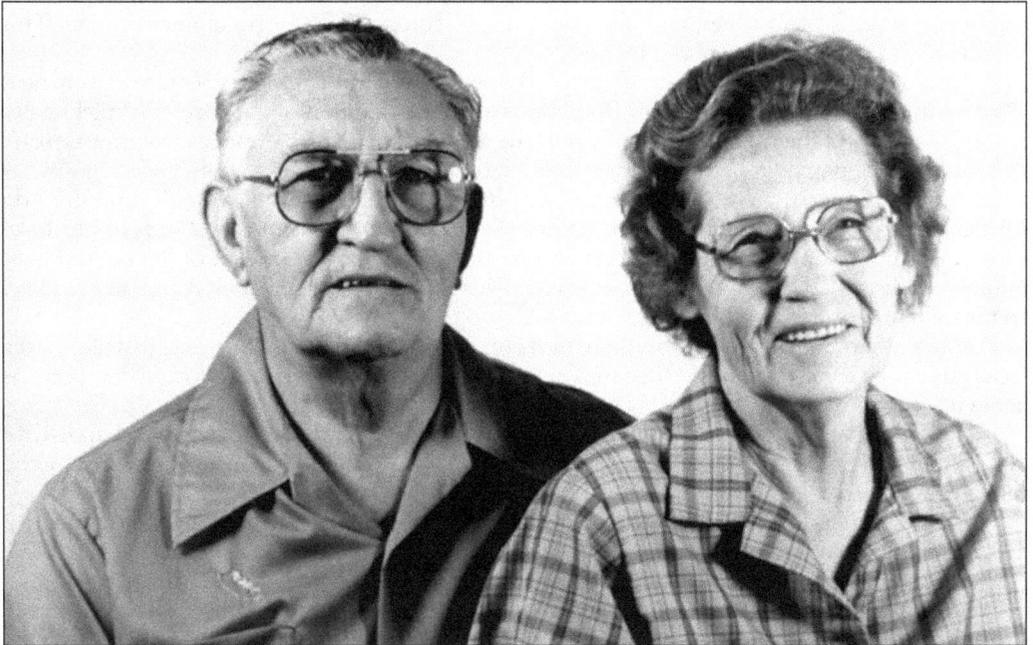

Carroll Shaubaunia Bourbonnais and Lula Bourbonnais (née Maddox), members of the Citizens Nation Potawatomi, came from California to visit the Bourbonnais area in 1985. This was their first visit to the village that has Carroll's family name. The trip east to Illinois was part of the celebration of their 54th wedding anniversary. Lula Maddox was from Fort Worth, Texas, Carroll from Tecumseh, Oklahoma. During the dust bowl days, Carroll and his wife moved to California. Carroll's great-grandfather was François Bourbonnais Sr. (THC.)

One

THE KANKAKEE RIVER VALLEY

LA SALLE'S GATEWAY TO THE ILLINOIS COUNTRY

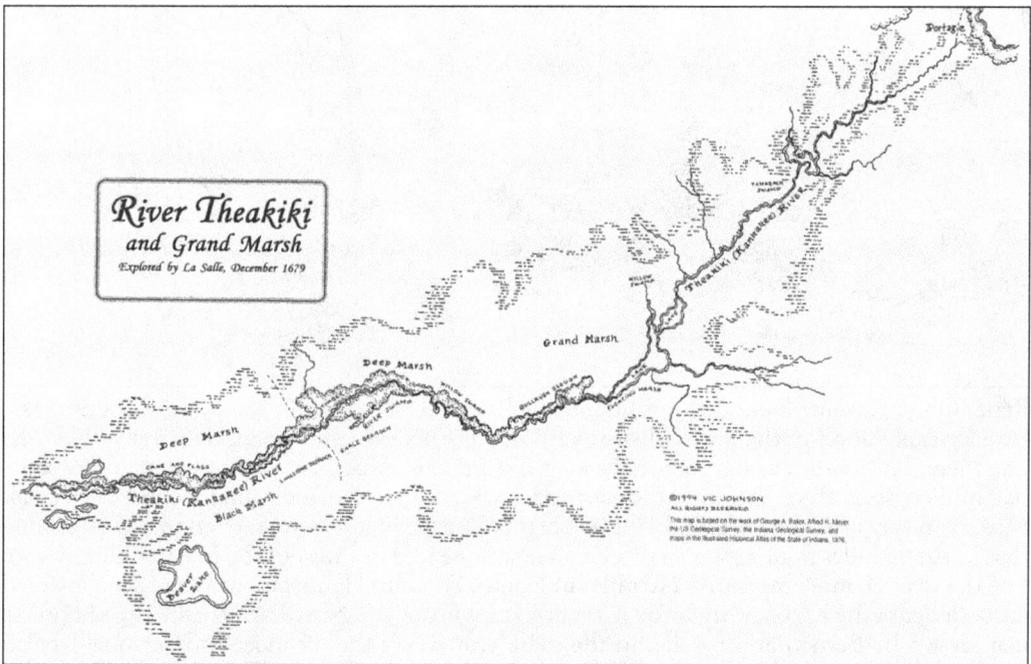

The exploration of the geographic region in which the village of Bourbonnais would be located—the discovery of the "Great West," as historian Francis Parkman put it—was accomplished by a French adventurer, Réné-Robert Cavelier, later better known by the self-applied title of "Sieur de La Salle." On a gray December morning in 1679, La Salle's party of 33 men made a portage from the St. Joseph River to a small stream that lay half-hidden among reeds and marsh grass. The men launched their eight canoes on the stream's sluggish headwaters. La Salle would name the river Seignelay in honor of the French Marine and colonial minister of France, the Marquis de Seignelay. It would later become known as the Theakiki, and in modern times, the Kankakee. La Salle's voyage from Montreal to the mouth of the Mississippi River by way of the Kankakee and Illinois Rivers was repeated in 1976 by a group of young *voyageuse* under the leadership of Reed Lewis. (THC.)

9

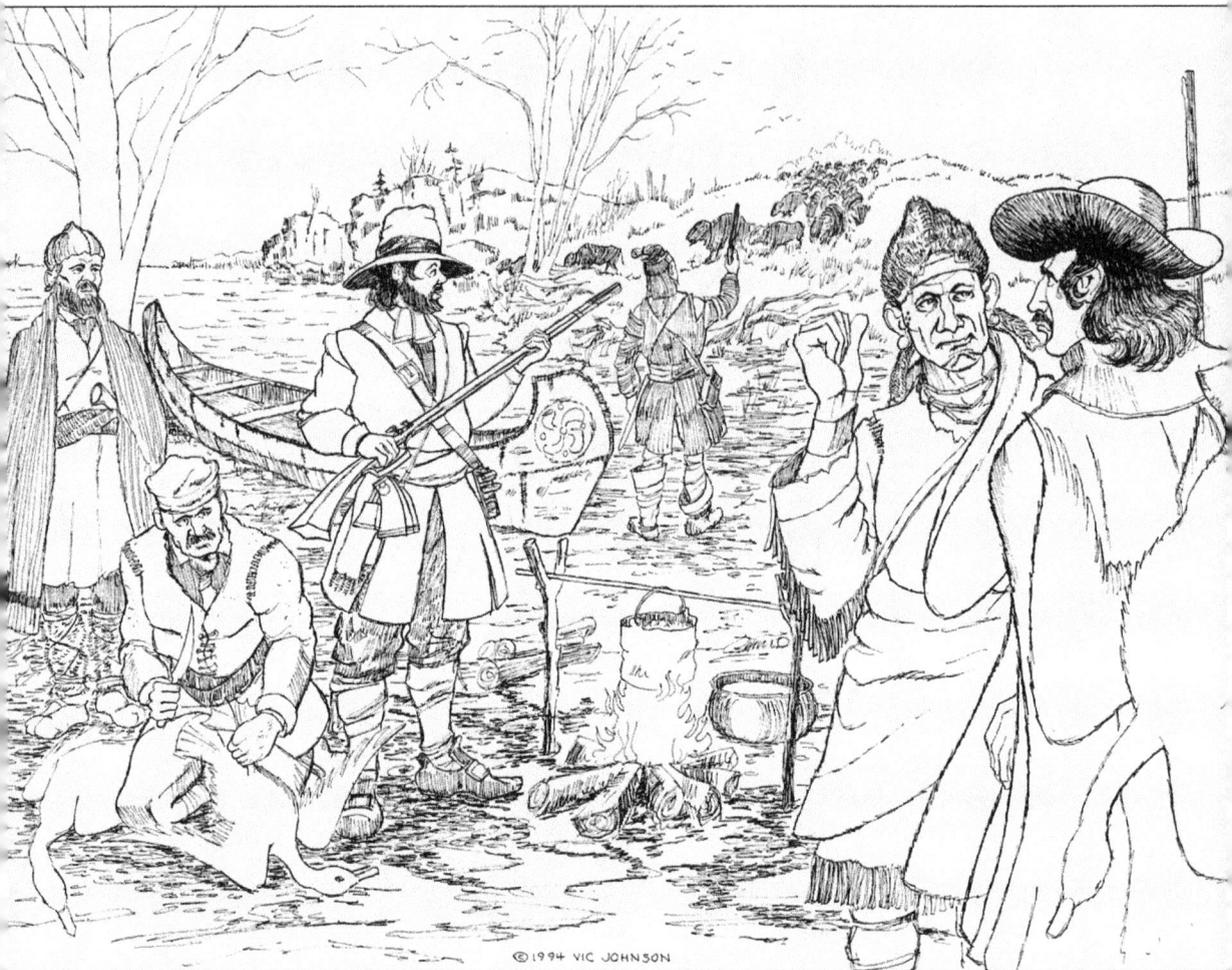

© 1994 VIC JOHNSON

Réné-Robert Cavelier Sieur de La Salle intended to establish a post in the Illinois Country as a base for exploration of the lower Mississippi River. He believed the Seignelay River would take him there. The journey would prove to be long and arduous. Ahead lay a freshwater marsh of some half-million acres through which the Seignelay twisted and turned, flowing around dreary oak barrens and encountering a legendary 2,000 bends. Decades later, cartographers would determine that in the 80 miles from its source to a broad limestone ford just west of the Indiana-Illinois state line the river channel measured 240 miles in length. Fr. Louis Hennepin, who had accompanied La Salle, published a book in 1683 in France recounting the North American expedition. A map drawn by Bernou and Peronel in the same year shows the meandering river now labeled "R. Teafiki." The name of the esteemed Seignelay graced another river. That river would become known as the Illinois. On later maps, La Salle's gateway river is labeled the "Theakiki," and in modern times called, the Kankakee. (THC.)

Following La Salle came a cavalcade of missionary priests, traders, hunters, trappers, adventurers, banditti, and pioneer settlers coursing the Kankakee River in dugout and bark canoes, rafts, Mackinaw boats, and skiffs. François Brunet dit Bourbonnais was probably among the first voyageurs. Records indicate he went west to the Illinois Country in 1685 to bring back furs. In 1739, a French army from Michilimackinac on its way to the Chickasaw Wars in Mississippi came down the Kankakee. A Spanish raiding party from St. Louis ascended the Kankakee to attack the British at Fort St. Joseph on the St. Joseph River during the American Revolution. (THC.)

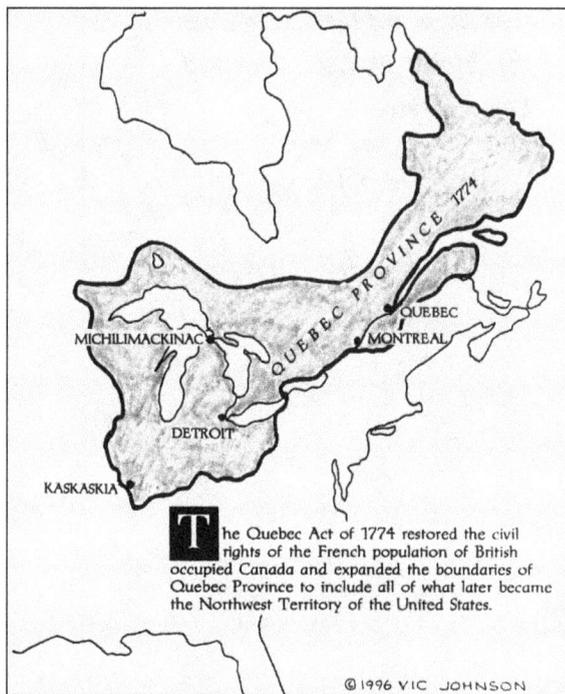

The Quebec Act of 1774 restored the civil rights of the French population of British occupied Canada and expanded the boundaries of Quebec Province to include all of what later became the Northwest Territory of the United States.

© 1996 VIC JOHNSON

Between 1774 and 1783, territory that would become Bourbonnais Grove was a part of the province of Quebec. (THC.)

ILLINOIS AND INDIANA IN 1818

Illinois became the 21st state of the Union on December 3, 1818. Indiana had been admitted to statehood two years earlier. The state capitol of Illinois was at Kaskaskia; Corydon was the first state capitol of Indiana.

Pioneer Anglo-American settlers arrived in the southern regions of these two states in the late 1700s and early 1800s. Most of these people came from the upland South: western Virginia and north Carolina, and eastern Tennessee and Kentucky. They were farmers who depended on hunting to supplement their food supply.

The northern two-thirds of both states were occupied by Native American peoples who had been long associated in fur trade with first the French and then the British.

Note: The Illiniwek ceded to the US government on September 25, 1818, a tract of land east of the Illinois River. But the Kickapoo continued to occupy and claim all the land between the Illinois and Wabash rivers. The Kickapoo land is outlined on the map by • • • • •; Anglo-American settlement is shown by.

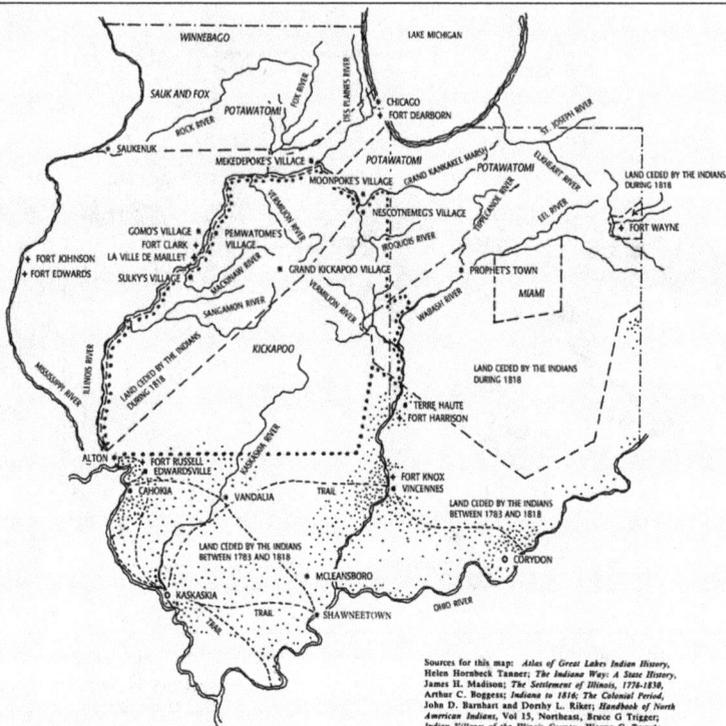

Sources for this map: *Atlas of Great Lakes Indian History*, Helen Hornbeck Tanner; *The Indiana Way: A State History*, James H. Madison; *The Settlement of Illinois, 1778-1830*, Arthur C. Boggess; *Indiana to 1816: The Colonial Period*, John D. Barnhart and Dorthy L. Riker; *Handbook of North American Indians*, Vol 15, Northeast, Bruce G Trigger; *Indian Villages of the Illinois Country*, Wayne C. Temple; and *Illinois: Land and Life in the Prairie State*, Donald E. Nelson.

Land Ceded by the Potawatomi of the Prairie and the Kankakee in the October 20, 1832, Treaty of Camp Tippecanoe

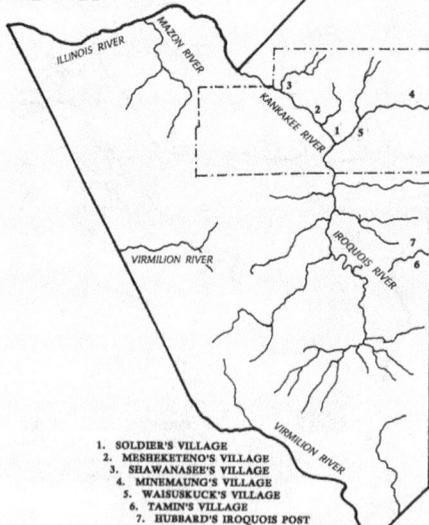

1. SOLDIER'S VILLAGE
2. MESHEKETENO'S VILLAGE
3. SHAWANASEE'S VILLAGE
4. MINEMAUNG'S VILLAGE
5. WAISUSKUCK'S VILLAGE
6. TAMIN'S VILLAGE
7. HUBBARD'S IROQUOIS POST

At the end of the War of 1812, veterans were given warrants for land west of the Illinois River. These warrants were negotiable, and veterans who had no intention of moving to the new frontier sold them to persons who did. At the same time, pioneers from southeastern states were moving into southern Illinois. This wave of immigration triggered a series of treaties between the United States and the resident Native American tribes.

Shab-eh-nay (better known as Shabbona), a Potawatomi headman, and his wife P'kuknoqua had removed to the West in 1836, but he returned with his extended family and became well known in Bourbonnais Grove. Shabbona established a camp on Davis Creek and hunted on the Grand Prairie to the southwest, and the Kankakee Marsh to the east. During the War of 1812, Shabbona had been an aid of Tecumseh. After Tecumseh's death, Shabbona decided to live in peace with the Anglo-Americans. (Courtesy of Gary Soper.)

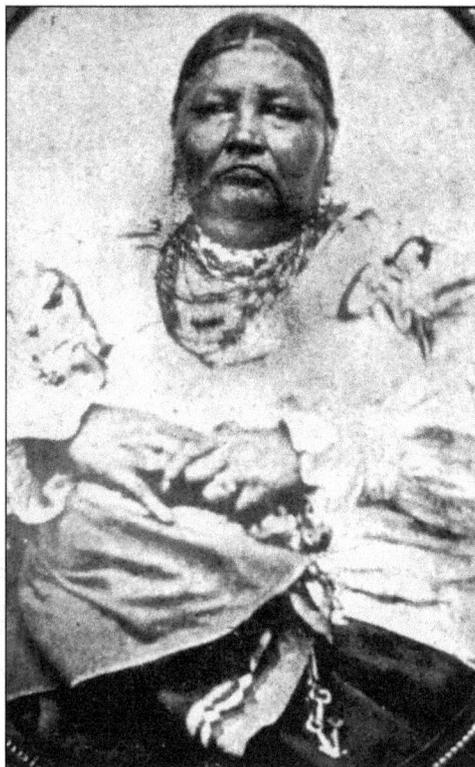

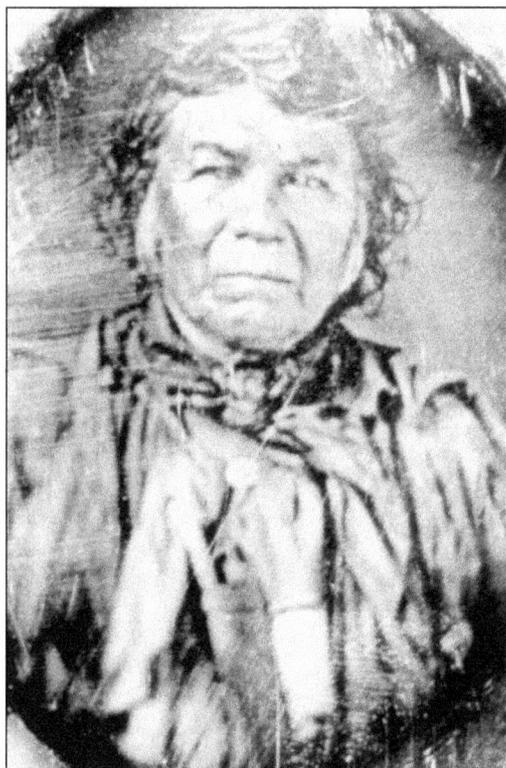

At the beginning of the Black Hawk War in 1832, Shabbona, who was then a "peace chief" for the United Nations of Odawa, Ojibwa, and Potawatomi, refused to encourage his people to join the Fox and Sauk in war against the pioneer settlers of northern Illinois. Shabbona and his son made a famous ride across the countryside to warn settlers of impending Native American raids. For this betrayal of ethnic solidarity, Shabbona was branded an outcast by many Native Americans who called him the white man's friend. Shabbona died on July 17, 1859. He lies buried along with P'kuknoqua in the Morris, Illinois, Evergreen Cemetery. (BGHS.)

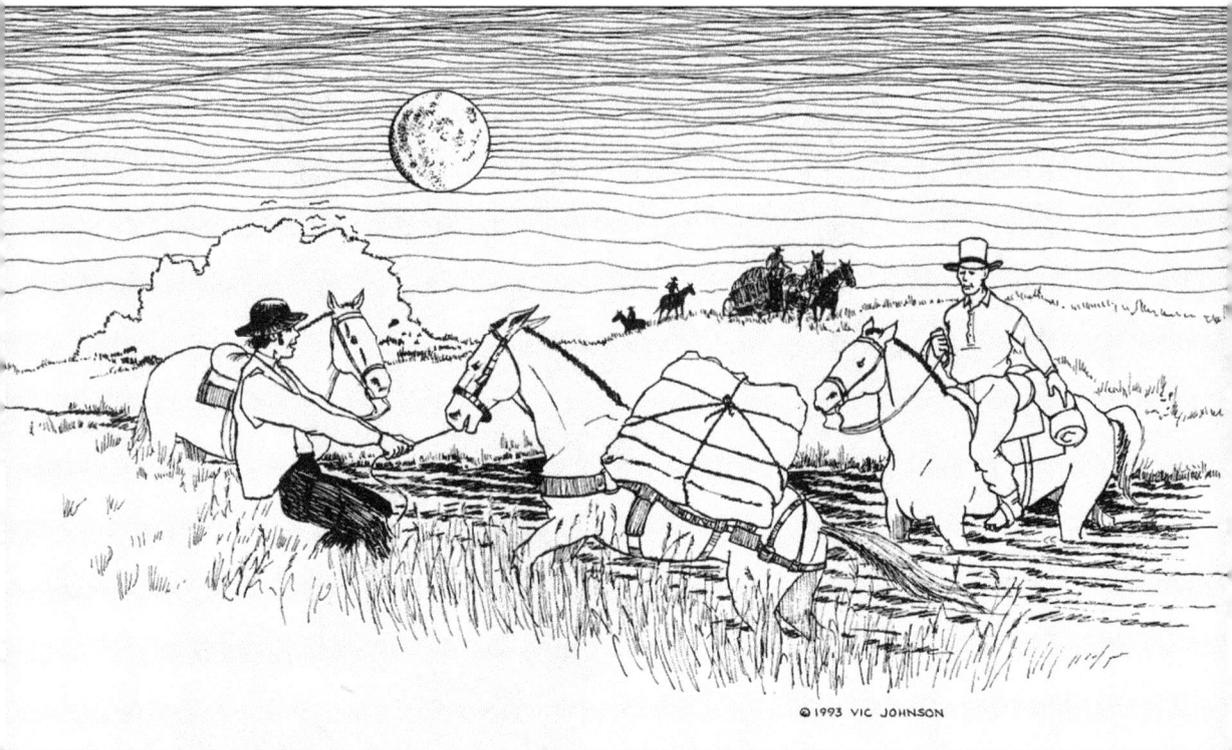

© 1993 VIC JOHNSON

Surveyors of the Old Northwest are among the unsung pioneer heroes. Often in the field for months, they faced danger and privation while tracing their compass-directed lines unswervingly over prairies and through swamps, through forests and across treacherous terrain. Routine land surveys of Illinois did not begin until 1813 and continued until 1849. Most Illinois surveys were laid out either using the second or third principal meridian, and a latitude baseline, all established in 1805. Surveys of north-central Illinois and the reserves established by treaties between the Native American tribes and the United States government occurred in the 1830s. In 1834, Daniel H. Beckwith surveyed two sections of land given to Mesheketeno by the 1832 Tippecanoe Treaty. Beckwith wrote in his field notes that he began the survey "as near the center of Me-she-ke-ten-o's village as I can determine by inspection." Beckwith further remarks that the village consisted of several lodges in the timber where Mesheketeno and his band stayed during maple sugar season. Mesheketeno's two sections were sold to Noel LeVasseur soon after the survey was made. As near as can be determined from Beckwith's survey Mesheketeno's lodges were located in an area adjacent to Lake Brittany. The lake is in Bourbonnais's Briarcliff subdivision. Developers of Briarcliff created the lake by damming a small stream. (THC.)

Land surveyed in north-central Illinois was mostly open prairie. Some of the prairie was dry, some wet. Over thousands of years, the prairie grasses had sprouted, grown, and died, leaving layers of organic material to form a rich soil intermixed with lime and other minerals deposited during the last continental glaciation. (THC.)

Along the uplands and in the river valleys, the surveyors found stands of timber: willow, maple, ash, and beech within the flood plains; oak, walnut, hickory, and elm in the prairie groves. The early pioneer farmers settled in the groves. Trees were girdled and left to die so land could be turned into plowed fields. The pioneers considered the prairies fallow because trees did not grow there. Bourbonnais Grove was a 12-mile timber tract on the east bank of the Kankakee River. In some places it was a mile wide. A remnant of this grove still exists and is shown above. (THC.)

FAMILLE BOURBONNAIS

TABLEAU GÉNÉALOGIQUE
ANTOINE BRUNET DIT LE BOURBONNOIS ET PHILIPPE DAVID, DE BARTEL, ARCHEVÊCHÉ DE BOURGES EN FRANCE

This genealogical chart of the Bourbonnais family prepared in 1900 traces family members from 1645 down to the sixth generation. The compiler, Fr. M. A. C. Dugas, proclaims that François Bourbonnais and his wife, Catherine "Catish" Chevalier, went to the prairies of Illinois and "gave their names to a village [Bourbonnais Grove] that will become well known by its Canadian population and religious establishments." He also noted that the Bourbonnais family was "numerous, powerful and respectable in view of its moral, social and domestic virtues." (KCM.)

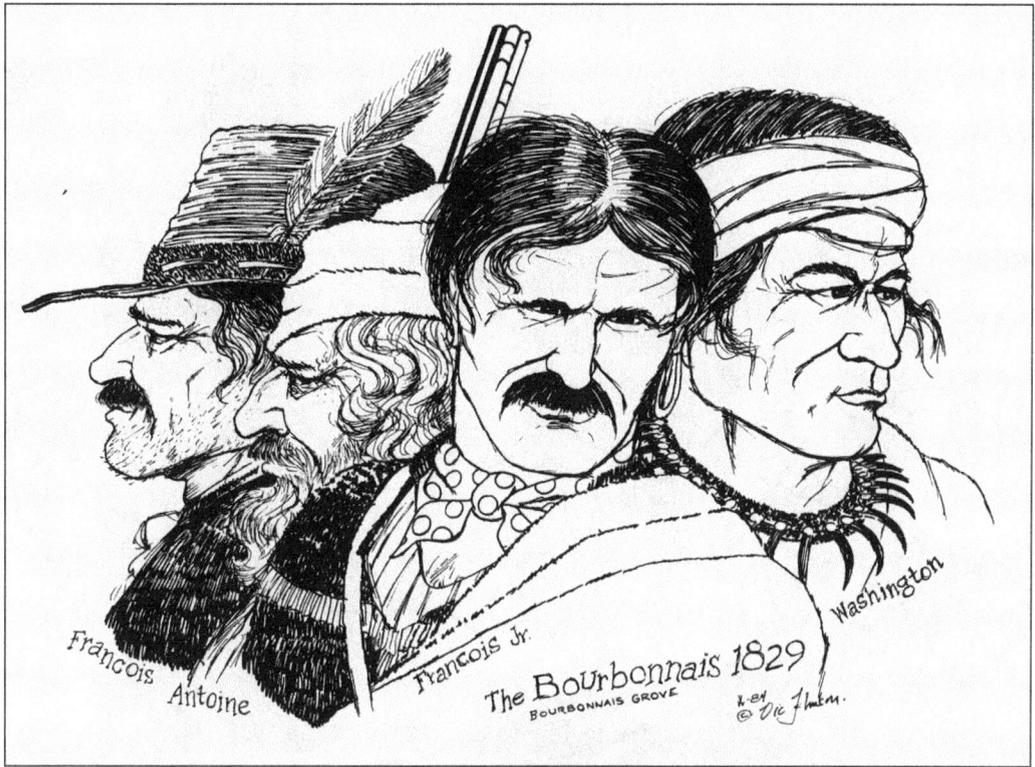

François Antoine François Jr. Washington

The Bourbonnais 1829
BOURBONNAIS GROVE

The history of the Bourbonnais family in Illinois is sketchy. Although tradition says they were living in Bourbonnais Grove in 1829, the actual year is probably 1832. They are known to have been living in Bureau County, west of the Illinois River, in the spring of 1832, at the outbreak of the Black Hawk War. Bureau County historian Neamiah Matson wrote that they left Bureau County at that time and removed to the Kankakee River. Four of the men (above), listed from left to right, are François, Antoine, brother to François Sr., and François's sons François Jr. and Washington. Other Bourbonnais children are shown to the right with their mother, Catish. These drawings are not meant to be actual portraits but are based on descriptions and photographs of descendants. (THC.)

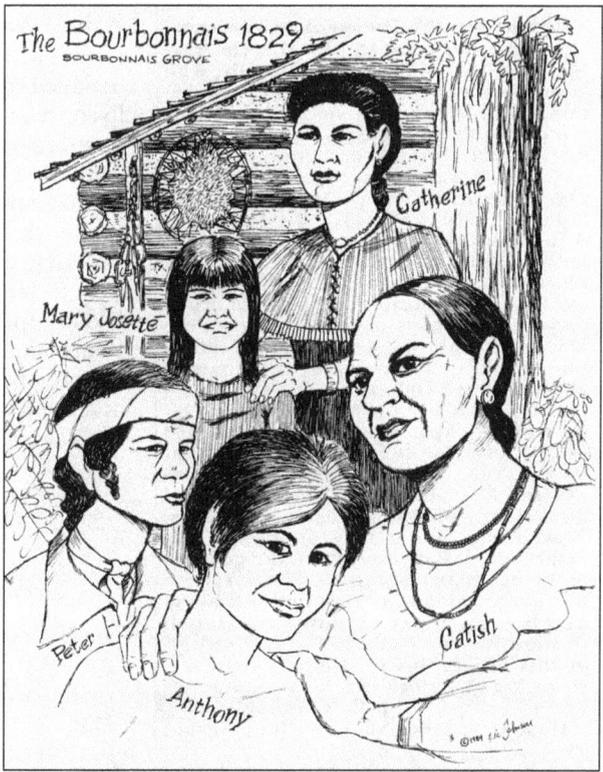

The Bourbonnais 1829
BOURBONNAIS GROVE

Catherine
Mary Josette
Peter
Anthony
Catish

17

©1997 VIC JOHNSON

A deed to the east section of Mesheketeno's reserve acquired by Noel LeVasseur in 1834 included the notice that François Bourbonnais lived there. However it appears François soon removed his family to the reserve granted Catherine "Catish" Chevalier in 1832. This section adjoined Soldier's village and was adjacent to the reserves ceded by François's granddaughter Mawteno and son Washington. These reserves were located where the city of Kankakee was laid out in 1853. In the late summer of 1836, the Bourbonnais family loaded their belongings into wagons and followed the Potawatomi of the Prairie and the Kankakee to the Platt country of western Missouri. (THC.)

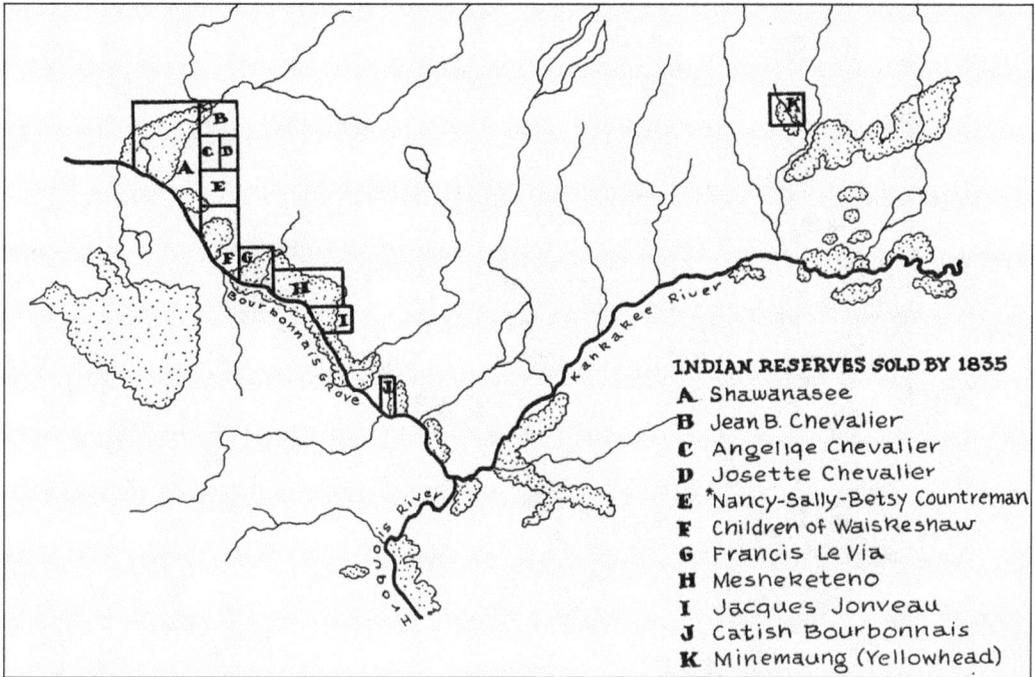

INDIAN RESERVES SOLD BY 1835
A Shawanasee
B Jean B. Chevalier
C Angeliqe Chevalier
D Josette Chevalier
E *Nancy-Sally-Betsy Countreman
F Children of Waiskeshaw
G Francis Le Via
H Mesheketeno
I Jacques Jonveau
J Catish Bourbonnais
K Minemaung (Yellowhead)

All of the reserves granted to "Indians" or "persons of Indian descent" by the October 20, 1832, treaty of Camp Tippecanoe, except those received by the Bourbonnais and Nancy, Sally, and Betsy Countreman, soon were sold to land speculators. It was not until March 1847 that a wealthy Crawfordsville, Indiana, banker, Isaac C. Elston, went to Kansas and bought the reserves of Catish and Mawteno for $2,400. A year later, Augustus M. Wiley paid $800 for Washington's reserve. (THC.)

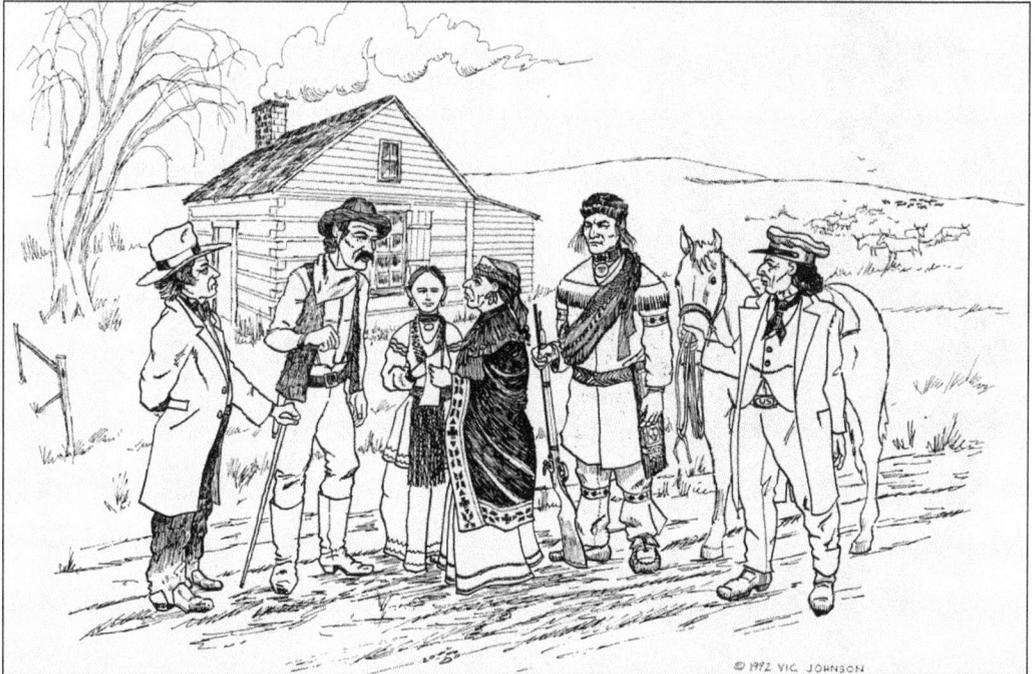

© 1992 VIC JOHNSON

©1990 VIC JOHNSON

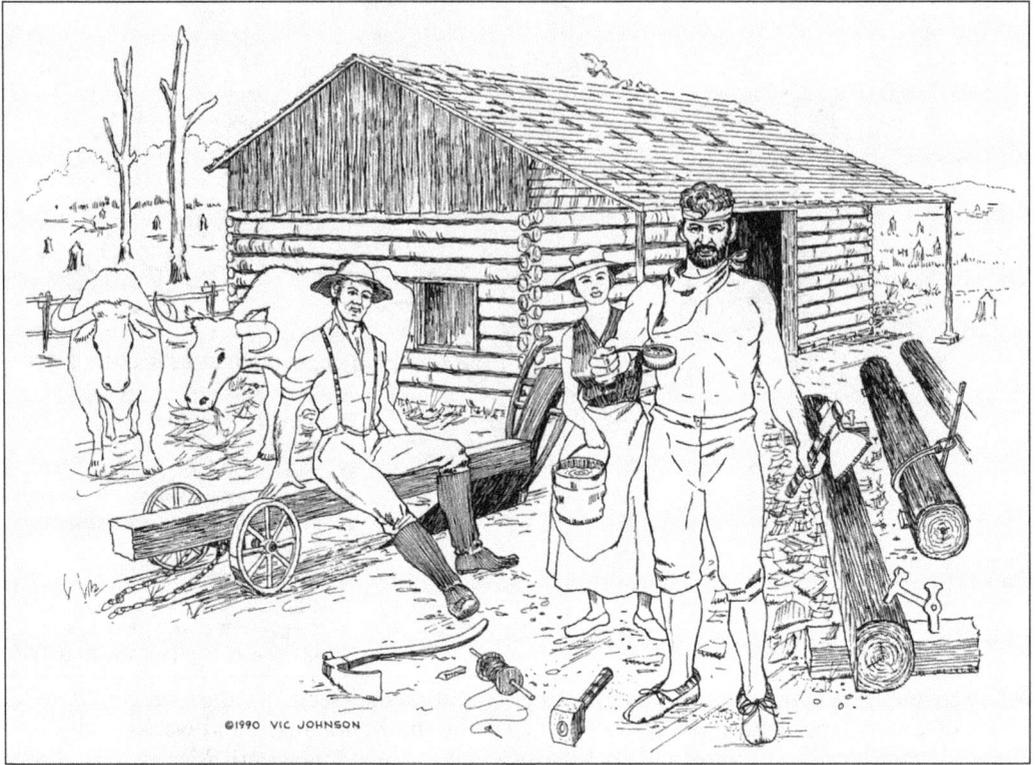

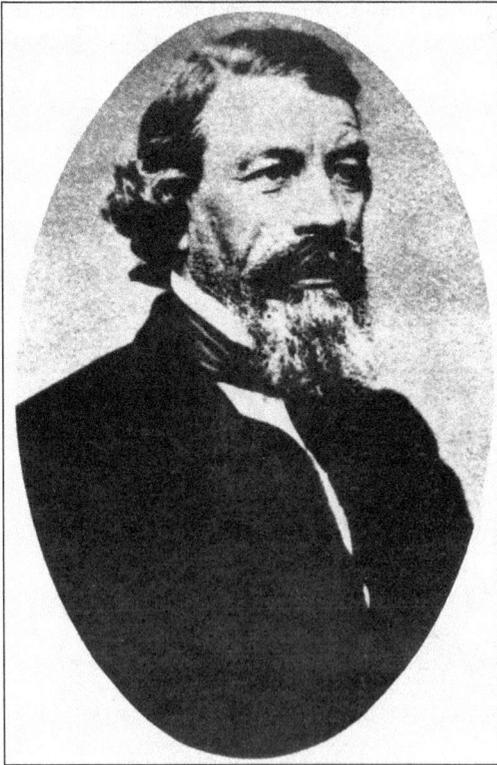

The area in north-central Illinois treated away by the Potawatomi of the Prairie and the Kankakee was one of the last areas of the state to acquire a significant population of pioneer settlers. It took another treaty signed in Chicago in 1833 to satisfy the government that all Native American claims to land in Illinois were severed. The 1832 treaty, however, by oversight or design, failed to grant the reserves in fee simple. Even though nearly all the reserves were in the hands of land speculators, by 1835 their titles were clouded. Those squatters who had built cabins as early as 1834 on that land had no legal claim. It was not until the 1840s that Congress cleared the titles. In the meantime, men such as Gurdon S. Hubbard (left), and Noel LeVasseur, once employees of the American Fur Company, acted as agents for eastern investors. The first non-reserve land purchases in Bourbonnais Grove were made through the Chicago Land Office in 1838. (Above, THC; left, KCM.)

Dominick Bray (also Dominique Brais), whose home is shown here as it appeared in 1940 shortly before it was torn down, was a French Canadian who was employed by the American Fur Company. He was stationed, along with Noel LeVasseur, at Gurdon S. Hubbard's trading house on the Iroquois River in the 1820s. Burt E. Burroughs wrote, "The scene of Bray's active operations in Kankakee county, was the farm now [in 1923] known as the America Brosseau farm, lying two miles out on the Bourbonnais road, in Bourbonnais township, and between this place and the river laid the reservation of the Pottawattomie chief, 'Me-she-ke-te-no.' Through the intervention and kindly offices of his friend, LeVasseur, Bray succeeded in purchasing his land from its Indian owner for a cash consideration of twenty-five cents an acre, in specie gold, together with a few bead trinkets, which, in the eye of the Indian, possessed a value in excess of specie. He set to work and built a commodious double log cabin and here, in 1833, was born Andre Bray, the first white child born in Bourbonnais township . . . Most notable among the achievements of Bray, when you consider the time in which he lived, and the limitations imposed by lack of funds and the wherewithal to do, was the erection of a two-story brick dwelling—a mansion, if you please—which was the talk of the settlers generally, far and wide. This building was put up in 1848 or 1849 and was the first of its kind to be built on the river." Burroughs seems to have overlooked the fact that LeVasseur built a brick mansion near LaPointe in Bourbonnais Grove in 1838.

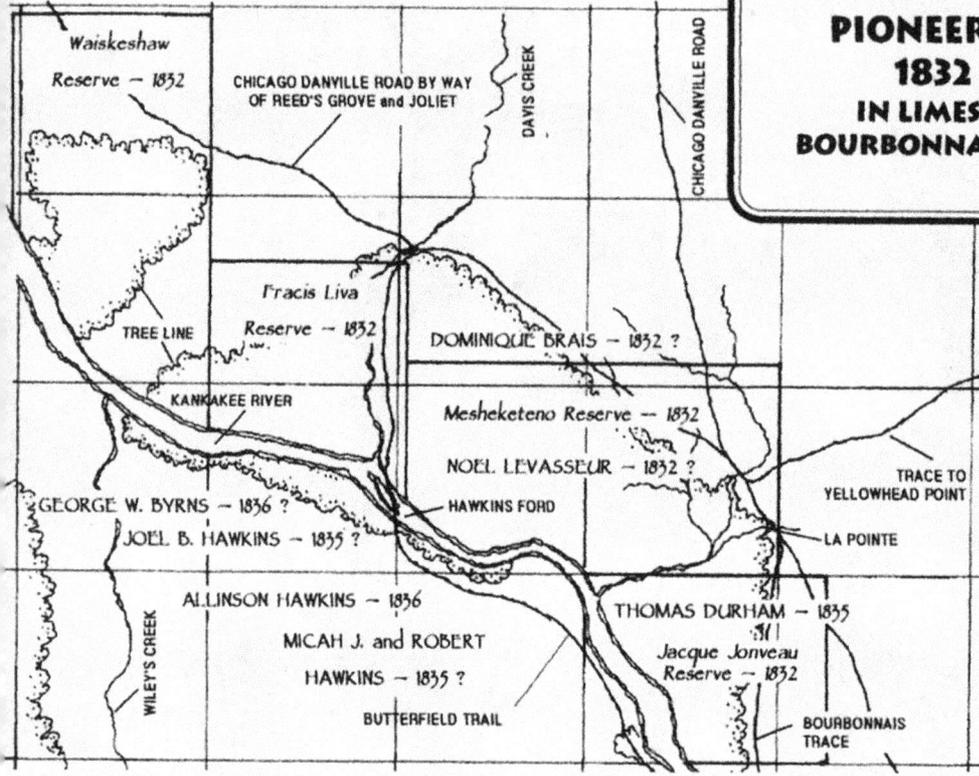

PIONEER SETTLERS
1832 —1836
IN LIMESTONE AND
BOURBONNAIS TOWNSHIPS

Waiskeshaw Reserve — 1832

CHICAGO DANVILLE ROAD BY WAY OF REED'S GROVE and JOLIET

DAVIS CREEK

CHICAGO DANVILLE ROAD

Fracis Liva Reserve — 1832

TREE LINE

KANKAKEE RIVER

DOMINIQUE BRAIS — 1832 ?

Mesheketeno Reserve — 1832

NOEL LEVASSEUR — 1832 ?

HAWKINS FORD

TRACE TO YELLOWHEAD POINT

LA POINTE

GEORGE W. BYRNS — 1836 ?

JOEL B. HAWKINS — 1835 ?

ALLINSON HAWKINS — 1836

WILEY'S CREEK

MICAH J. and ROBERT HAWKINS — 1835 ?

BUTTERFIELD TRAIL

THOMAS DURHAM — 1835

Jacque Jonveau Reserve — 1832

BOURBONNAIS TRACE

Prepared by Vic Johnson, based on the *Illustrated Historical Atlas of Kankakee County, Illinois, 1883* and land sales records.

Claims of settlement before 1836 are difficult to document. Traditionally, Noel LeVasseur is recognized as the first "permanent" settler in Bourbonnais Grove. Two other pioneer settlers who are said to have settled along the Kankakee River in 1832 are Robert Hill and William Baker

Between 1833 and 1836, several Anglo-American families established homesteads on both sides of the Kankakee River. Prominent among these were the Hawkins brothers, Allinson, Joel Baldwin, Micah Jepson, and Robert Buck. They were members of a large family who moved from Bloomfield, New York, to Danville, Illinois, in 1825. According to county historian Burt E. Burroughs, Micha Jepson "pitched his tent" along the Limestone road [Butterfield Trail], west of the river in 1832. "By 1833-4-5 conditions changed materially out on the Limestone road so far as the young homesteader was concerned. His three brothers came from Danville and settled in the immediate area." Chicago Land Office records show that the brothers bought property along the Butterfield Trail in 1838. A Quaker family, the Durhams, who had migrated up from Virginia and eastern Tennessee, settled on a portion of the reserve ceded to Jacques Jonveau. Their farmstead lay three-quarters of a mile south of Noel LeVasseur's trading post at LaPointe. The extended family of Durhams would play an important part in the future of the Bourbonnais Grove area. (THC.)

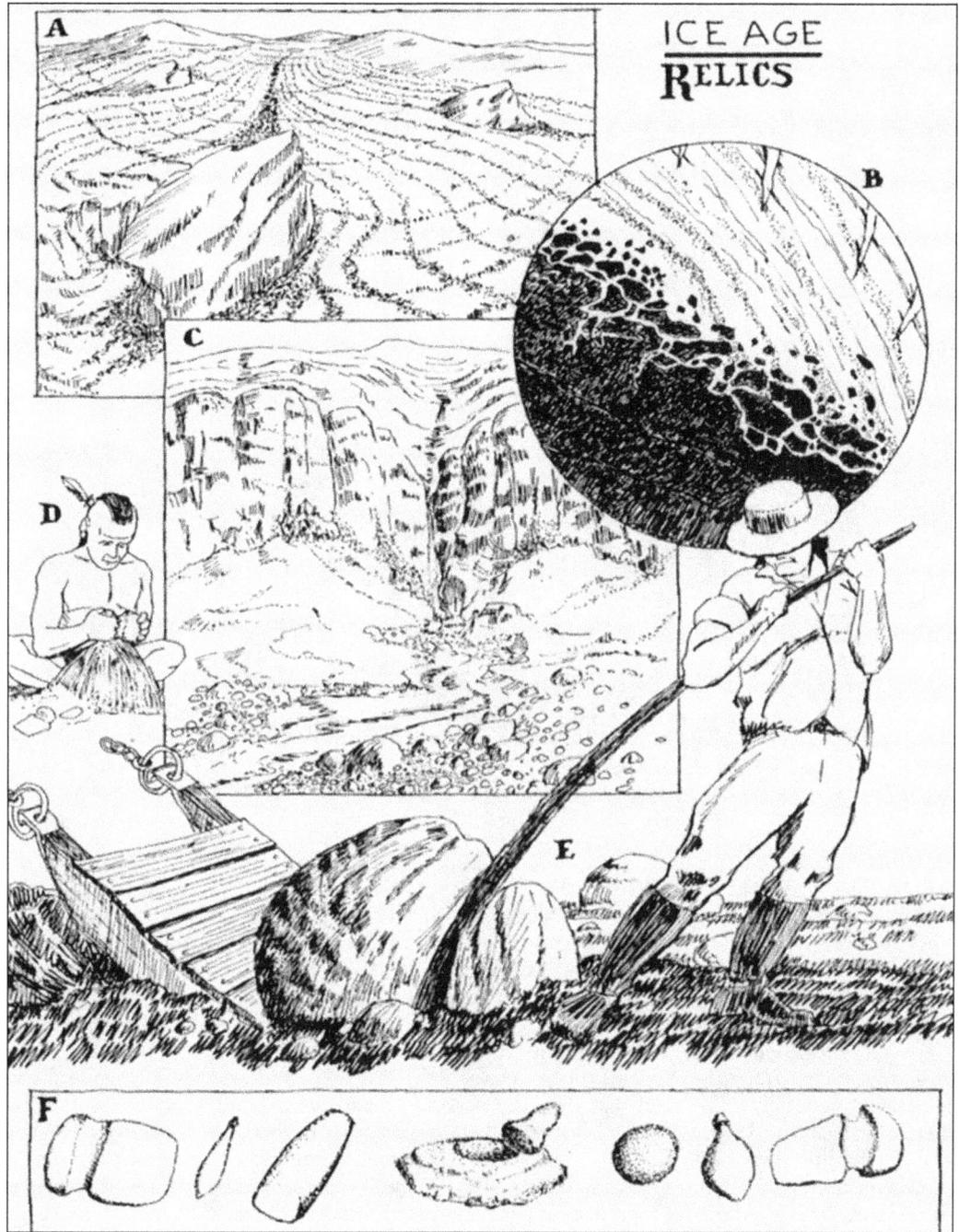

French Canadian immigrants came to Bourbonnais Grove partly influenced by promises of cheap land. The land was available, but farming it was not as easy as anticipated. During the last ice age, the continental glacier engulfed Canadian highlands, and the ice flowed into the Great Lakes region (A). The moving glacier transported granite rock "quarried" from the Canadian Shield (B) southward into the Midwest. When the glacier melted, it left granite boulders strewn about the landscape (C). Prehistoric Native Americans made ground-stone tools from the rocks (D and F). Pioneer farmers cleared their land hauling the rocks away on "stone boats" (E). (THC.)

© 1992 VIC JOHNSON

At the time Daniel H. Beckwith surveyed Mawteno Bourbonnais's reserve in 1834, he found the road "leading from Danville to Chicago by way of Hickory Creek" crossed his survey lines at two points. Fur trader pack trains made up of strings of ponies had traversed the Vincennes-Danville-Chicago Road at an early date. In pioneer days, great canvas-covered freight wagons pulled by teams of lumbering oxen and huge draft horses passed in lengthy caravans over this road. The road made commerce possible between the Wabash and the Illinois River valleys. Henry S. Bloom, who came to Rockville in March 1837, recalled that from 1836 to 1840, "there was an immense freighting business done between the Wabash country and Chicago and the Northwest generally." The road had seen the passing of trail herds being taken to market by men known as "Cattle Kings" and witnessed the midnight sorties of those notorious horse thieves and cutthroats, the Prairie Banditti. The road also carried circuit-riding lawyers, judges, and preachers. It brought scheming land speculators and dogged homesteaders to this western frontier of the early 1800s. After the founding of permanent settlements, the road became a route for itinerant Yankee tradesmen, post riders, and stagecoaches. In 1836, settlers petitioned the state to make the Vincennes-Danville-Chicago Road a state road. Today it is state Route 102. (THC.)

©1992 VIC JOHNSON

"Soon after the Durhams arrived in Bourbonnais Grove and the Hawkinses had settled west of the river, stories of two squatter families," wrote Burt E. Burroughs, "the Snodes and the Bizees began circulating. They lived on the west bank of the Kankakee at a place soon named by the gossips, Horse Thief Hollow. The two families were a mysterious, clannish and surly folk, who had little truck with their neighbors. In the late 1830s, when the plague of horse thieving began, the Snodes and the Bizees were prime suspects. Either they were members of the horse thief ring or they had close connections was the verdict of the weekly gathering at the 'Bullbonus' Post Office. It would only be a matter of time before one of them would pay for his crime at the end of a rope . . . But there was never any evidence." Theft of horses did not end with the departure of the Snodes and Bizees. "The Prairie Banditti, a cutthroat gang of counterfeiters and horse thieves whose headquarters were on Bogus Island in Indiana's Beaver Lake, continued to pillage the settlers' stock to well into the 1850s." (THC.)

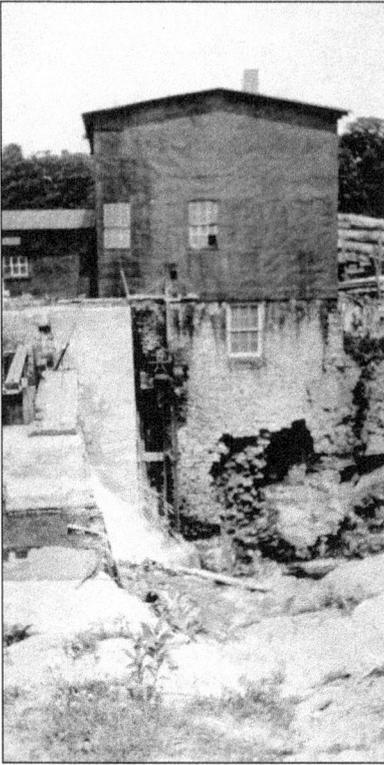

The history of the Yost Mill on Davis Creek is mostly lost. Only a few memories captured several years ago by journalists and a few photographs taken in the 1880s and around 1920 remain. The mill was built before 1853, probably in the 1840s. The mill's dam consisted of large blocks of limestone laid across a narrow gorge in the creek's bed. One account says the dam was "3-feet thick, 15 to 20 feet wide and some 20 feet high." Thomas J. Lindsay wrote in the *Kankakee Sunday Journal* that at the bottom of the remains of the dam "can be seen remnants of a arch where a valve or control gate probably first let water through the run, perhaps a conventional undershot water wheel. It is possible that in later years runoff from the fields that fed Davis Creek, as more and more acreage opened up to tillage caused heavy silting behind the dam. By the 1880's it was necessary to take the water over the top of the dam, down a silo-like affair, down to a verticle-shaft turbine of about 30 inches diameter. Power was transmitted by a shaft up to the saw." Historian Harold W. Simmons believed that timber sawed by the mill was used to build cabins in a small French Canadian settlement on Davis Creek called Petite Canada. Lindsay said that one of his sources, Mrs. Arthur Ahrends, told him she thought the deserted old mill was seen as a dangerous place and that it had been blown up with dynamite. (TJL.)

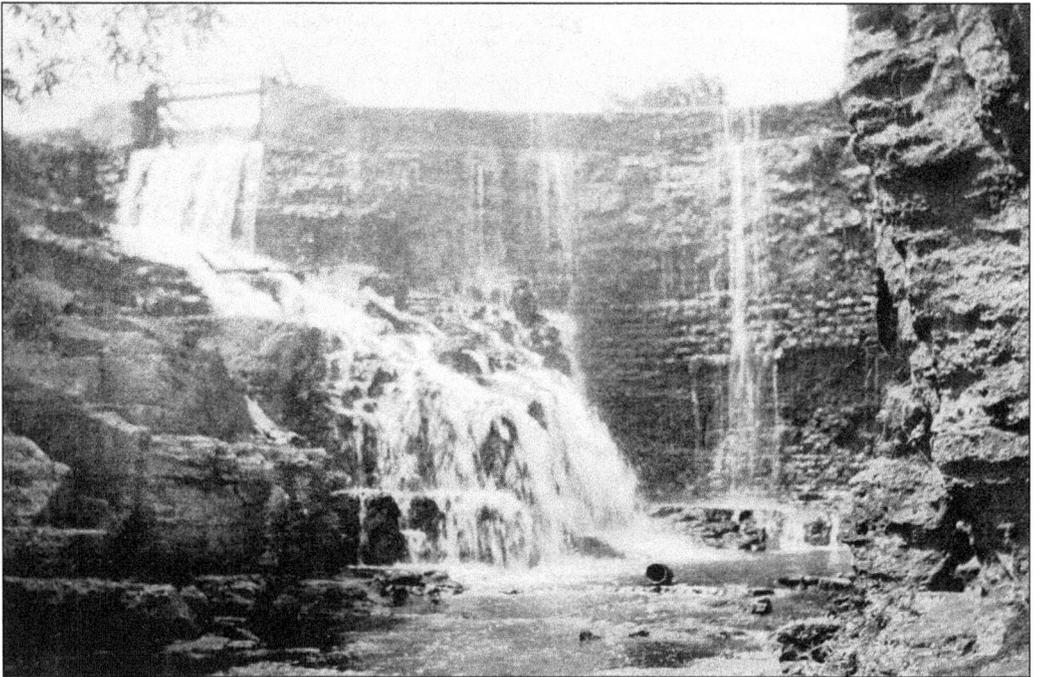

Two

LaPointe
1829–1838

The village that became known as Bourbonnais Grove grew out of an 1830s settlement variously called LaPointe, La Ville, and Vasseurville. The name of the settlement's post office was Bullbonus Grove. Bullbonus is an early regional Anglo-American pronunciation of the name Bourbonnais. Today the name is pronounced Boor-bon-náy. Years passed before the village became officially known as Bourbonnais Grove. However, a tract of timber some 12 miles long, and up to a mile wide in some places, on the north bank of the Kankakee River, had been known as Bourbonnais Grove much earlier. At what period in history the grove was given the name Bourbonnais is not known with certainty. It appears to be earlier then 1832. A Canadian trader named Antoine Bourbonnais was working in Illinois for a company in St. Louis. He was hired "in the services of the American Fur Company, and he was afterwards stationed at Kankakee, where he died." That would place Antoine, François Bourbonnais's brother, in the area of Bourbonnais Grove in 1823, and that might be when the name originated. (THC.)

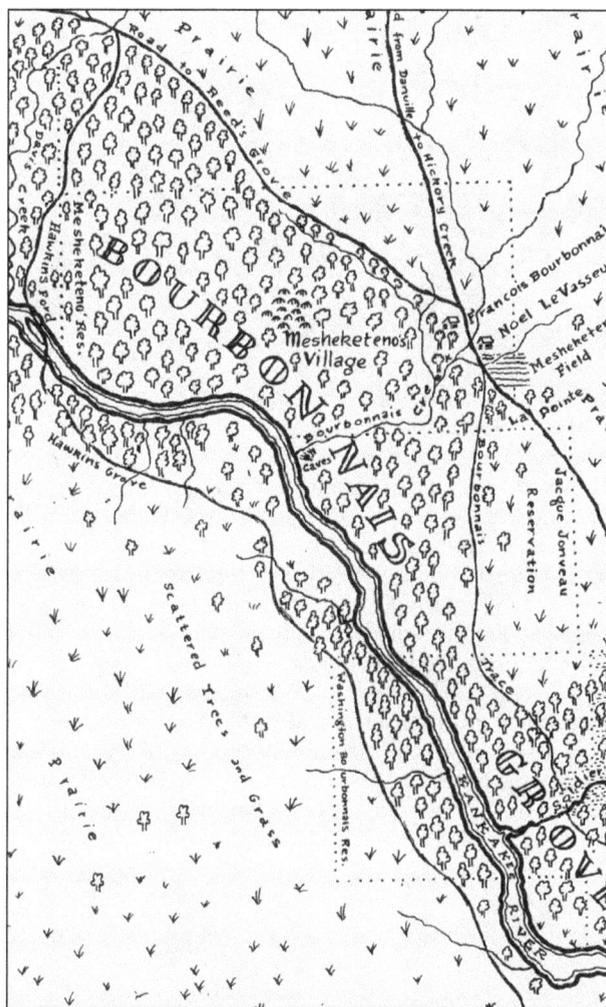

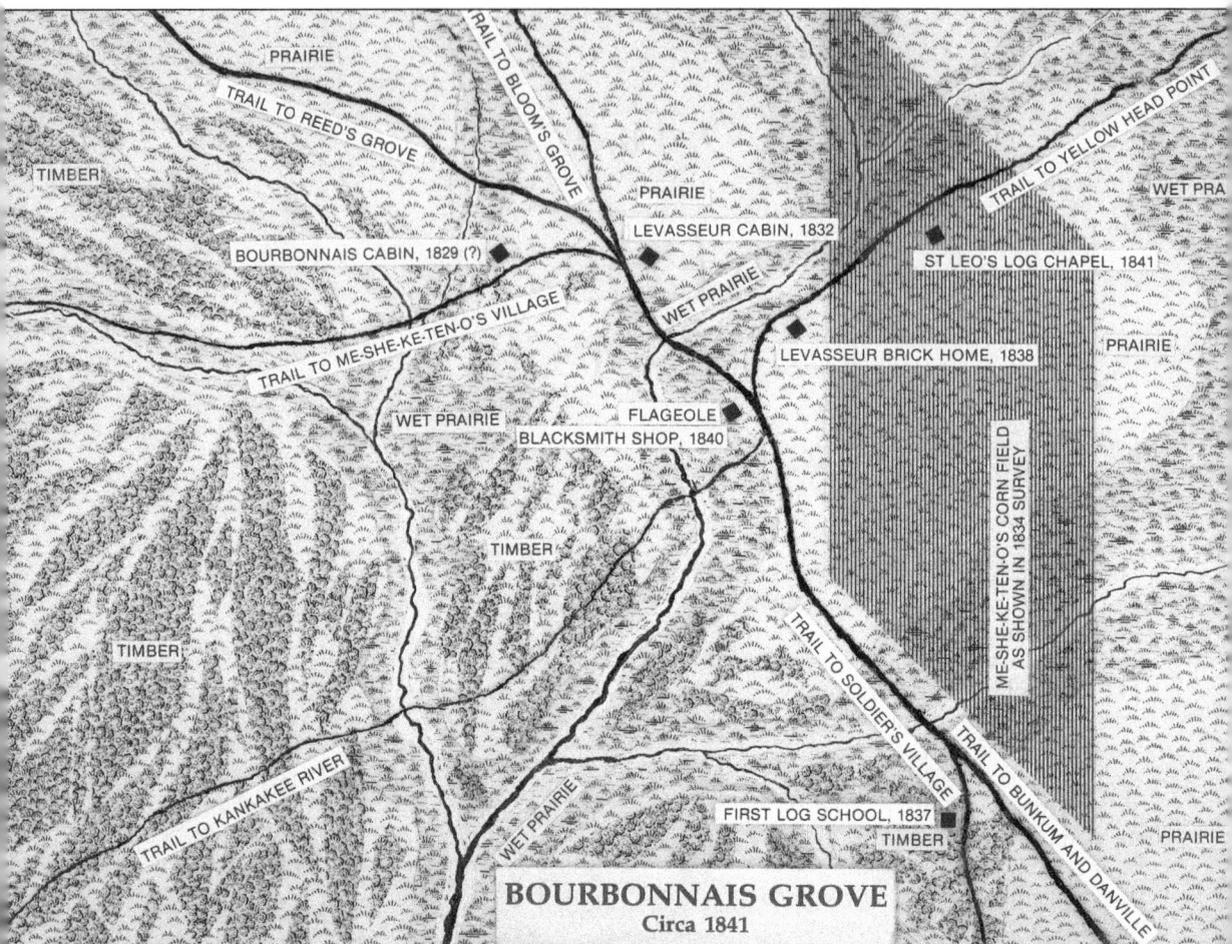

PRAIRIE

TRAIL TO REED'S GROVE

TRAIL TO BLOOM'S GROVE

TIMBER

PRAIRIE

TRAIL TO YELLOW HEAD POINT

WET PRA

LEVASSEUR CABIN, 1832

BOURBONNAIS CABIN, 1829 (?)

ST LEO'S LOG CHAPEL, 1841

TRAIL TO ME-SHE-KE-TEN-O'S VILLAGE

WET PRAIRIE

LEVASSEUR BRICK HOME, 1838

PRAIRIE

WET PRAIRIE

FLAGEOLE

BLACKSMITH SHOP, 1840

TIMBER

ME-SHE-KE-TEN-O'S CORN FIELD
AS SHOWN IN 1834 SURVEY

TRAIL TO SOLDIER'S VILLAGE

TIMBER

TRAIL TO KANKAKEE RIVER

TRAIL TO BUNKUM AND DANVILLE

WET PRAIRIE

FIRST LOG SCHOOL, 1837

PRAIRIE

TIMBER

BOURBONNAIS GROVE
Circa 1841

Although the village eventually bore the name of the Bourbonnais family, the founder was not a Bourbonnais, but a former employee of the American Fur Company, Noel LeVasseur. Gurdon S. Hubbard and LeVasseur had established a trading post on the Iroquois River in the fall of 1823. LeVasseur began to trade with the Potawatomi in the neighborhood of Rock Creek some 30 miles to the north. In his book *Les Canadiens de L'Ouest*, Joseph Tasse describes LeVasseur's first impression of the area that would later be known as LaPointe. On a journey back from Rock Creek, LeVasseur and his two companions set up camp. When they awoke the next day, "the morning light revealed a landscape that had been hidden from them by the night. To the east, the plain unfolded green and as immense as an emerald sea. To the west, along the border of the woods, on the edge of the river, swayed lofty tops of maples and oaks still damp with dew. Near them gushed, in the midst of flowering bushes, a spring of clear waters, which fed a stream that lost itself in the distance of the prairie. This was a picturesque landscape, an enchanting landscape, deserving the brush of an artist! LeVasseur, not being able to hide his admiration, said to his companions: What a beautiful country in which to live!" (THC.)

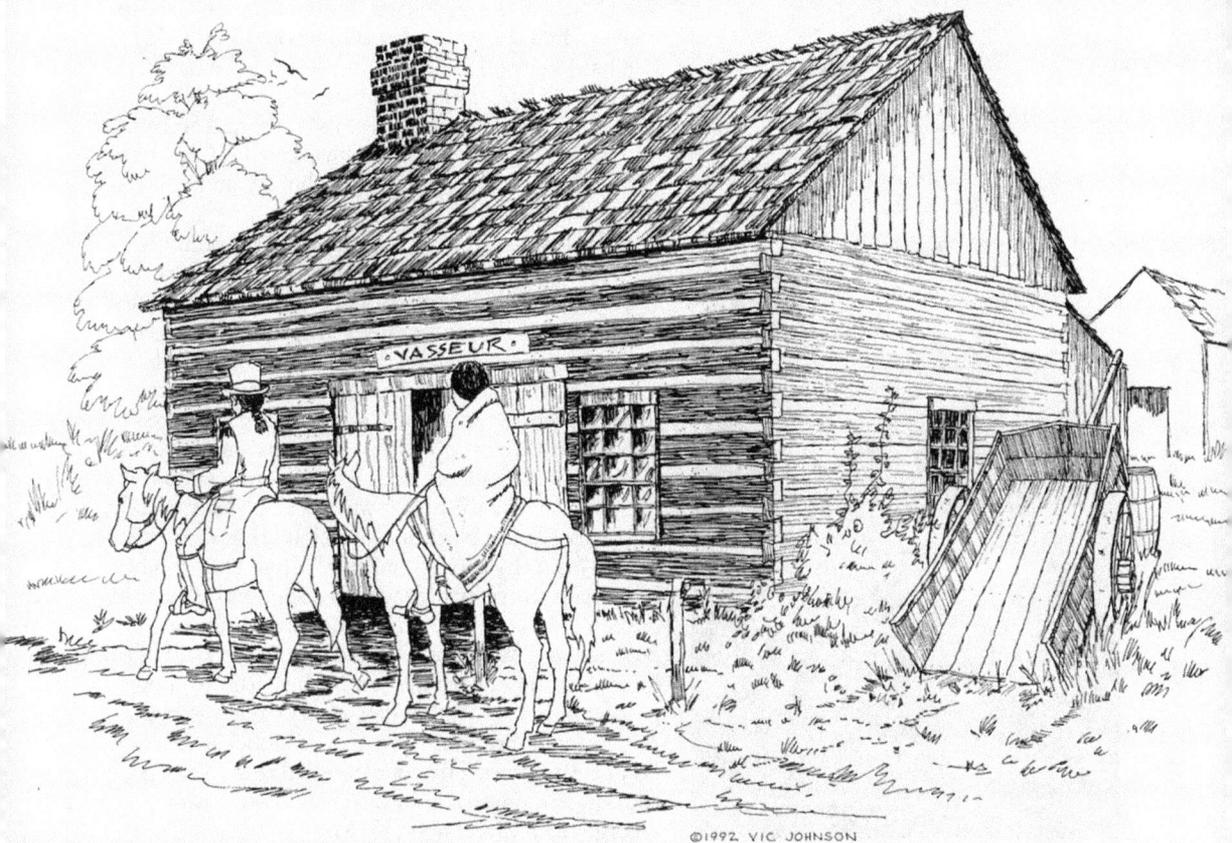

©1992 VIC JOHNSON

The traditional date that LeVasseur built a trading post in Bourbonnais Grove is March 1832, but it seems reasonable to assume LeVasseur's home was at the Iroquois post on the Iroquois River until at least 1834. He bought property at Iroquois in 1832 and 1833. His purchase of Mesheketeno's land came in the summer of 1834. The actual builders of Bourbonnais Grove post in 1832 or 1833—probably following the instructions of Noel LeVasseur—were Henry Boucher and Dominick Bray. Bray is believed to have been hired by the American Fur Company in 1818. He was at the Iroquois post with LeVasseur in the late 1820s. A son and daughter, Dominique Jr. and Ellen, were born there in 1830 and 1832. Boucher also was an employee of the American Fur Company. He had a Potawatomi wife and was stationed at Iroquois post. Boucher probably moved to Bourbonnais Grove before 1834. As evidence that Bray, at least, was living near LaPointe before LeVasseur settled there is a statement of Ellen Bray, who at the age of 90 said her family preceded LeVasseur in settling in Bourbonnais Grove. (THC.)

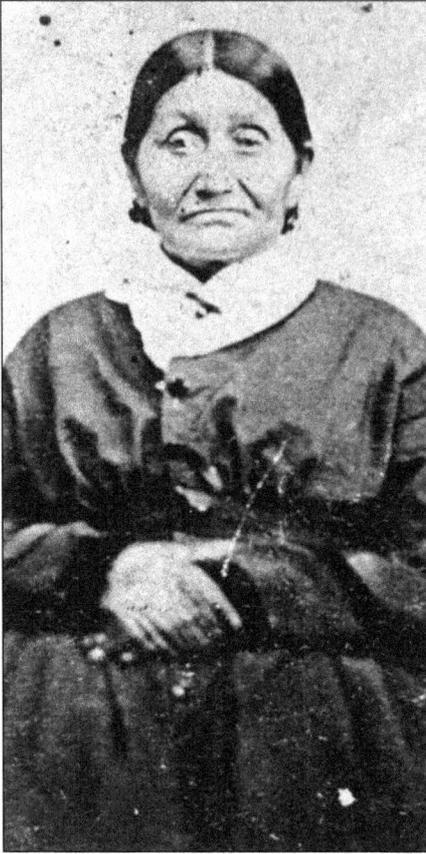

Watchekee is the legendary "Indian Princess" (shown above, when she was in her 60s) whom Gurdon S. Hubbard married in 1826. They separated in 1828. Many years later, Hubbard wrote to Cornelius F. McNeill that the separation was "by mutual agreement and in perfect friendship." Hubbard's wife's Christian name was Josette or Josephine Babin. Watchekee married Noel LeVasseur (right) after her separation from Hubbard and lived with him in Bourbonnais Grove until around 1836. In 1923, historian Burt E. Burroughs told a fanciful story of Watchekee's life and marriages to Hubbard and Noel LeVasseur in *Legends and Tales of Homeland on the Kankakee.* "The old squaws of the village had noted the sign of the star under which she was born," said Burroughs, "noted also that its brightness was dimmed, momentarily by a gauzy, vial-like cloud, and that as it dropped lower and lower in the west lo! It was enveloped completely in the increasing blackness of a cloud that seemed to rise up from the earth to meet it." That "star" might have been the planet Venus. To decipher the meaning of such a sign the women sought out an ancient prophetess. "'Watch-e-kee,' said she, 'is the ward of the Great Spirit; her path lies not in the pathway of our people; to her shall fall much joy and much sorrow.'" After separation from LeVasseur, Watchekee married Francis Bergeron. The couple settled near Wamego, Kansas, and raised a family. (Above, courtesy of George L. Godfrey; right, KCM.)

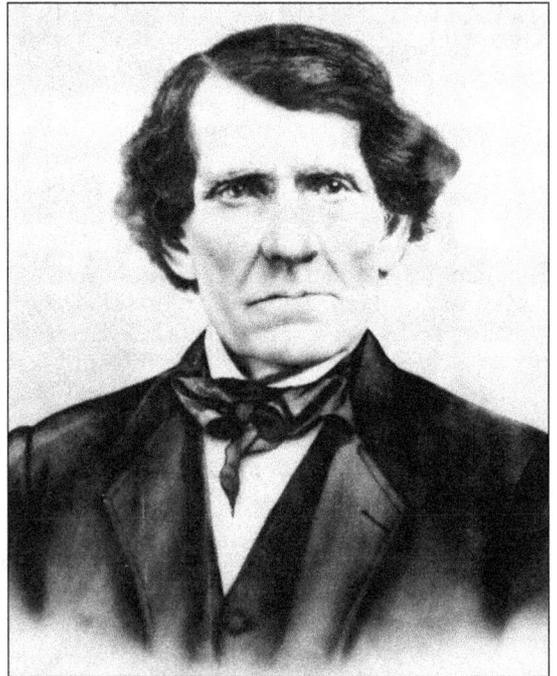

The story of Watchekee an "Indian Princess" circulated for years among the pioneers of Bourbonnais Grove and Iroquois County. This portrait of her was created based on an engraving of another Native American woman from the McKenny-Hall *The Indian Tribes of North America*. The relationship between Watchekee, Hubbard, and Noel LeVasseur conformed to a long established trade culture tradition called "the custom of the country." This custom originated in the early days of the fur trade in Canada. A new trader would form an alliance with an Native American village headman by marrying one of his daughters or nieces. If that trader was replaced by another, in many instances, the new man would inherit the former trader's wife. Both parties accepted this as a possible consequence. The arrangement was subject to abuse, of course. On the other hand, many of these marriages lasted a lifetime and the Native American–French children, "métis," as they are known, were the progeny of an influential subculture that produced several notable tribal leaders. Of Watchekee, Judge Stephen R. Moore said, "Nor let it be inferred that Watseka [sic] held immoral relations with these men. She was a true woman, and faithful to her husband while he remained her husband. And she was equally faithful to Vasseur, and he ever spoke kindly of her, and when he left her he gave her a large fund amounting to several thousand dollars." (KCM.)

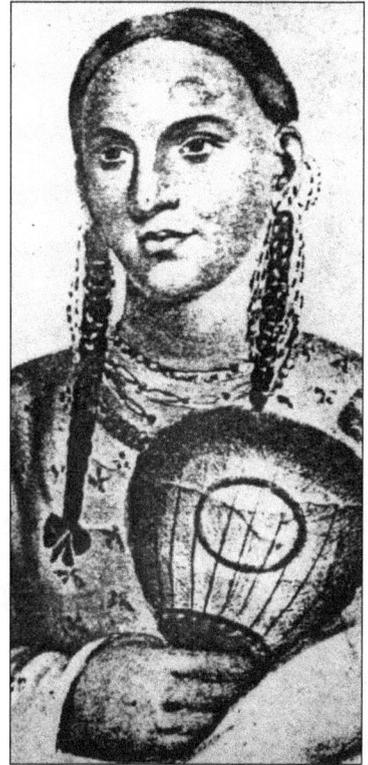

In 1837, Noel LeVasseur had a home built using native clay bricks. This sketch, by Austin Conrad Shreffler, is based on a description by a close friend of LeVasseur's, Alfred H. Senesac. LeVasseur then returned to his parents' home, where he was born on Christmas night 1799, in the Canadian parish of St. Michael d'Yamaska. He came to St. Michael seeking a wife, but found none. However, he did encourage a few families to venture out to his *seigneurie* in Bourbonnais Grove. Later, as more immigrants arrived, they settled a few miles from LaPointe at a place on Davis Creek. They called this community Petit Canada. (KCM.)

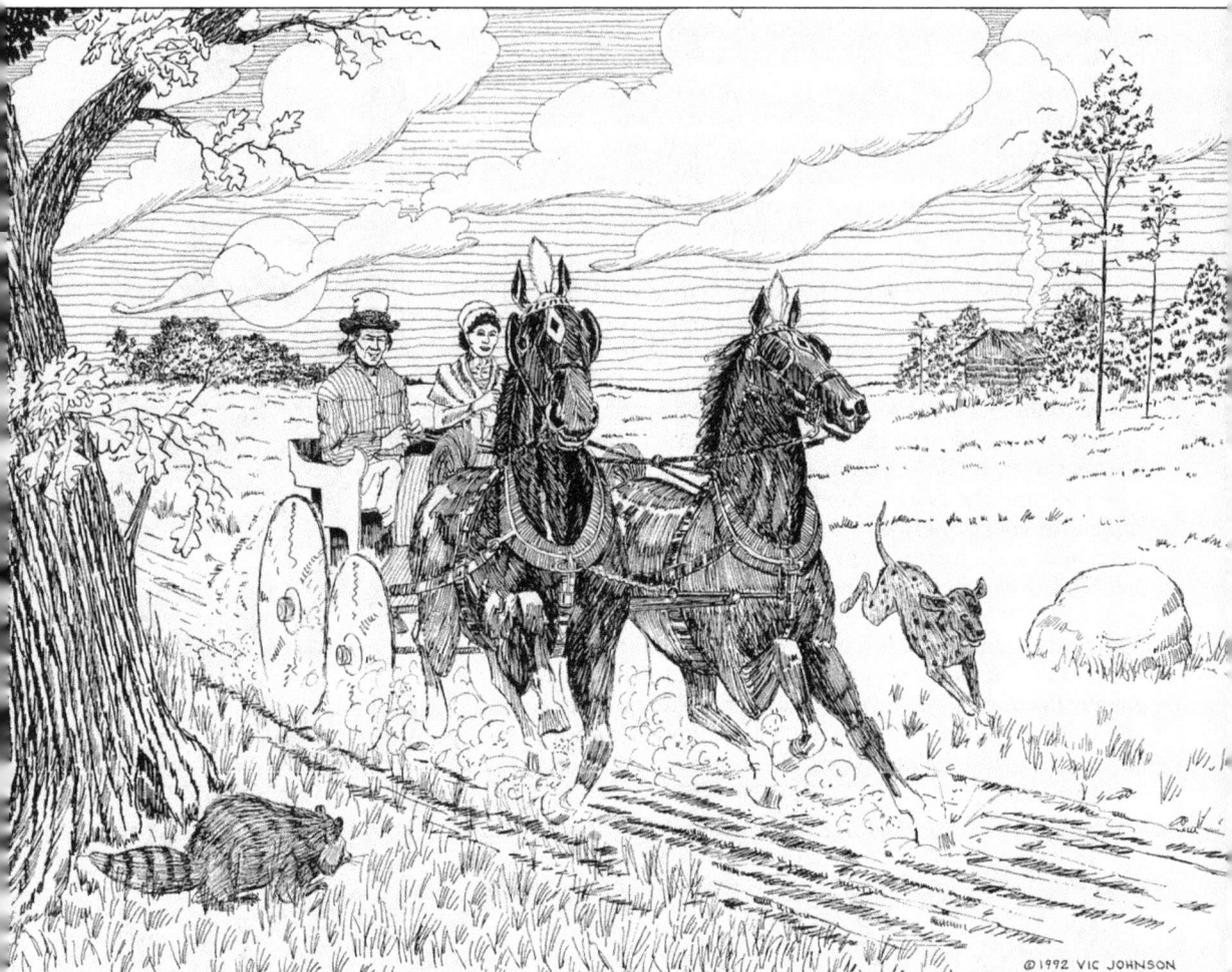

©1992 VIC JOHNSON

Returning to Bourbonnais Grove, Noel LeVasseur met a young lady half his age. Ruth Russell Bull had arrived from Danville, Illinois, to visit her uncle, Samuel Russell, the Bourbonnais Grove postmaster. She was born in Middletown, Connecticut, to George William Bull and Harriet Wadsworth (née Russell). As improbable as it might seem, Ruth—whose sterling linage is replete from Puritan days with noble clergymen and heroic frontiersmen—and Noel, an illiterate backwoodsman, fell in love. The story as told by Henry F. Tower, who at the age of 99 wrote, "LeVasseur's first act was to invite the young lady to take a spin behind the famous blacks." The couple was married on February 18, 1838, in Danville and had eight children. Ruth died on November 16, 1860, but Noel married again. He died on December 12, 1879. His widow, Eleanor "Fannie" Franchere, sold off most of the LeVasseur estate to St. Viator College. Their house was demolished in 1885, and four years later, the college built a large chapel on the site as a memorial to the first college president, Fr. Thomas Roy. (THC.)

This is a photograph of Noel LeVasseur's wife Ruth Russell Bull. Capt. Thomas Bull, born in 1605, was Ruth's ancestor and one of the founders of Hartford, Connecticut. He served in the Pequot War of 1637. Gov. John Winthrop called him "a godly and discreet man," and he was known as a gallant and intrepid officer. William Russell came from England in 1638. William's son, Noahdiah, was one of the founders of Yale University. Ruth's grandfather William E. Russell arrived in Danville about 1832. George R. Letourneau, a resident of Bourbonnais Grove for almost 40 years, knew Noel LeVasseur quite well. Letourneau cowrote a history of Kankakee County in 1906. Among his notes for that work, he recalled that Ruth came to Danville with her uncle Othniel Gilbert. It is not known when Ruth's mother and father came to Danville; however, her father died there on August 25, 1833, at the age of 43. (KCM.)

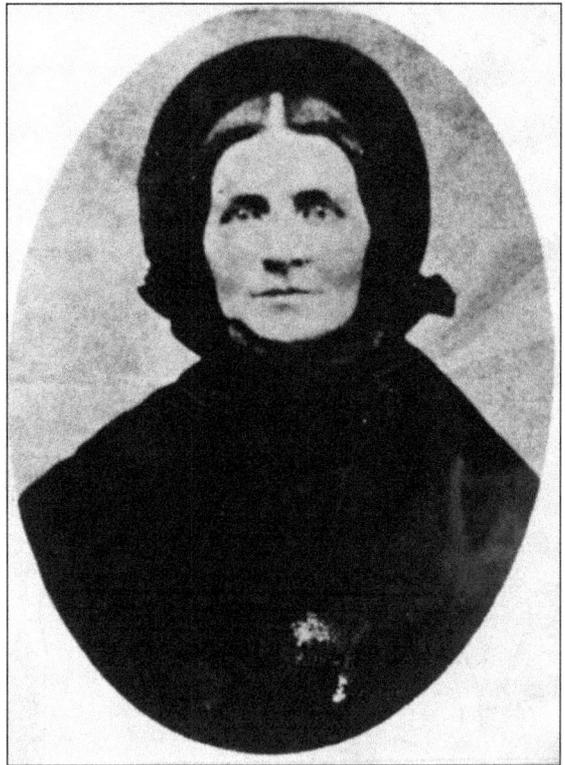

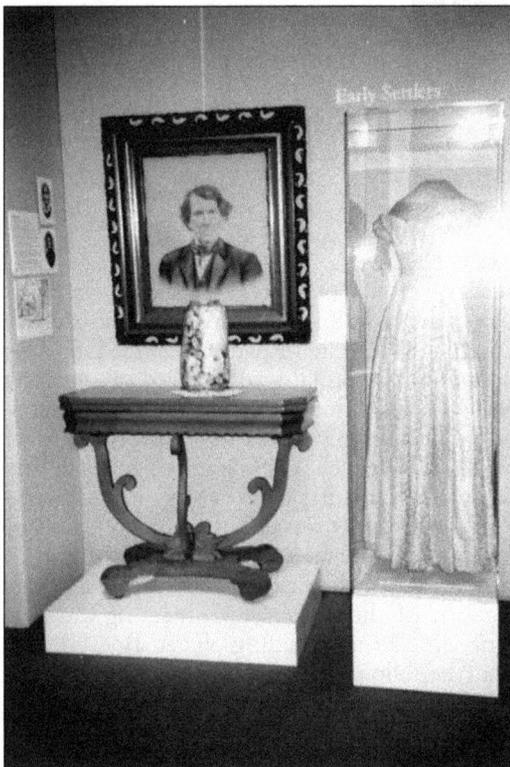

The Kankakee County Museum has on exhibit, as shown in this photograph, a portrait of Noel LeVasseur and a walnut table that belonged to him. Ruth Russell Bull wore the dress in the glass case at her wedding to LeVasseur. (KCM.)

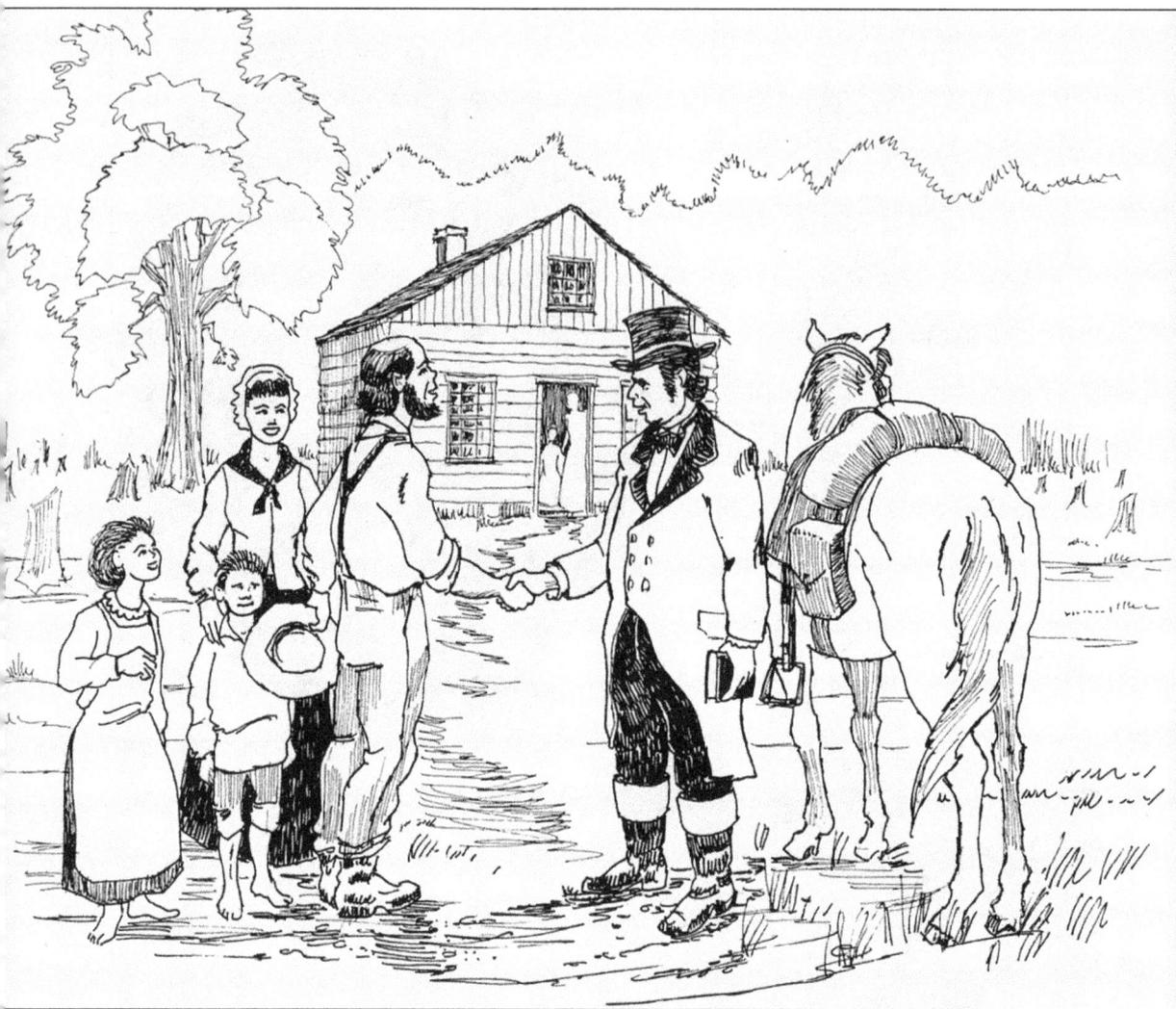

In 1837, Thomas Durham, precinct commissioner of Will County's Rock Creek Precinct, probably supervised the construction of a square, story-and-a-half log building a half mile north of the Durham home, on the west side of the Danville to Chicago Road. Until 1848, the log building housed a public school supported by subscription. The building also served as a meeting place for Methodist circuit riders Stephen R. Beggs, Rufus Lummery, and Simon K. Lemon. The *Illustrated Historical Atlas of Kankakee County, Illinois, 1883* relates that the "Rock River Conference was organized at Mount Morris in 1840. W. Weigley was appointed to Joliet and Rufus Lummery to Wilmington. During the next summer the first class was organized in the schoolhouse at Bourbonnais, Isaac Legg, leader." The first teacher was either Solomon Yeader or Joseph Boltonhouse, hired by Will County School District commissioner Levi Jenks. Milton O. Clark, who later settled in Momence, taught in the early years. He was followed by Charles Starr (1844–1845) and Joseph Jeffcoat (1847–1848). The First Methodist quarterly meeting was held in the schoolhouse during January 1842, with John Sinclair as presiding officer. Bourbonnais Grove became part of a six-week Methodist circuit the following year. Beggs, Levi Jenks, and James Leckenby were the ministers. In 1848, Joseph Lesage, a French Canadian blacksmith, bought the log school and made it his home after the school's classes were moved to a new location. (THC.)

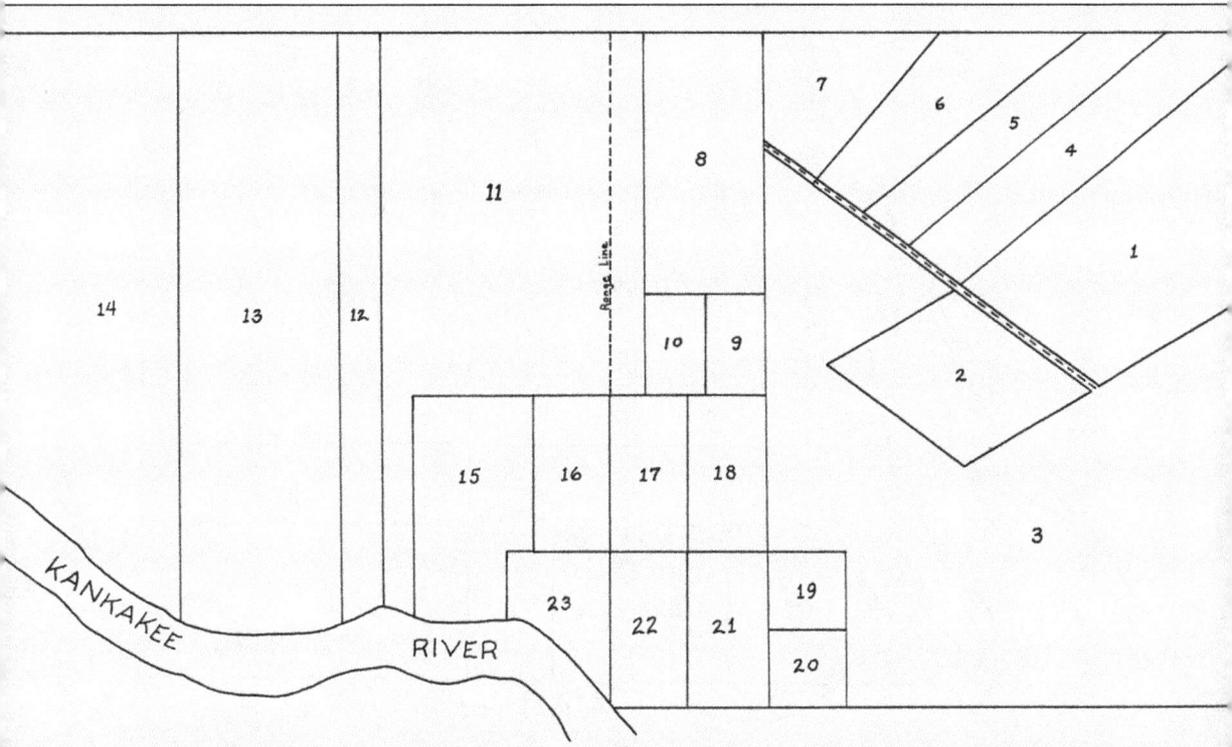

Labels within the figure:
- 14
- 13
- 12
- 11
- 8
- 7
- 6
- 5
- 4
- 1
- Range line
- 10
- 9
- 2
- 15
- 16
- 17
- 18
- 3
- KANKAKEE
- RIVER
- 23
- 22
- 21
- 19
- 20

This is a facsimile of Robert J. Boylan's original subdivision of Noel LeVasseur's two sections of land, made in December 1843. Lots are shown by numbers. A straight section of road, petitioned to become a state route 102, lies between lots 1 and 2. Lots on the east (right) side of the road reflect the tradition of seigniory property division along the St. Lawrence River. (THC.)

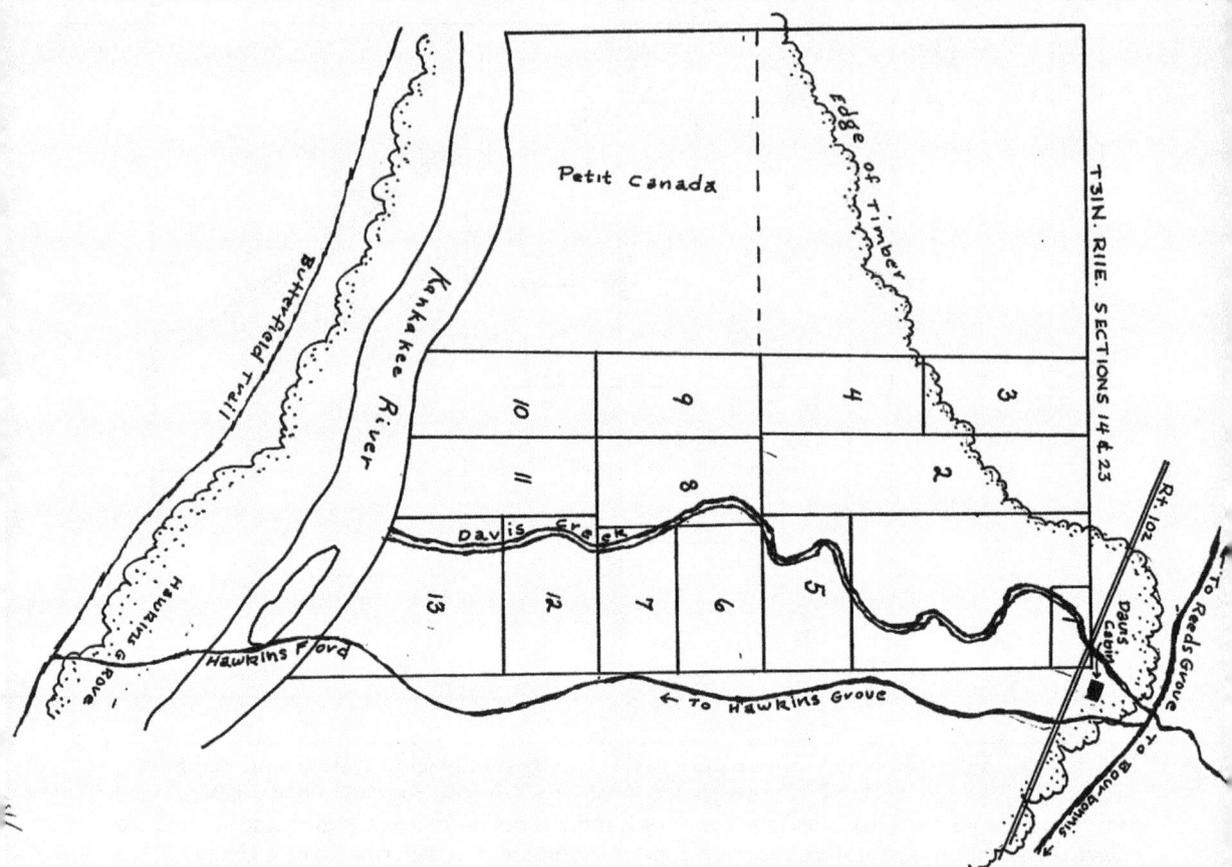

The majority of research on an early French Canadian community known as Petit Canada was compiled by Dave King. He contributes the following: "The township of Bourbonnais in Kankakee County, Illinois, claims our attention and interest by reason of the fact that during the late 1840s a number of Canadian families, brought to the western wilderness by Noel LeVasseur, settled on the François Levia Reservation west of Davis creek, forming a unique and populous settlement which for years was known as 'Petite Canada.' . . . Here, then, was an opportunity for the poor man to live while getting a 'toehold,' and here these Canadians settled on small parcels of land, none of which exceeded thirty acres in extent. This little settlement of ten or a dozen families was a most primitive one, as may be readily imagined. Of the original first settlers, Charles Thibault held sixteen acres, Jean Baptiste Audet twenty acres, Alex Dandurand twenty acres, Luke Betourne thirty acres, John Dandurand thirty acres, François Balthazor thirty acres, and nearer to the river were located Louis Goyette with three acres, and Alexine Guay Castoneau and one Deschon (Louis Deschampes) with not to exceed three or four acres apiece. The inference is natural that the title of 'Little Canada' was fittingly applied to a community that held tenaciously to old manners and customs and traditions of the Canadian homeland." (THC.)

36

Three

BOURBONNAIS GROVE
1838–1875

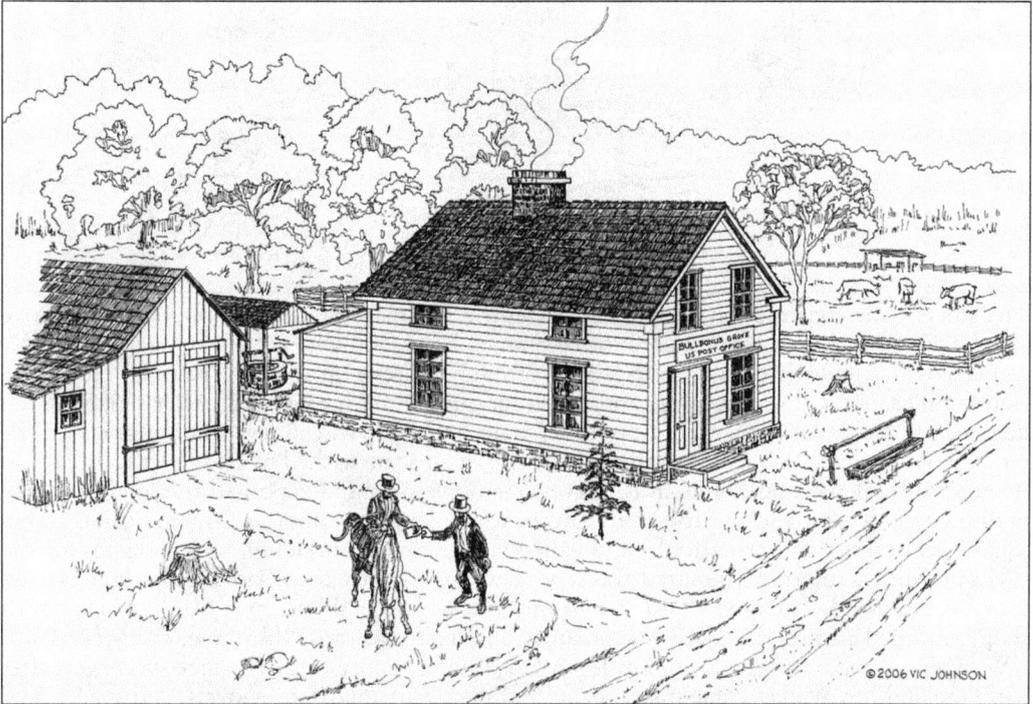

In the early days along the dusty, well-traveled Danville to Chicago Road that ran past Noel LeVasseur's brick *maison* lay a scattering of cabins and John Flageole's blacksmith's shop. The earliest structures built in LaPointe were LeVasseur's log cabin, trading house, and brick home. Then there were the log cabin used for a schoolhouse, St. Leo's Chapel, and a timber frame constructed farmhouse. In July 1852, George R. Letourneau and Elodie Langlois were married. A small subsistence farmstead, including the timber frame farmhouse, became their new home. The farmhouse had an interesting story of its own. Letourneau said he had bought a little over three acres of land and a "pioneer structure" from Jacob Russell. Russell was the receiver for the Port of Chicago. Russell had bought the property from LeVasseur in 1848. The farmhouse, said Letourneau, had served as a post office and general store in 1840. It could have been the Bullbonus Grove post office kept by Samuel Russell in 1838. LaPointe's population grew slowly at first. Sixty families arrived during 1848–1849. A sizable immigration of Quebecois came between 1851 and 1854. (THC.)

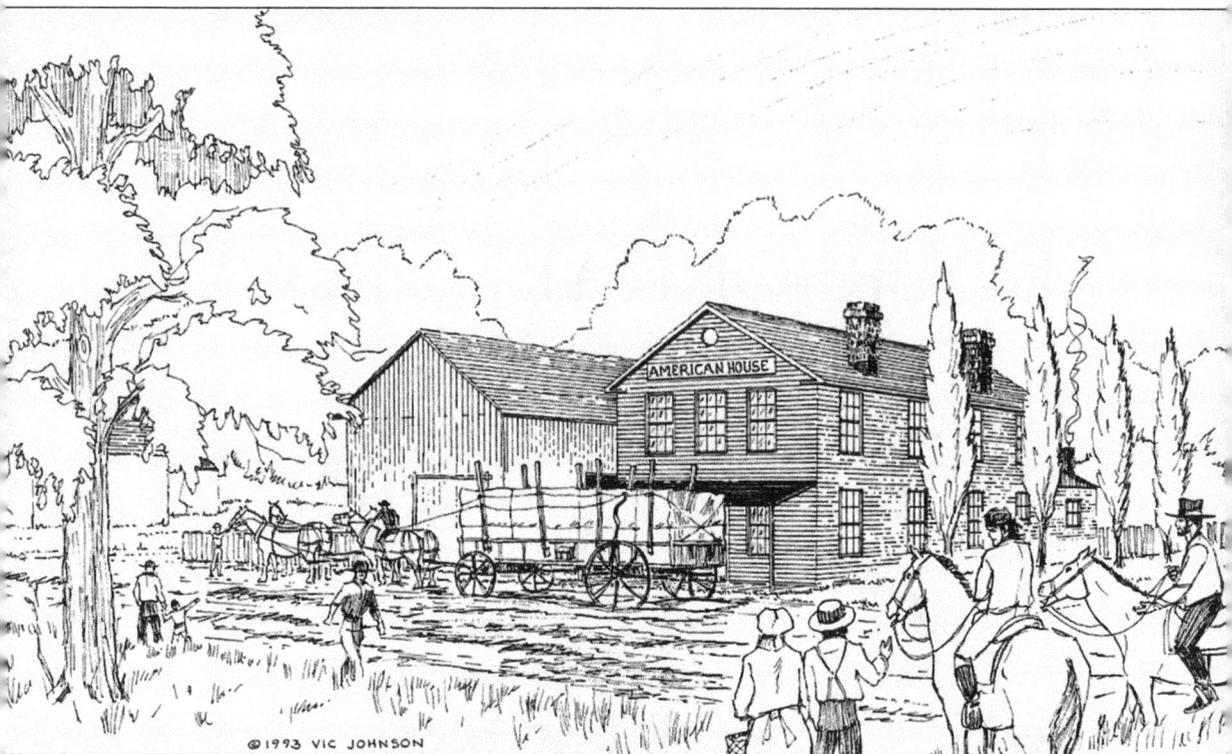

© 1993 VIC JOHNSON

The story of the construction of the Illinois Central Railroad through the Bourbonnais Grove area begins with this eyewitness account by Samuel L. Knight, who recalled that in June 1852, "a man with a four-horse team, with a load of lumber, drove up to the 'American House,' in Bourbonnais, which I was keeping, and called for dinner and horses' feed. After satisfying the demands of the inner man with a dinner of ham and eggs, with a few trimmings added, he ordered out his team and inquired the road to the river, as he wished to cross over to the south side of the Kankakee, on the I.C.R.R. survey. He drove over and deposited the lumber on the prairie one-half mile south of the river. Two or three days after, another stranger came with a square, scratch-awl and other tools, and called at the American House, took lodgings for the night and in the morning inquired the way to where the first man had left the lumber, and took his departure. The next heard of him was that he was building up (I think, a blacksmith shop), and had named the place Sacramento. The first man was Milo June, the second was L.W. Walker, and in the employ of Linsley & Co., railroad contractors. In quick succession after Mr. June and Mr. Walker came many teams and men, carts, barrows, shovels, and spades, and in one year the road was graded from Chicago to Spring Creek, Iroquois County." Contrary to folk history, Bourbonnais Grove was never considered to become a town on the Illinois Central Railroad. (THC.)

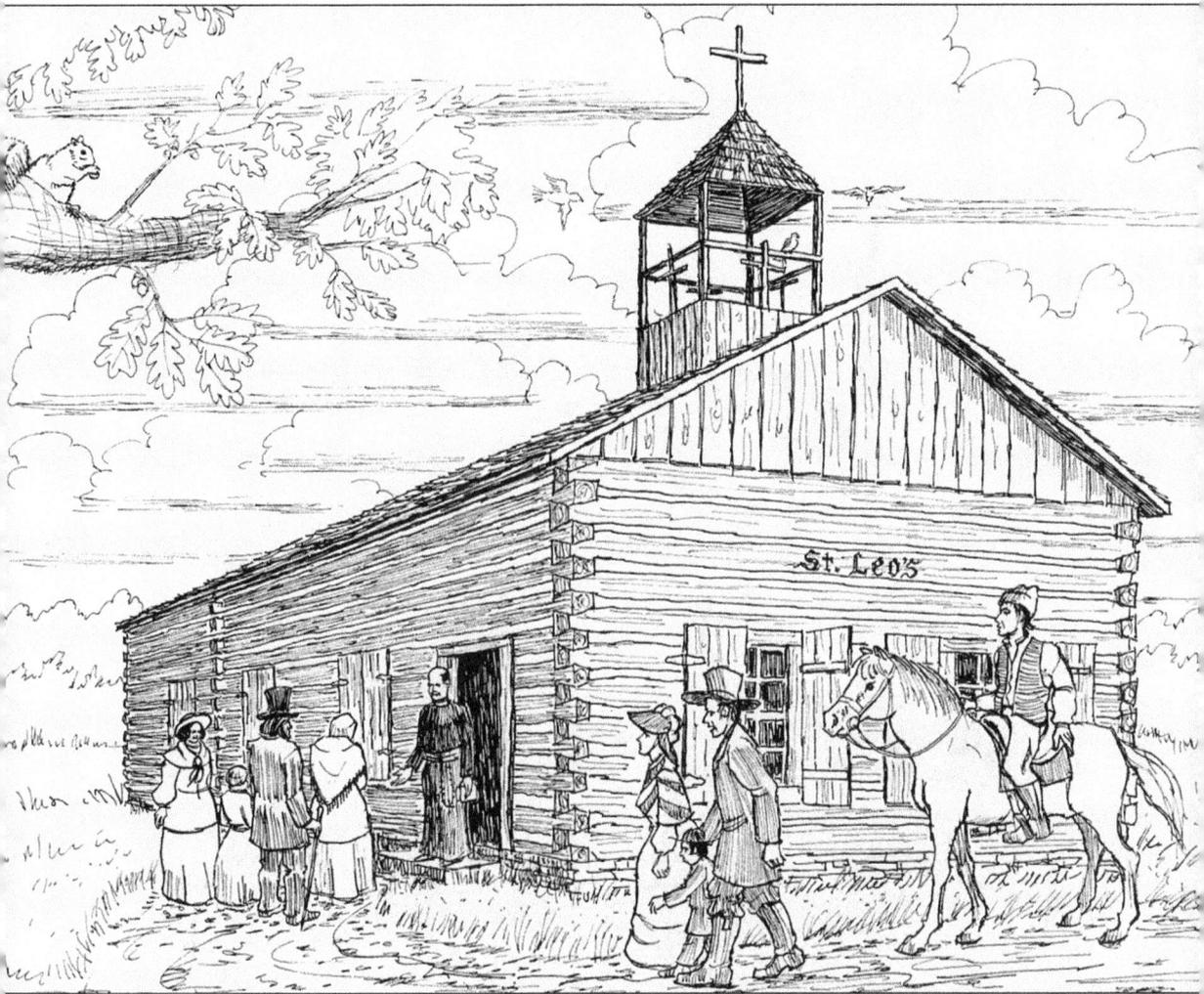

A missionary priest from Vincennes, Indiana, Fr. Simone Lalumiere, was the first priest of record to offer mass in Bourbonnais Grove in June 1837. At that time, he also baptized little André Bray, the son of Dominique Bray. During the missionary period, Fr. Stephen Theodore Badin, the first priest ordained in the United States, ministered to Bourbonnais Grove's Catholic community. The first Catholic marriage to be celebrated in Bourbonnais Grove occurred on October 20, 1840. Blacksmith John Flageole and Mary Marcotte were married by Fr. James M. Maurice de Long d'Aussac de St. Palais, who was the pastor of St. Mary's in Chicago. St. Palais later became the fourth bishop of Vincennes. Fr. Hypolite Du Pontavice of the Vincennes Diocese was named the pastor at Joliet in 1839. He built a 20-by-30-foot log chapel dedicated to St. Leo in 1841 on a half acre of land bought from Noel LeVasseur for $20. Fathers Du Pontavice, Dunn, Crevier, and St. Palais served the mission until 1846. Created in September 1843, the diocese of Chicago included all of Illinois. On July 9, 1846, Chicago's Bishop William J. Quarter bought St. Leo's Chapel in Bourbonnais Grove from the bishop of Vincennes. Shortly after, Quarter wrote of Bourbonnais Grove, "This congregation is composed almost exclusively of French Canadians; the present pastor is Reverend [Renee] Courjault, a native of France. The congregation is increasing daily, especially by immigration from lower Canada." (THC.)

©1993 VIC JOHNSON

In *A History of Urban America*, Charles N. Glaab and A. Theodore Brown say that railroad officials knew great profit would come from urban growth in the West. The Illinois Central Railroad Company "used the threat of building new towns or running its tracks through neighboring places in order to force local officials in established communities to offer concessions of right-of-ways, railroad station site donations, or stock purchases. Newspaper advertisements, posters, and pamphlets glorifying the agricultural advantages of Illinois were widely distributed in the United States and abroad by the Illinois Central Railroad during the 1850s. The goal of these publications was to encourage immigration to Illinois and sell railroad-owned farmland. The "railroad lands" were those sections of land that had been given to the Illinois Central by the federal land grant bill in 1850. An advertisement offering for sale 200,000 acres of railroad lands appearing on October 15, 1854, read, "Augustine [variously spelled Augustin and Augustus] Chester, Land Agent, ICRR Co., Bourbonnais or Kankakee City. A. Chester also Attorney and Councillor at Law." (THC.)

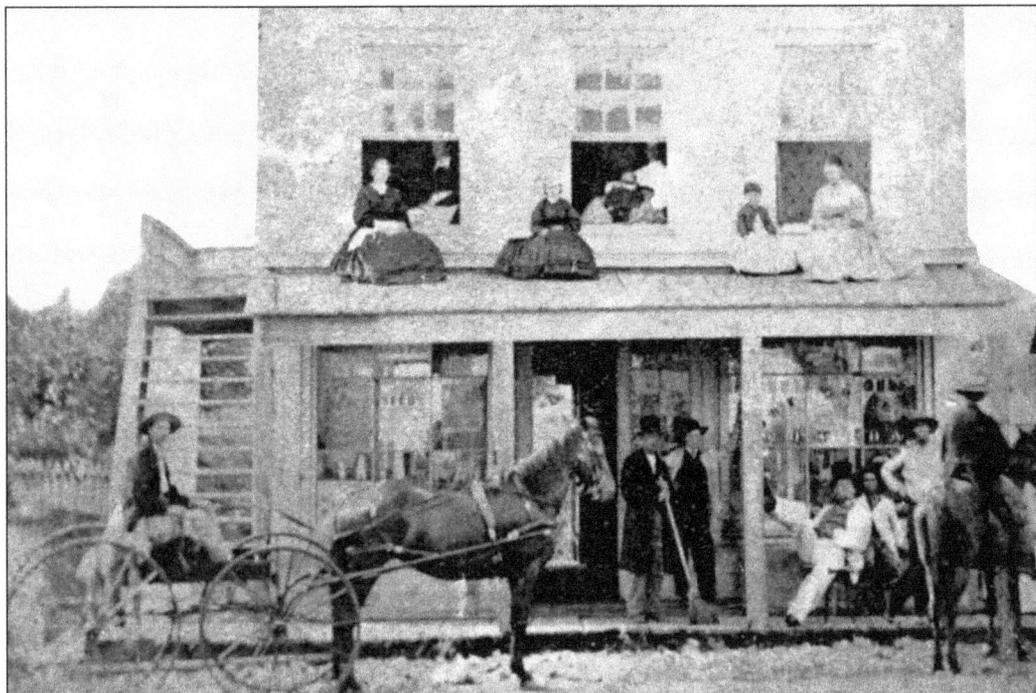

These are two of the earliest known photographs (around the late 1860s or early 1870s) taken in the village of Bourbonnais Grove. The Perrault family owned the store and the home shown at bottom. The proprietor's name was Louis Perrault. His wife was Nathalie Lecuyer. Perrault died in February 1872. By the late 1890s, Harvey J. Legris owned the store building. It housed a bakery and candy store operated by Alfred H. Senesac. George Arseneau took over the bakery in 1905. Senesac continued as proprietor of the candy store for a while. He later became the village funeral director. (TJL.)

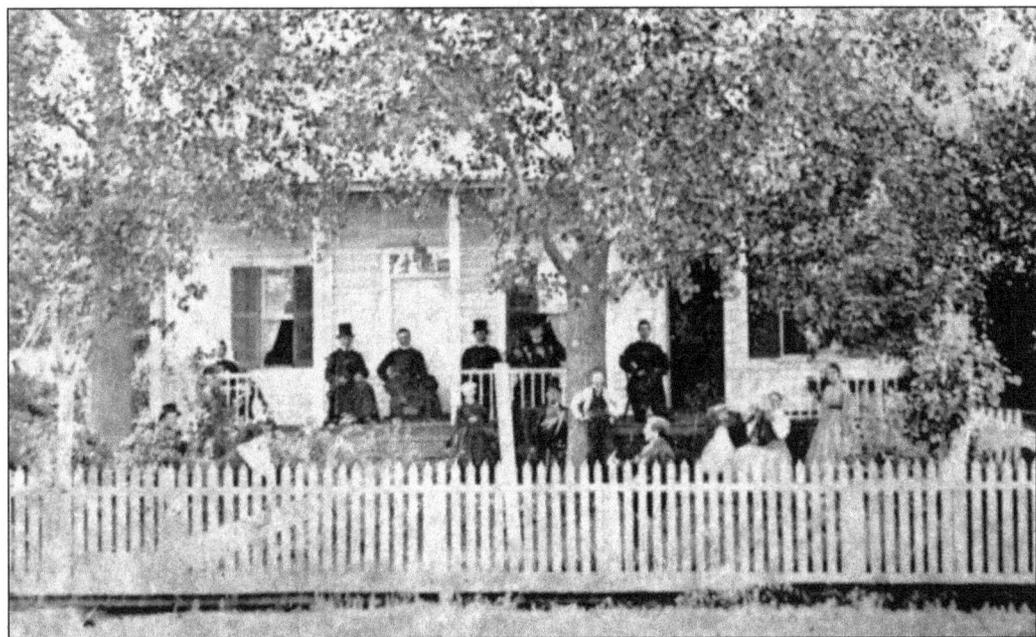

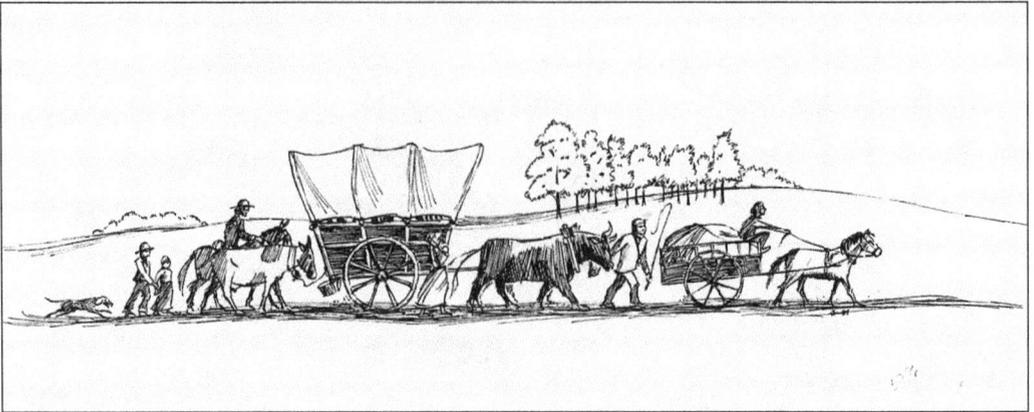

John Flageole arrived in Bourbonnais Grove from Canada in the late 1830s. He encouraged his family and friends to immigrate. Antoine Marcotte and Eloi Bergeron soon followed. A large migration to Bourbonnais Grove began in 1847. Capt. Francis S. Seguin relocated to the village in 1853 and "proved an agreeable and useful acquisition to both town and county." In the fall of that year, George R. Letourneau returned from the California goldfields. He had traveled west in 1850 to seek his fortune and came back with money earned in quartz mining and hauling supplies for other miners. Both men would take an active interest in village and county politics. Letourneau, Seguin, and Noel LeVasseur participated in the organization of Kankakee County out of Will and Iroquois Counties. "At the founding of the Republican Party," William Kenaga recalled, "the three friends turned the tide of the county to the Republican side." Letourneau served in nearly every county elective office, as mayor of both Bourbonnais and Kankakee, and two terms in the Illinois legislature. Seguin was the third sheriff of Kankakee County, and mayor of Bourbonnais between 1876 and 1878. (THC.)

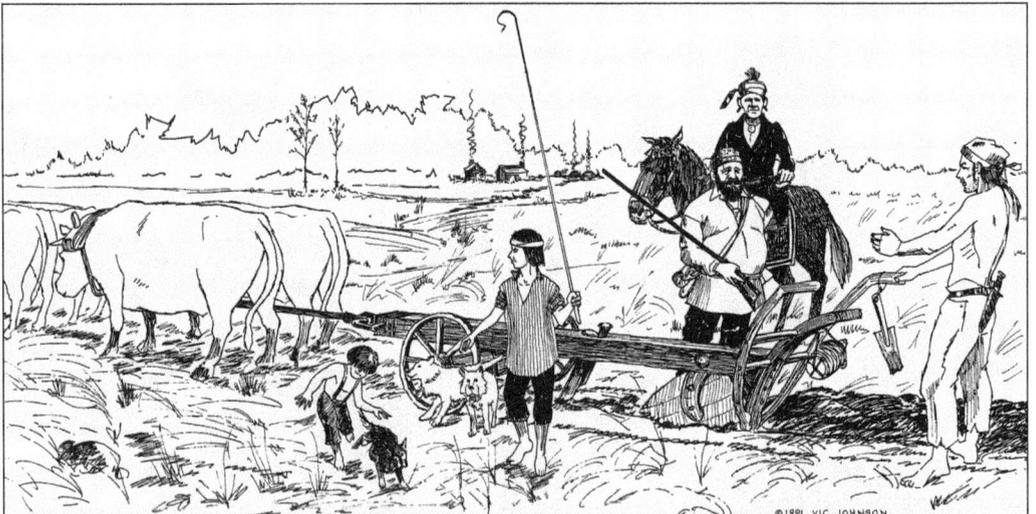

Many of the new arrivals began to open farms of 20 acres or more on the prairie northeast of the village. Years later, Letourneau recalled that prominent among fellow French Canadians were "Joseph LeSage, a general blacksmith, and Levi and Alexis Bessette, practical wagon makers. Edward and Antoine Langlois located on the prairie near the town, as did Antoine Brosseau, father of Peter, Noel and Jeremiah Brosseau, and many other heads of families." (THC.)

42

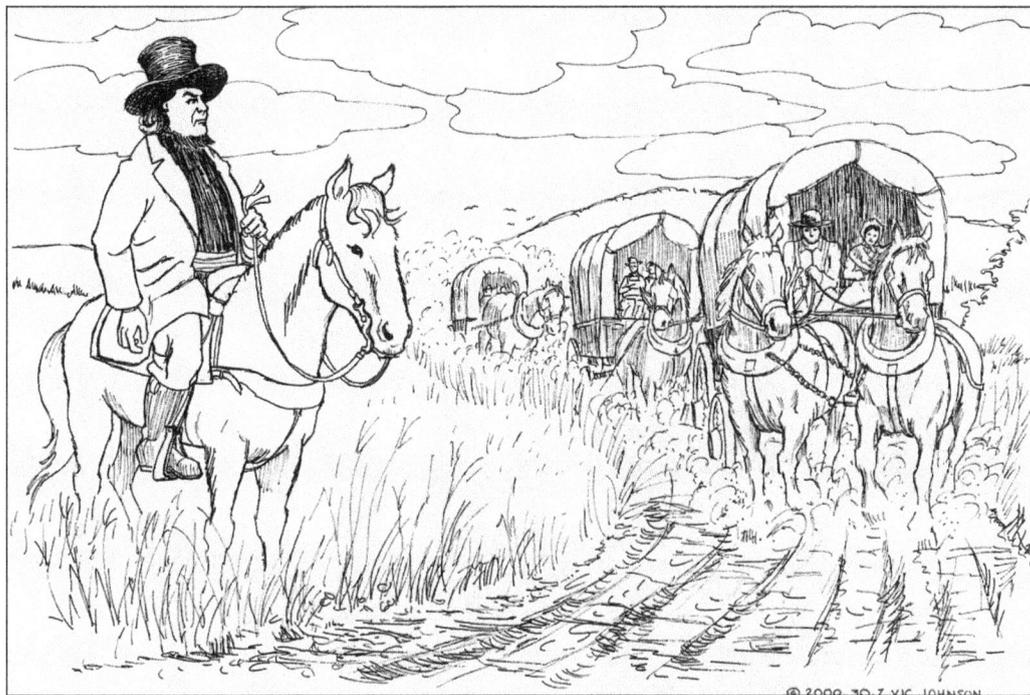

Early French Canadian immigration to Bourbonnais Grove came mostly as a response to Noel LeVasseur's plan to harvest a modest profit from his real estate investments. A new incentive for leaving Canada for the prairie lands of Illinois began to unfold in 1851. That year a 42-year-old Catholic priest arrived on the doorstep of the Maternity of the Blessed Virgin Mary Church (Maternity BVM) in Bourbonnais Grove. He was Fr. Charles Pascal Telesphore Chiniquy from Montreal. He was a man with a grandiose plan to promote his own ambitious dreams by exploiting the growing opposition of many conservative Catholics to a policy of democratizing church administration in America, begun by the first bishop of Baltimore in 1784 and known as "Trusteeism," and the discontent of his Canadian countrymen, who had lived under the chaffing thumb of the British king. Chiniquy was pastor of Maternity BVM parish for a short time. He persuaded three families to leave Bourbonnais Grove and settle in St. Anne, a village and parish that he founded in eastern Kankakee County. Chiniquy had letters published in Canada encouraging immigrants to come to Illinois. A conflict with policies and teachings of the Roman Catholic Church led to his excommunication in 1856. He then organized the Christian Catholic Church of St. Anne. (Above, THC; right, BGHS.)

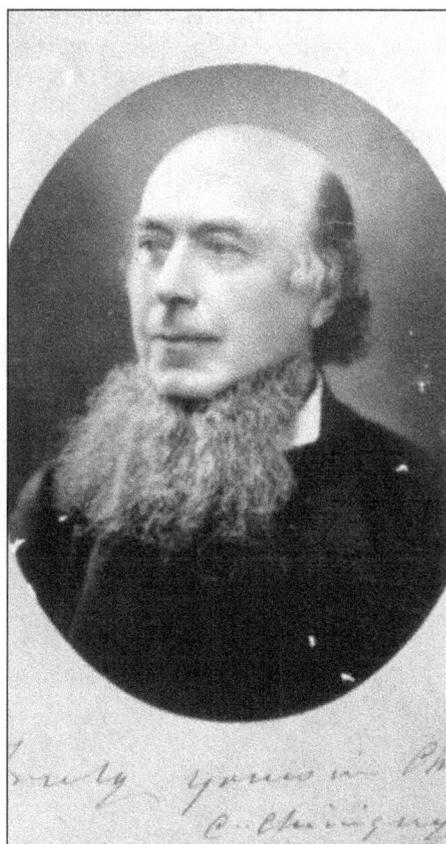

43

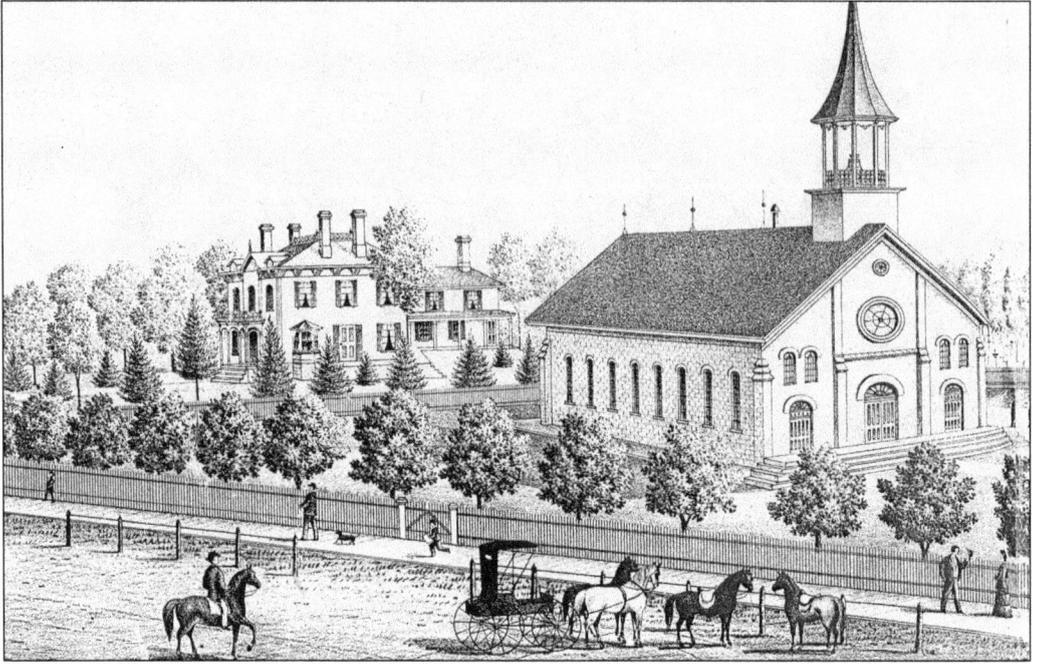

In September 1853, during Fr. Charles Pascal Telesphore Chinquy's residency as pastor of Maternity BVM Church (1852–1853), the frame building that replaced St. Leo's Chapel caught fire and burned to the ground. Parishioners suspected that Chiniquy had set the fire. Chiniquy fled to St. Anne, where he remained as pastor of St. Anne parish. Fr. Isadore Antoine Lebel became Maternity BVM pastor in November 1854 and immediately began to plan for a new church building. His first act was to appoint a committee of trustees to supervise the administration of parish affairs. Members of the committee were John Flageole, treasurer, Henry Boucher, Jacob Pilotte, Eloi Bergeron, Joseph Rivard, Antoine Marcotte Sr., and André Martin. A new church, designed by Lebel and built of native limestone by parishioners, was completed in 1858 and still stands today. (THC.)

A cemetery was opened near St. Leo's Chapel in 1842. Many Bourbonnais Grove pioneers were buried here. By 1884, the old graveyard had no more empty space. The parish located a new cemetery about a mile from the church on River Road. In 1974, Adrien M. Richard found some 30 headstones in the old cemetery that had legible engravings. He recorded those names in his book *The Village*. The earliest legible burial was David Spink, 1848. (THC.)

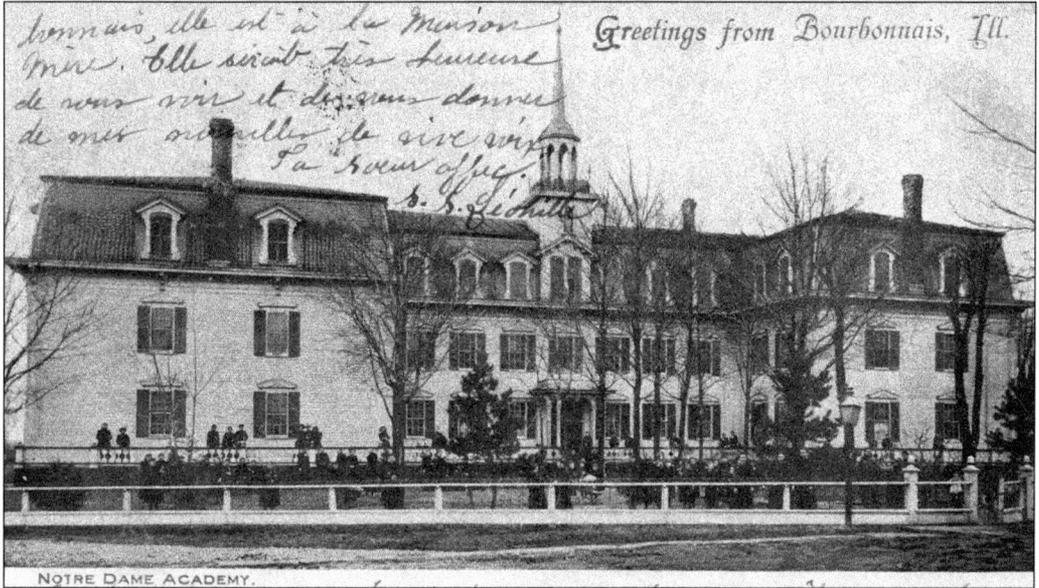

NOTRE DAME ACADEMY.

The Chiniquy schism from the Roman Catholic Church caused "many lost sheep" among Maternity BVM parishioners. Family ties were split as some members followed Chiniquy in his new Christian calling. In 1857, Rev. Alexis Mailloux, "one of the most distinguished of many noted priests of Canada," and vicar-general of Quebec, took charge of Maternity BVM parish. "During his five years of hard labor," wrote Rev. Elder A. Senesac, C.S.V., "he won back many lost sheep." During the summer of 1860, Mailloux persuaded sisters St. Alexis de St. Joseph, St. Alphonse de Ligouri, and St. Marie de la Victoire of the Congregation of Notre Dame to come to Bourbonnais Grove and open a school for girls. Over the years, this school grew and became Notre Dame Academy. Work on the academy building shown above began in 1865. Between that year and 1910, the two large additions flanking the main building were completed. (TJL.)

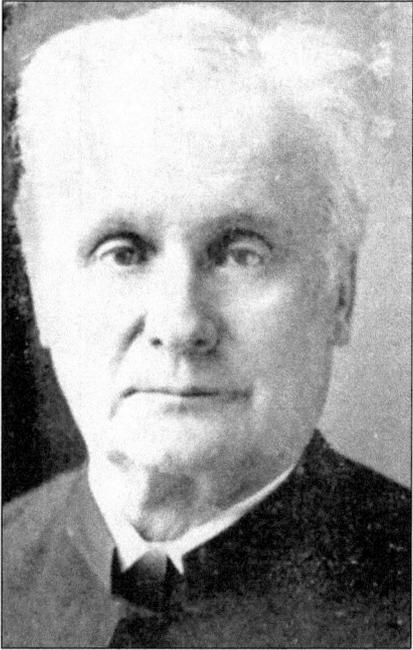

Rev. Jacques Cote became the pastor of Maternity BVM Church on October 30, 1864. He was satisfied with the education of Catholic girls by the Notre Dame sisters, but the education of boys remained in the hands of secular teachers. With the permission of Chicago's Bishop James Duggan, Cote went to Canada to enlist the Clerics of St. Viator as teachers for a boys' academy. He offered to resign as pastor of Maternity BVM if the Viatorians would send a priest to replace him along with brothers as teachers. His offer was accepted. (BGHS.)

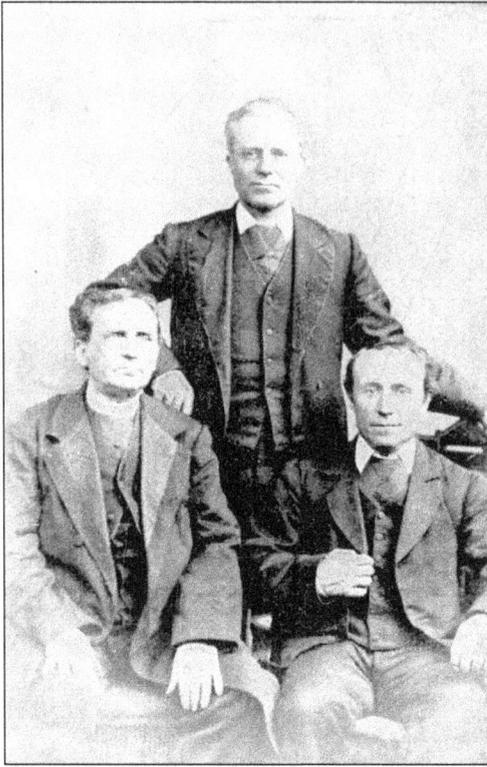

The Rev. Peter Beaudoin (left) and two brothers, Jean Baptist Bernard (standing) and Augustin Martel (right) arrived in Bourbonnais Grove on September 10, 1865. They soon were certified by the Kankakee County superintendent of schools and began to teach in a boys' school. At the end of the first year, the number of pupils increased and Brother Joseph Lamarche joined the teaching staff. By the fall of 1868, Fr. Thomas Roy had added a commercial course to the curriculum courses in French, Latin, philosophy, and mathematics to what now had become St. Viator College, and a commercial department was opened. The college offered training in vocal and instrumental music in 1870 and established a department for the teaching of theology. (BGHS.)

In 1859, according to Fr. Elder A. Senesac, "a two-story structure was erected near the present site of the church" (stone building on the right). The Viatorians bought the building from the school board in 1868 and added a third story. (See lower drawing on opposite page.) The building, called St. Viator Academy, continued to be the district school for boys, taught by male clergy, until 1891. At that time, a two-story frame building was constructed by the public school district on the north side of Marsile Street, opposite the church and rectory. This school was staffed by Viatorian brothers who continued to teach the grade school boys of the village until 1918. (THC.)

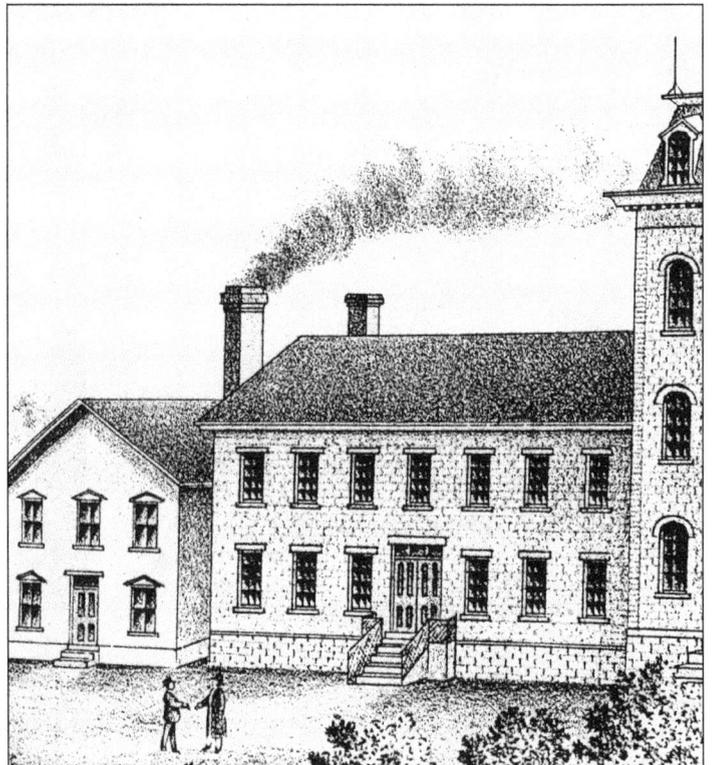

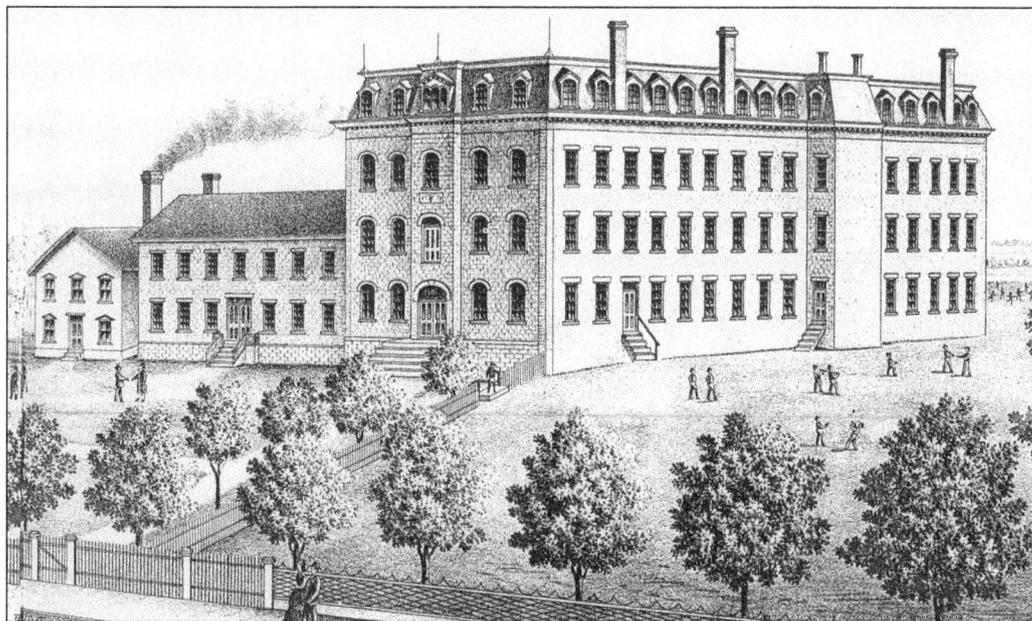

The Viatorians broke ground in 1870 for a new stone building that would house St. Viator College. On September 1, 1871, Brother Moses J. Marsile came down from Canada to head the French literature department. Three years later, the Illinois state legislature granted the school a university charter. Father Senesac said, "Thus did a small grade school, humbly begun, enlarge in a brief span of years to a classical college and commercial college." (THC.)

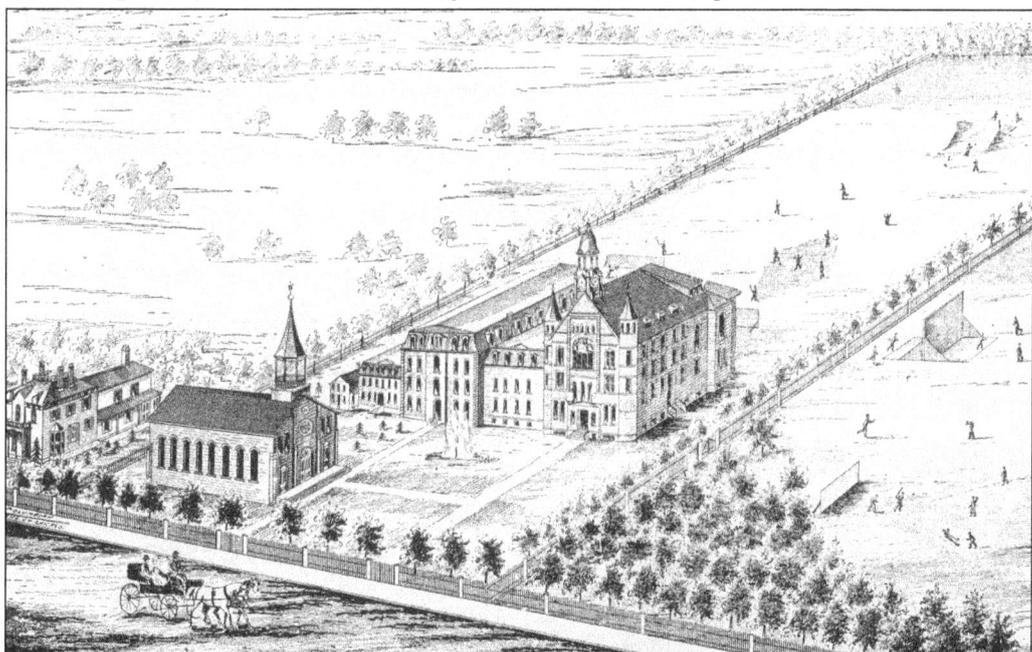

In following years, the college faculty expanded the curriculum to include courses in English literature, science, and philosophy. Average attendance was 250. College alumni contributed funds in 1889 to build the Roy Memorial Chapel. It is seen in the center of this drawing. Later the college built a gymnasium and another building for classrooms and a dormitory. (BGHS.)

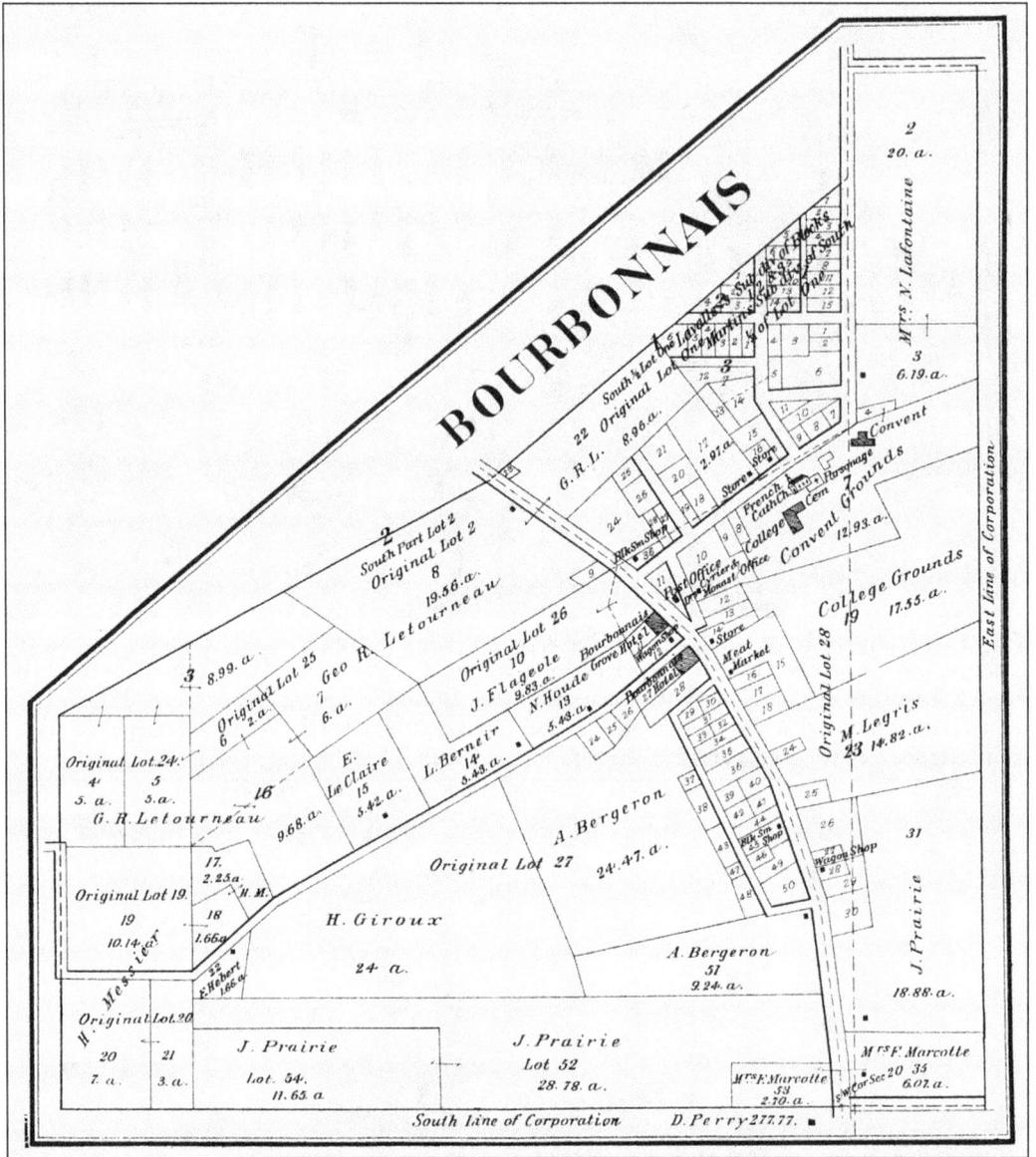

In 1875, the village of Bourbonnais Grove incorporated and shortened its name to Bourbonnais. The map above shows the village as it appeared about 1880. The village is located in a township of the same name. Bourbonnais Township lies near the center of Kankakee County. As one of the original six townships established in the new county of Kankakee in 1853, Bourbonnais was bounded on the west by the Kankakee River, on the north by Rockville Township, on the east by Momence Township, and on the south by Limestone and Aroma Townships. As the French Canadian immigrant population grew many of these families moved to farmsteads in the townships surrounding Bourbonnais. Others relocated to villages established along the Illinois Central Railroad—Kankakee, Manteno, Chebanse—and to the outlaying villages of Momence and St. Anne. (BGHS.)

Four

LES HABITANTS
1829–1875

Nova Scotia and Acadia (L'Acadie) are the same piece of land, almost an island, which was English in 1621, then French in 1632, and then English again from 1713 on, according to a treaty by which the French gave it to England. The Acadians, who had come from France as early as 1636, had made many improvements. They lived peacefully in this beautiful place. English and French wars were their only trial. After 1713, the English allowed them to practice their Catholic religion and to keep their land. In the 1750s, the governor of Nova Scotia, Charles Lawrence, decided that the Acadians must be removed from their lands and possessions. "On September 10, 1755, the Acadian nightmare began," according to author Suzanne Smith-Pruchnicki. Wholesale deportation of the French Acadians began. Families were broken apart and scattered along the American coast from Massachusetts to Louisiana, and in the Guianas and West Indies. Some eventually made their way to the upper St. Lawrence and Montreal. Many descendants of these people immigrated to Bourbonnais Grove. (BGHS.)

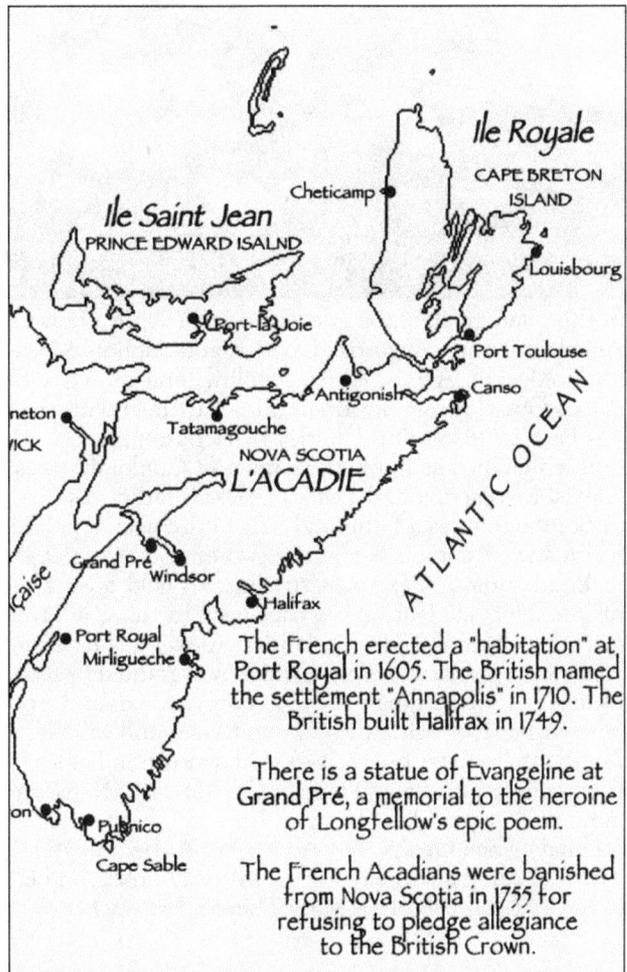

The French erected a "habitation" at Port Royal in 1605. The British named the settlement "Annapolis" in 1710. The British built Halifax in 1749.

There is a statue of Evangeline at Grand Pré, a memorial to the heroine of Longfellow's epic poem.

The French Acadians were banished from Nova Scotia in 1755 for refusing to pledge allegiance to the British Crown.

In this photograph of the Alexis Gosselin family, shown standing are, from left to right, Edward, Amedee, Arthur, Augustin, Charles, and Alphonse. Seated are, from left to right, Rev. Mother Mary Alexine, Alexis, Alma, Apoline, and Sr. Mary St. Bernard, and seated in front is Ida. Alexis Gosselin came to Bourbonnais in 1843 with the family of Jean Baptiste Martin. Alexis was born in 1828 in St. Charles Bellechasse, Quebec. He was the eighth of Charles Gosselin's nine children. His mother, Marguerite Coulombe, was Charles's second wife and mother of Alexis, Marguerite, and Damas. Alexis's father died in 1830. Fourteen-year-old Alexis moved to Bourbonnais as a farmhand. His future wife, Apoline Martin, was born in 1842, but Alexis had many adventures before the two married in 1859. As happened to many other young men in Bourbonnais, Alexis was struck with gold fever around 1849 or 1850. Over the course of his life, he made four or five trips back to the California goldfields, particularly around Yreka, near the Oregon-California border. Alexis was back in Bourbonnais in 1853 to complete his application for naturalization, which was granted in 1861. When he married in 1859, his brother Damas was the best man at the wedding. Alexis and Apoline had 13 children, 10 of whom were born in Bourbonnais. Alexis was a farmer and was elected to the first board of directors of the Bourbonnais Township in 1875. A downturn in health, the opportunity to invest in a mill, and the immigration of many French Canadians to Kansas all contributed to the family decision to move to Aurora, Cloud County, Kansas. The partners in the mill included a Mr. Lanoue, the original owner, George R. Letourneau, A. Berard, and Alexis Gosselin of Bourbonnais Grove. The mill dam burst the night the sale was closed, and it took $2,500 and a month of hard work to repair. (Courtesy of Sr. Mary Therese Sweeny.)

This vintage photograph was taken in 1886. It is labeled "Bourbonnais Grove Students, 1853–1854". Standing are, from left to right, Stephen Taut, Milton D. Butts, and Benjamin Morse. Seated are Charles A. Brosseau (left) and Alfred Bernier. Bernier is said to be the first to volunteer for service during the Civil War. He was a member of the 19th Illinois Infantry. Stephen Taut kept a billiard hall and sample room across from the Illinois Central Depot in Kankakee in 1883. Milton D. Butts was a charter member of the Kankakee County Agricultural Society. Charles A. Brosseau had a grocery store on the west side of South West Avenue in Kankakee in 1883. (KCM.)

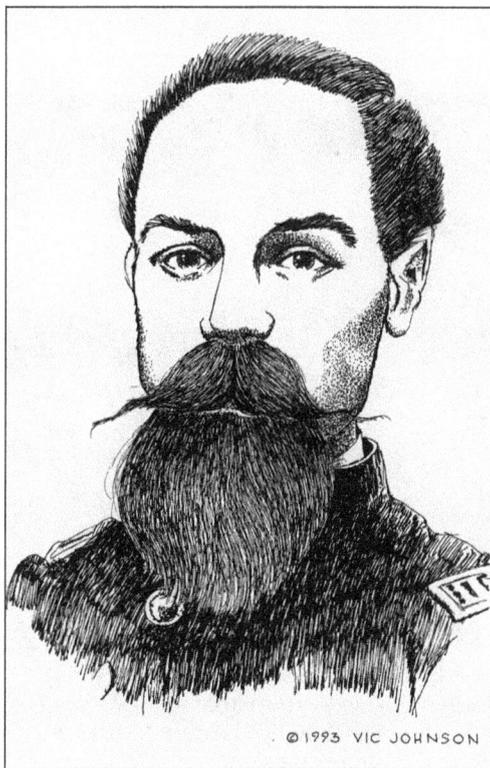

Having become disabled, Capt. Francis Seguin of Company D, 76th Volunteer Illinois Infantry Regiment, was discharged on April 14, 1864. Lt. Charles O. Savoie, a 30-year-old shoemaker from Kankakee, took command. Promoted to captain on April 16, Savoie remained with the 76th until the end of the war. At Three Rivers, Quebec, in 1834, Savoie had been born as Onesime Savoie, the third child of Jean Savoie and Felicite Savoie (née Martin). He came with his grandparents to Bourbonnais Grove in 1846. At the age of 17, Savoie adopted "Charles" as his first name. After learning the cobbler's trade, Savoie became a salesman. He sold his leather goods through Iowa, Missouri, and the southern states. In the late 1850s, he had established a boot and shoe store in Little Rock, Arkansas. When war seemed inevitable, Savoie returned to Kankakee and enlisted in the 76th. Nearly all the men in the 76th were French Canadian from Kankakee, Iroquois, Champagne, and Grundy Counties. They were engaged in the siege of Vicksburg and earned the name "Alligator Regiment" during a Louisiana expedition. (THC.)

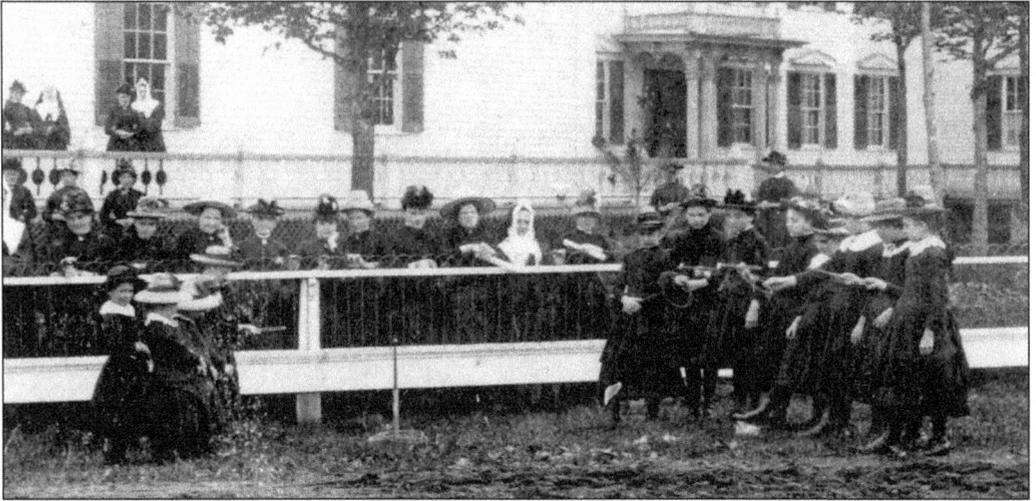

Passing along La Rue de l'Église in Bourbonnais Grove on a Sunday afternoon in the 1890s, one might encounter a ring-tossing contest between two teams of Notre Dame Academy students. Some very young girls (left) are competing against a group of older girls (right) while mothers and nuns look on. A difference in age and size has been mitigated by allowing the younger girls to stand closer to the target. Student uniforms, black dresses with white collars, are mandatory, but a variety of hats are allowed. (KCM.)

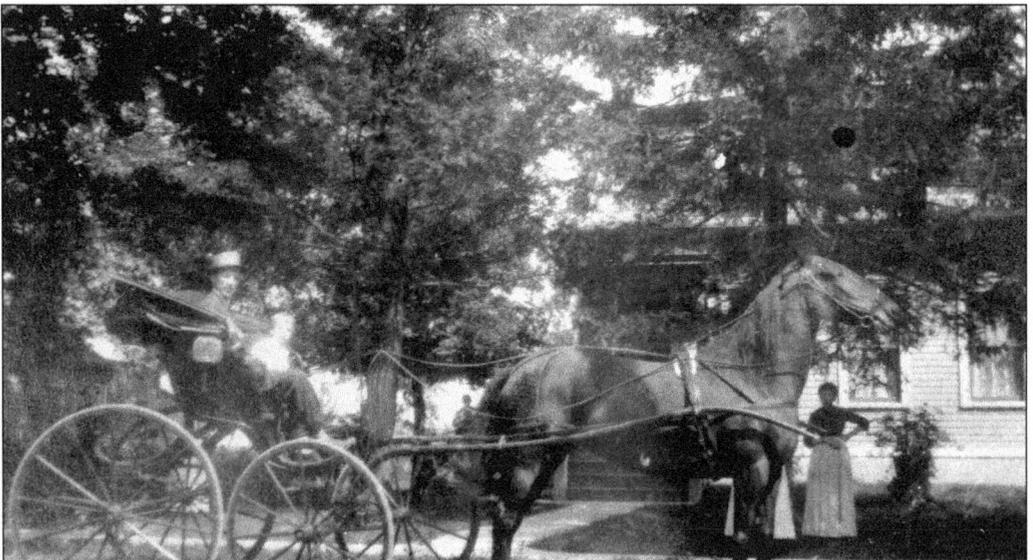

A fine carriage horse pulling a spiffy phaeton buggy was the high end of personal transportation in the days before the automobile became more than curiosity on the streets of Bourbonnais. On a lazy summer Sunday, Frederic J. Richard and his son Adrien set out for an afternoon "stroll" behind Richard's prize mare, Lady. (AMR.)

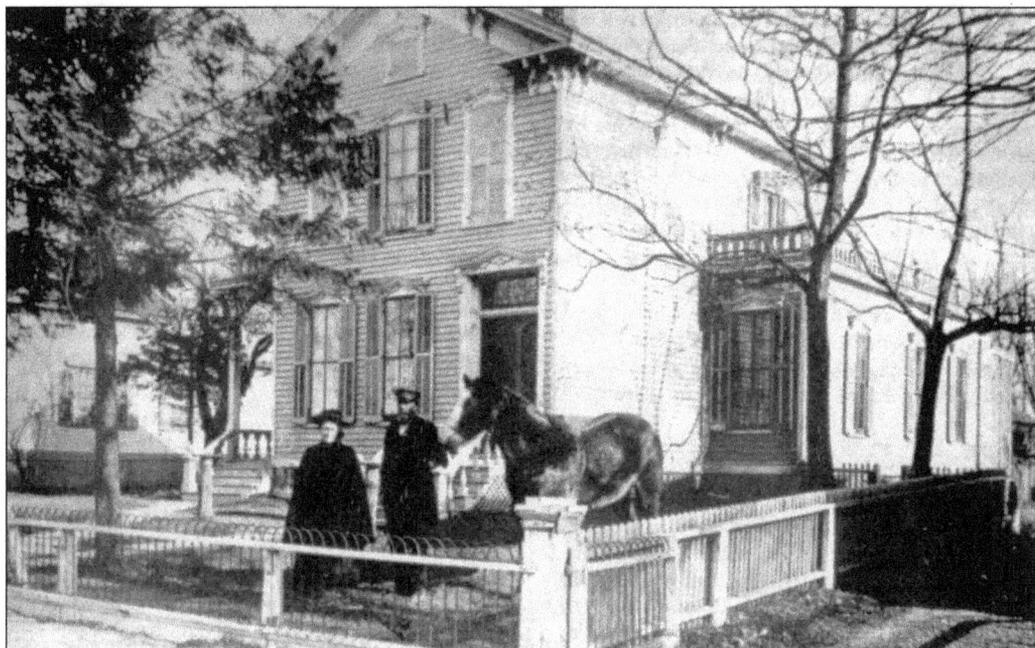

In this *c.* 1900 photograph are two of Bourbonnais Grove's oldest settlers, Antoine L. Bergeron and his wife Lucy Bergeron (née Bosse). Lucy was born in Canada 1834, and Antoine was born in 1831 at St. Leon, on the River Du Loup, in Canada. He arrived in Bourbonnais Grove in 1837. By 1912, Antoine and Lucy had been married 60 years. (BGHS.)

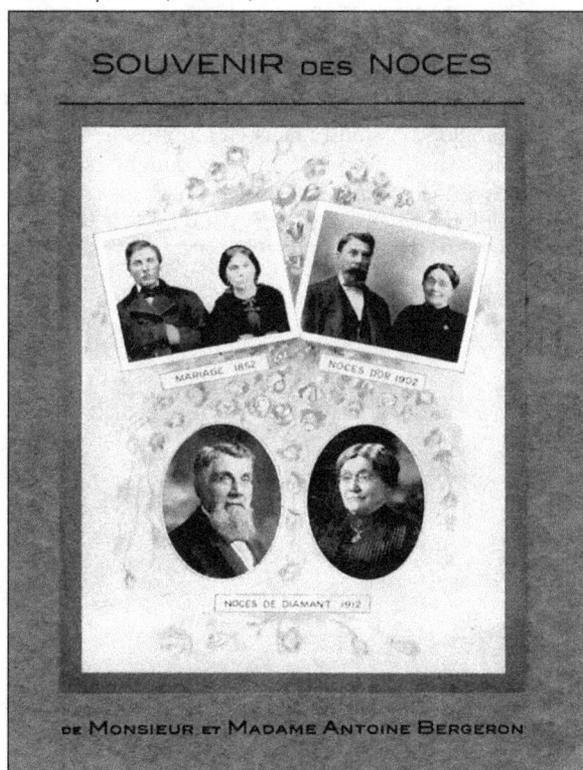

These photographs show the Bergerons as they appeared at the time of their wedding and succeeding anniversaries. Antoine died in 1919, his wife in 1921. (Courtesy of Nancy Arseneau.)

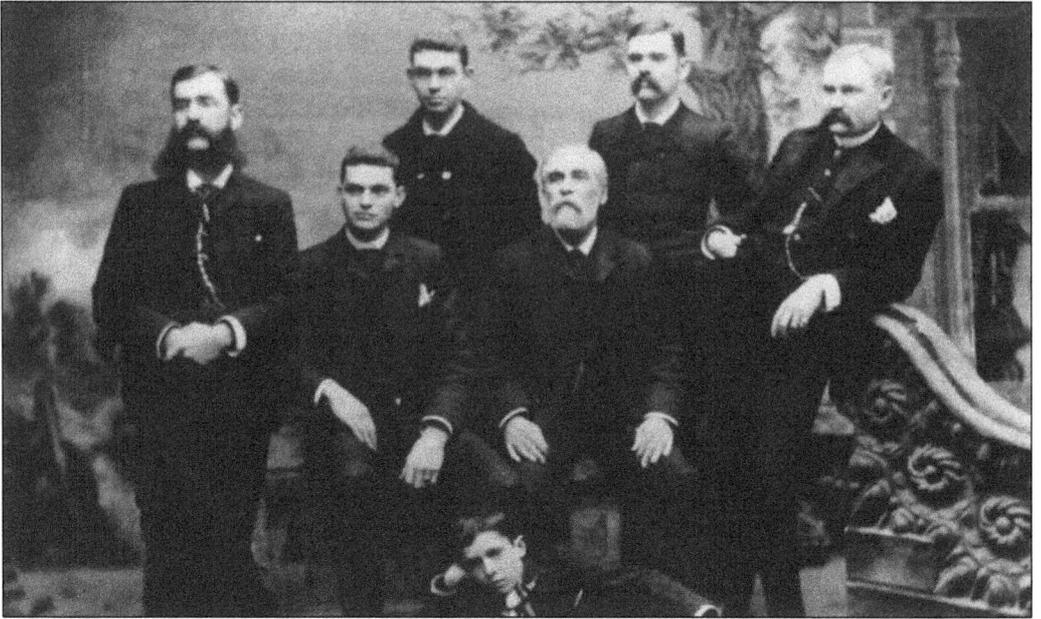

One of Bourbonnais Grove's most notable public figures—politician, miner, agriculturist, grain merchant, wholesale grocery man, and historian—George R. Letourneau was born in Canada of French parents in 1833. Letourneau left Canada in the spring of 1847, at age 14, and arrived in Chicago on May 10. After being employed for two years as a clerk for a Chicago grocery house, and then in a bookstore, the young Letourneau removed to Bourbonnais Grove, where he lived until March 1850. In 1849, thousands of fortune seekers from all over the world known as forty-niners or argonauts had rushed to the goldfields. Letourneau made his way west in the spring of 1850. He found it more profitable to haul supplies for the miners and prospect for quartz deposits than pan for gold. Letourneau returned to Bourbonnais Grove in 1852 and married Elodie Langlois. A small farmstead alongside the Danville to Chicago Road became their new home. Here they raised five sons, six daughters, and one grandson. All of Letourneau's children and the grandson are seen in these two photographs. The photographs were taken after the death of Elodie in January 1887. (BGHS.)

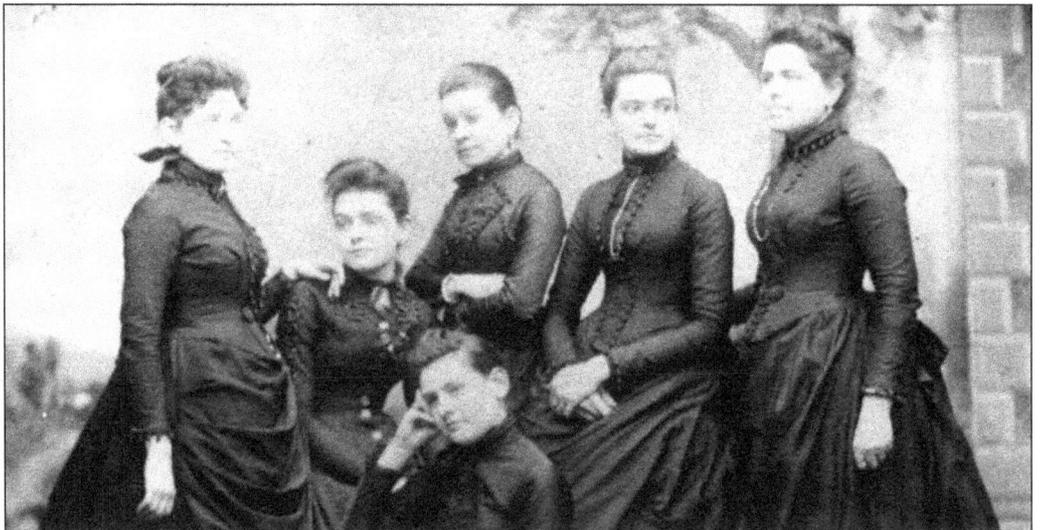

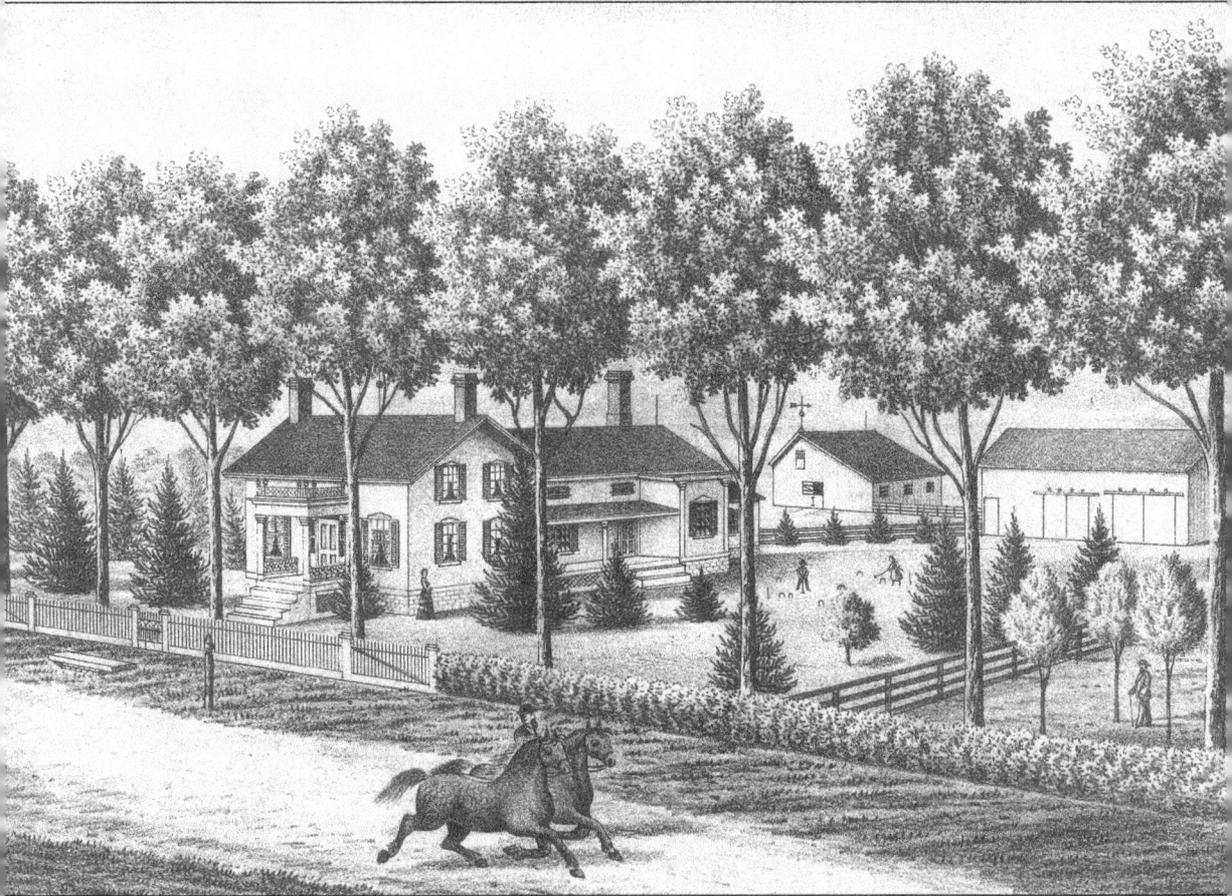

The farmhouse, shown here in an engraving from the 1883 atlas, was the George R. Letourneau home from 1854 to 1882. As William Kenaga and Letourneau recalled in their history of Kankakee County, the house had an interesting provenance. It originally had been the Bourbonnais Grove Post Office established in November 1837. Even though Letourneau made several additions to the house as his family grew, he claimed that "it is in part the same, and stands on the identical spot of the original building." Letourneau became sheriff of Kankakee County in 1882. The law required that he move his family into the sheriff's quarters at the county seat in Kankakee. The Letourneau family remained in Kankakee and built a new home. Letourneau became mayor of Kankakee in 1891. He was elected to the Illinois state legislature in 1892, where he served two terms. In 1896, Letourneau returned to Kankakee. His wife had died in 1887. He lived with two unmarried daughters and worked on a history of the county with Kenaga. Letourneau died in 1906, the same year the book *History of Kankakee County* was published. (BGHS.)

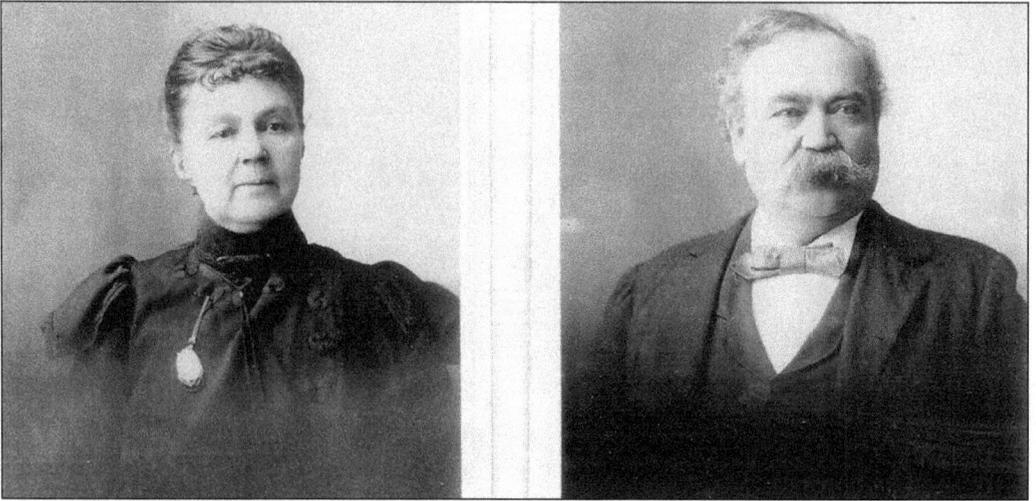

Sara Berard (née Constantine) and Pierre-Ambrose Berard were residents of Bourbonnais Grove in the 1870s. Ambrose Berard was born February 25, 1802, at Cuthbert, province of Quebec. On July 13, 1824, he married Julie Semper at Cuthbert. They had 16 children. The family immigrated to the United States in 1852, first to Chicago and then to Bourbonnais Grove. Ambrose farmed and was proprietor of a store. He was an associate of George R. Letourneau. In 1878, the Berards relocated to Concordia, Kansas, where he, Letourneau, and Alexis Gosselin invested in a flour mill owned by a man named Lanoue. Ambrose and his wife returned to Illinois about 1889. Ambrose died in 1912 in Chicago, and his is wife died two years later. (Courtesy of Joseph Berard Fitzpatrick.)

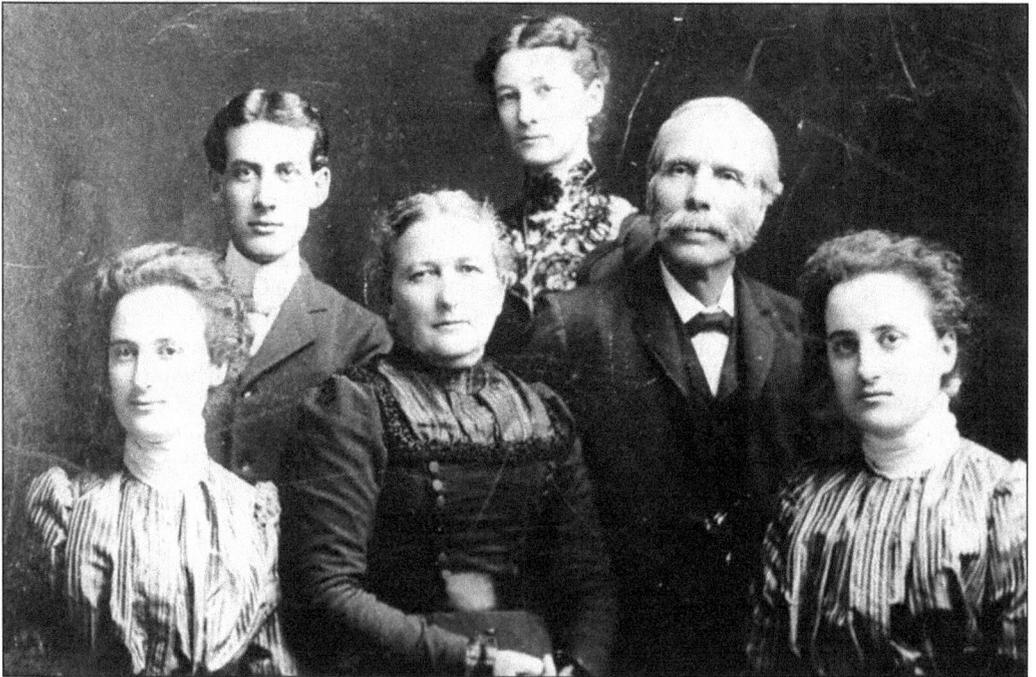

Oliver Marcotte was born at St. Lenede, Maskinoge, Canada in 1837. He died in Bourbonnais in 1915. His wife, Philomne Besse, was from St. Roch des Aunais, Canada. Born in 1846, she died in 1938. (AMR.)

Hypolite Brosseau and his wife, Philomine Brosseau (née Dupuis), celebrated their 50th wedding on June 28, 1908, surrounded by children, grandchildren, and great-grandchildren. Philomine was born at St. Constant, Canada, in 1843. (AMR.)

It was husking time during the fall of 1912 at the Xavier Raymond Sr. farm in Bourbonnais Township. Xavier is standing at left, and Josephine Raymond (née Longton) is at center in a white apron. (AMR.)

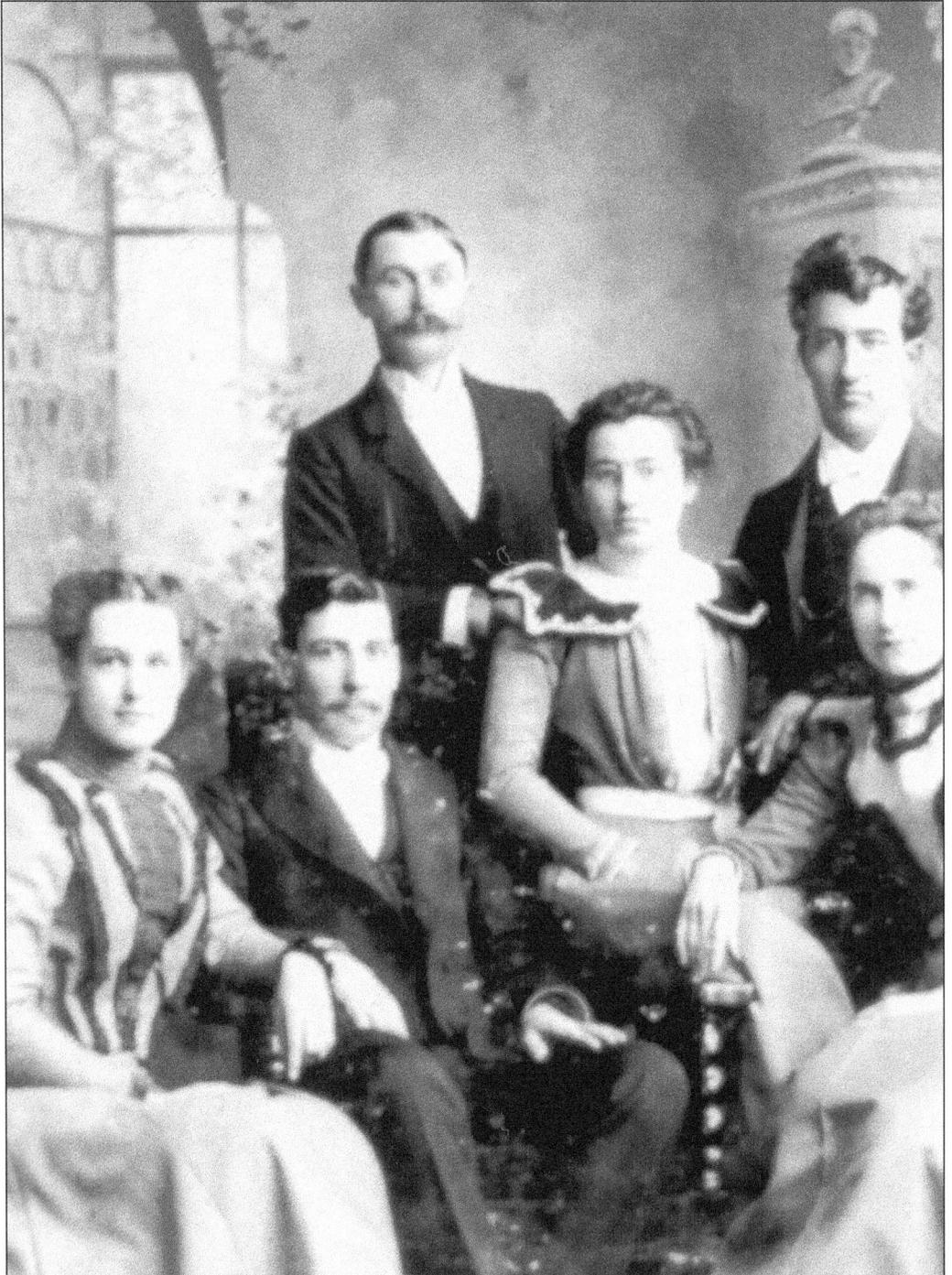

The Napoleon Senesac family are descendants of Preston (Prospere) Senesac, who was born to Daniel Senesac and Amelia Lague at St. George, Quebec province, in 1833. He came to Bourbonnais Grove in 1848 at the age of 15. After a sojourn in the West, Preston returned to Bourbonnais Grove, bought some farmland, and operated a livery stable. Later, in partnership with his son Alfred, Preston embarked in the undertaking business.

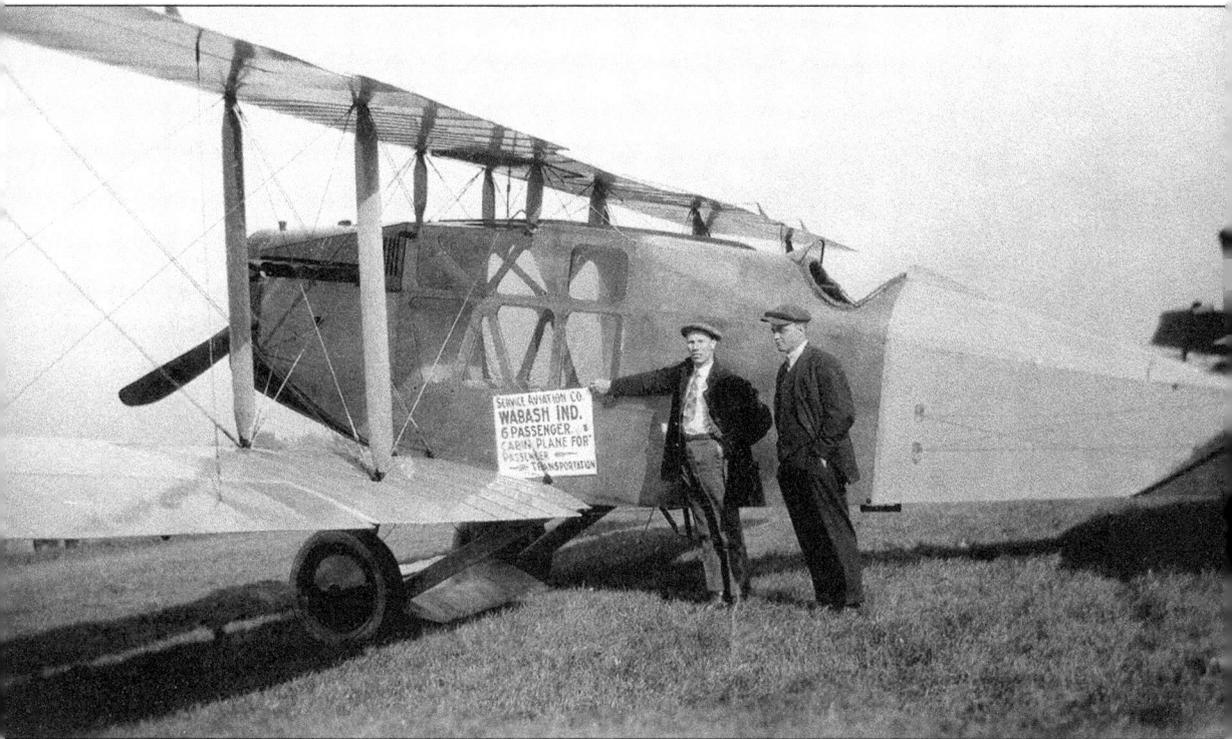

Joseph M. "Caproni-Joe" Pallisard (also Pallissard) is the grandson of Paulin Narcisse Pallisard and Solina Roger. Paulin and Solina came to Kankakee County directly from France in the mid-1850s. Joseph is descended from an ancient French family dating back over 700 years and noted for their loyalty to the French kings. Several Pallisard descendants have settled in Bourbonnais Township. Joseph M. Pallisard and two partners opened a flying school at Cicero Field near Chicago in 1913. As a civilian pilot in July 1917, Pallisard was one of the airmen who flew the first 20 Curtis JN-4 "Jennys" to Chanute Field. Six hundred and forty acres near Rantoul had been set aside as an army storage depot for paint and aircraft engines and as a pilot training facility. Later Pallisard served at Wright-Patterson Field in Ohio, and on April 14, 1920, he received license No. 4739 and was brevetted as "aviator pilot" by the Aero Club of America, Féderation Aéronautic Internationale. (Courtesy of Robert Pallisard.)

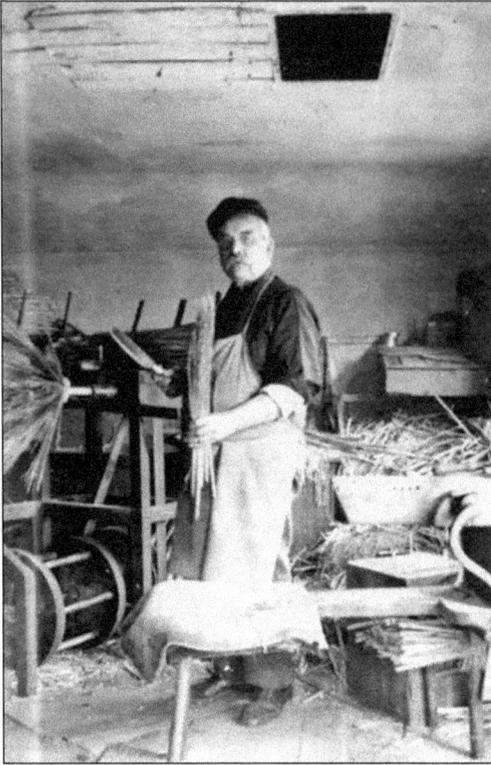

Antoine Cartier, whose trade was making brooms from broom corn, arrived in Bourbonnais Grove a few years before the start of the Civil War. He had been born in Quebec province in 1836 to Jeremie Cartier and Julia Parenteau. He was one of 18 children. Antoine left home at the age of 14 to work in a Massachusetts factory. Later he moved on to Galena, Illinois. It was in Galena that he learned of the French Canadian village of Bourbonnais Grove. Antoine found various places in the countryside to grow broom corn. Eventually he moved into Kankakee where he manufactured brooms in his home and sold them for $2 per dozen, or 17¢ each. (KCM.)

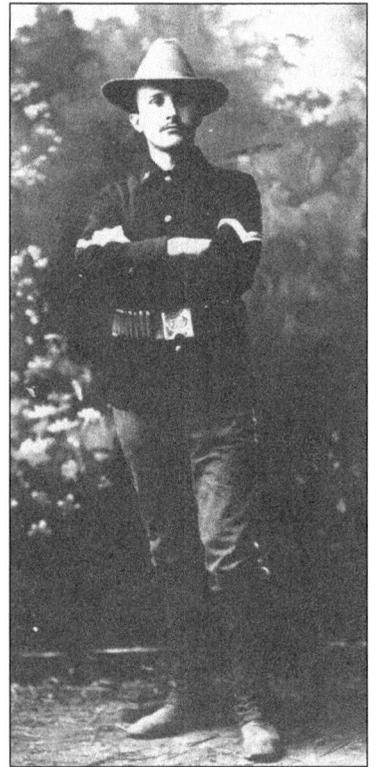

In 1898, Corp. Frank J. Cartier, son of Antoine Cartier, served in Company L, 3rd Volunteer Infantry Regiment, Illinois National Guard, during the Spanish-American War. After being mustered out of the army, Cartier resumed a profession he had trained for at the University of Illinois School of Pharmacy. Standard jobs for pharmacists at the beginning of the 20th century were making pills, mixing horse medicine, and so on. And then other duties such as sweeping out the store, seeing the furnace fire was tended, and jerking sodas were also required. Cartier worked at his profession in various local drugstores for more than 23 years. (KCM.)

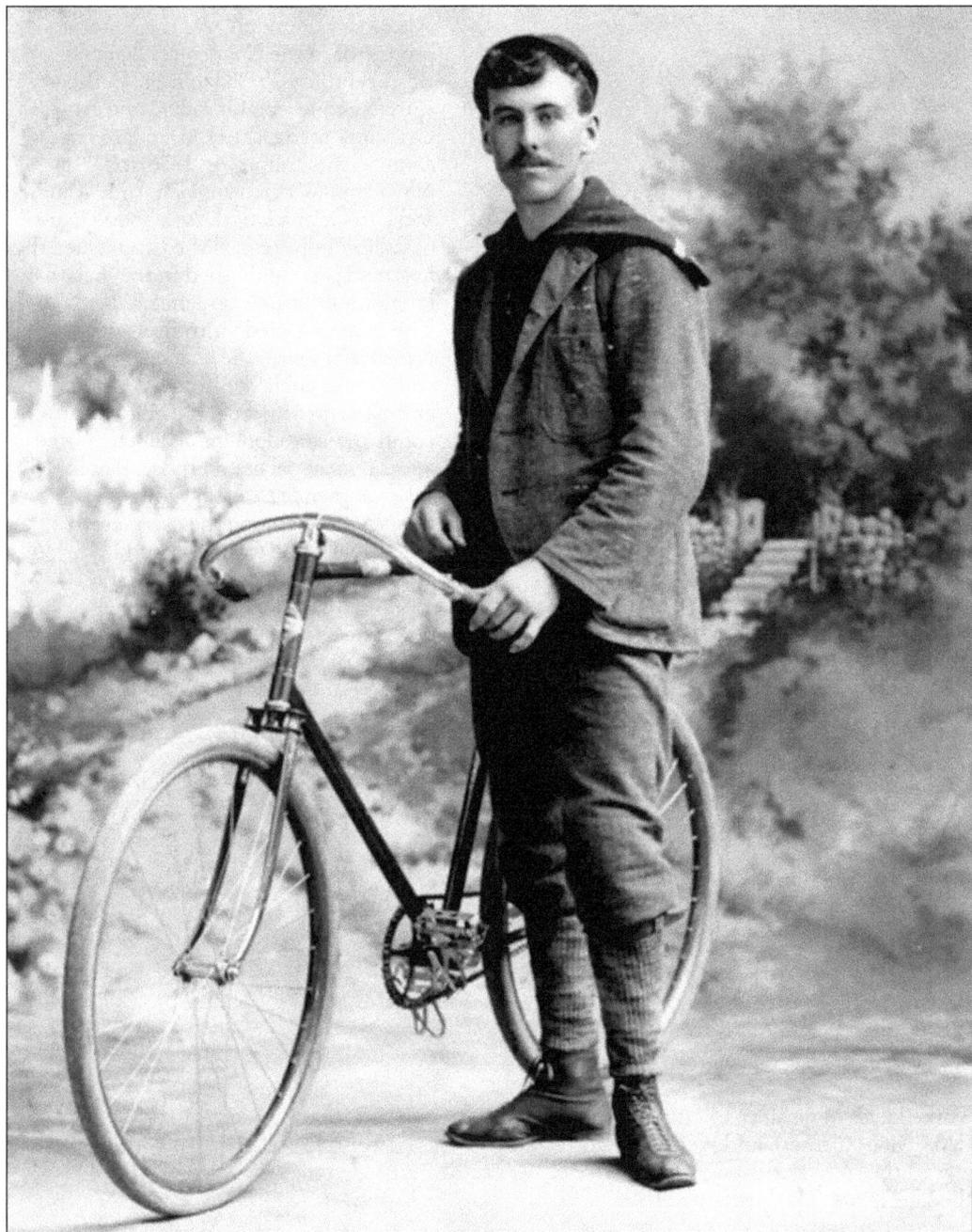

The first "safety bicycle" with equal-size wheels and a chain-driven back wheel came along in 1885. It revolutionized the bicycle industry and within five years replaced the bicycle with a large front wheel, known as the "Ordinary." Bicycles—10 million or more—ruled the roads until about 1900. In 1895, a local bicycle store proprietor said, "Bicycle talk is cheap; good bicycles are scarce. Our bicycles speak for themselves. Prices: $100, $75, $65 and $50." And a new bicycle was what every young man wanted. This photograph shows one of Bourbonnais's daring young blades, a Senesac, who proudly had his picture taken with his new safety bicycle. Notice the solid rubber tires. (BGHS.)

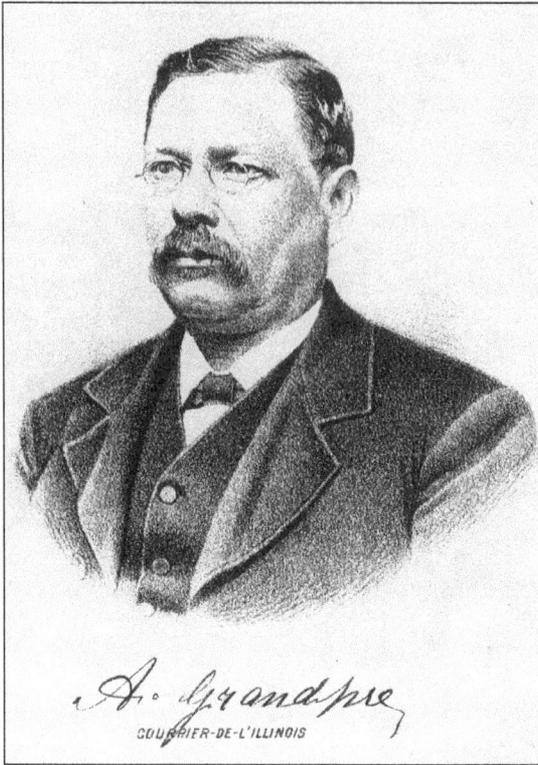

Alexander Grandpré was the editor and proprietor of the *Courier de l'Illinois*. Born February 25, 1835, in St. Cuthbert, Canada, to Joseph Grandpré and Angele Grandpré (née Dacier). Grandpré first came to this country in 1856 and was married in Watertown, New York, May 10, 1860, to Celina Dugal. As a young man of 22, Grandpré established and issued the first newspaper published in the French language in Illinois on January 2, 1857. The name adopted for the new newspaper was that of *Journal de l'Illinois*, and the editors and publishers were A. Grandpré and C. Petite. In 1868, the editors parted company. Grandpré immediately started another newspaper enterprise, naming it *Le Courier de L'Ouest*. Owing to some disagreement among the partners, this newspaper came to an end on July 7, 1869. Grandpré resumed publication the ensuing week, merely giving the paper a new name, *Courier de l'Illinois*. The *Courier de l'Illinois* was what it claimed to be, a Franco-American newspaper. (BGHS.)

Three ladies of fashion, Olivine Grandpré (left), Mary (center), and Nellie Marcotte, graced the streets of Bourbonnais in the late 1890s. The bustle had been discarded in favor of new fashions that complemented the chest and arms. Dresses remained long, and exposing the ankle in public was not acceptable. Hairstyles were simple, but hats were elaborately decorated with flowers, feathers, and fruit. At the beginning of the 20th century, hat brims became even wider and the hats more decorative. (AMR.)

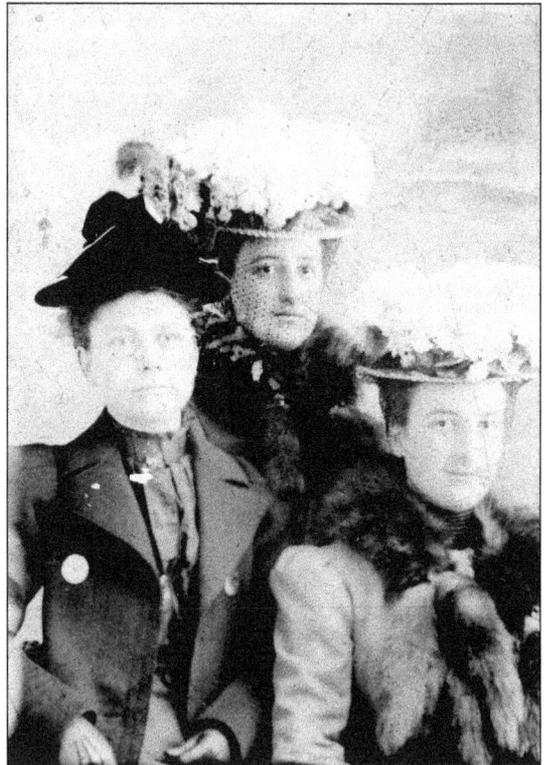

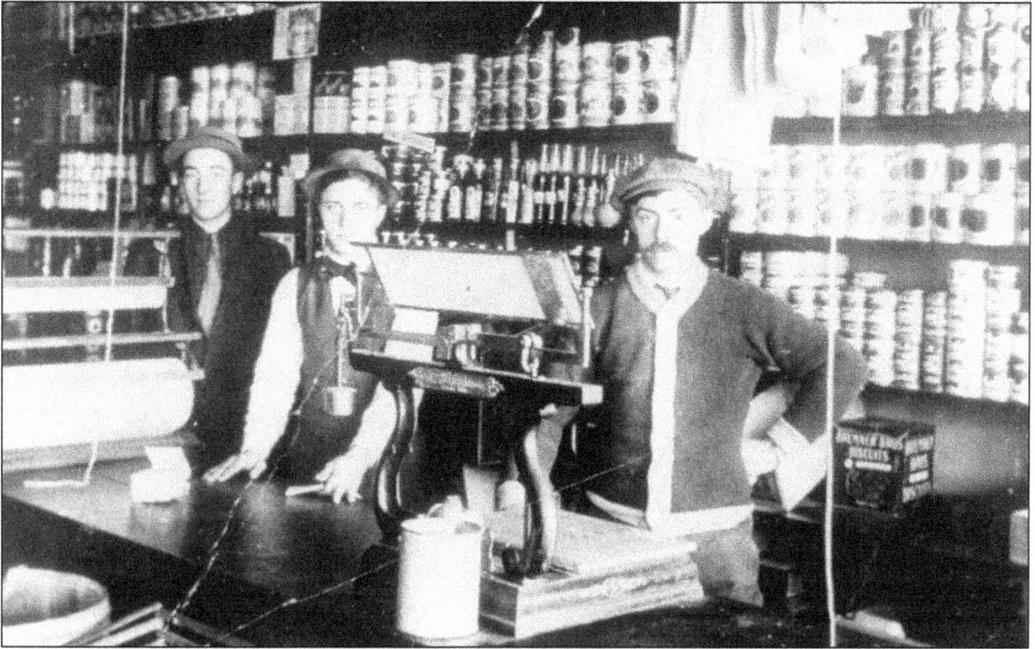

This is the interior of Jerry (Gerasème) Rivard's grocery store in Bourbonnais. The picture was taken shortly after the store opened in 1911. Standing are, from left to right, Alphonse Benoit, Leon Rivard, and Jerry Rivard. Jerry is the son of Telesphore and Christine Rivard. The Rivards and the Benoits were pioneer settlers in Bourbonnais Township. (BGHS.)

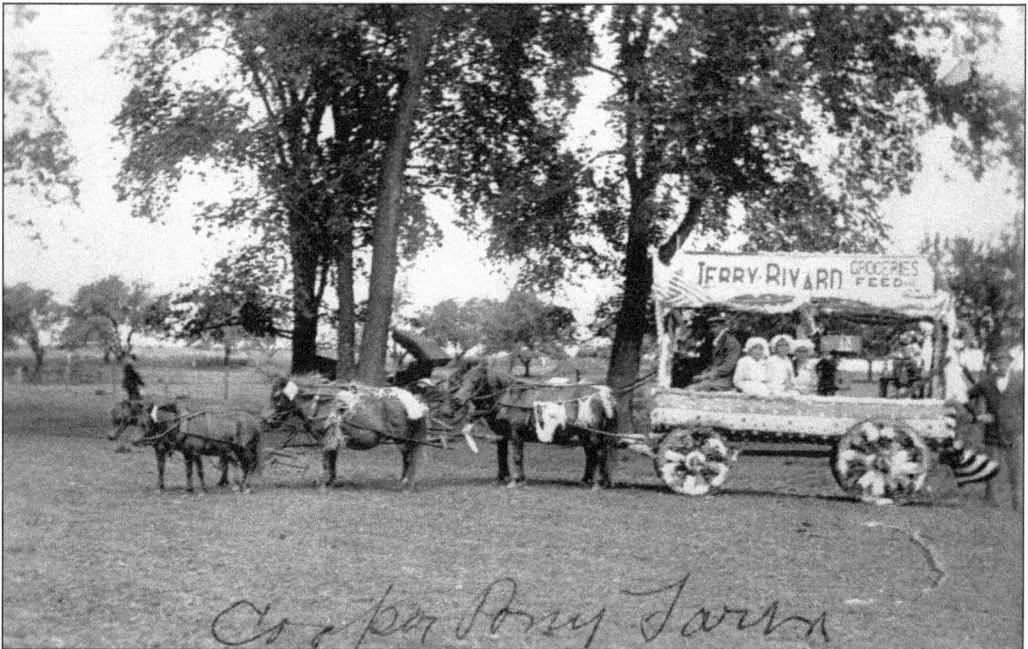

Here is a three-team hitch using three sizes of ponies, ready to participate in a Fourth of July parade about 1916. Harry Cooper, proprietor of Cooper's Pony Farm, is handling the reins. From left to right, Antoinette Rivard Lecuyer, Lumena Richard Rivard, and Elizabeth Rivard Senesac are on the float. The man standing behind the float is Emil LaFine. (TJL.)

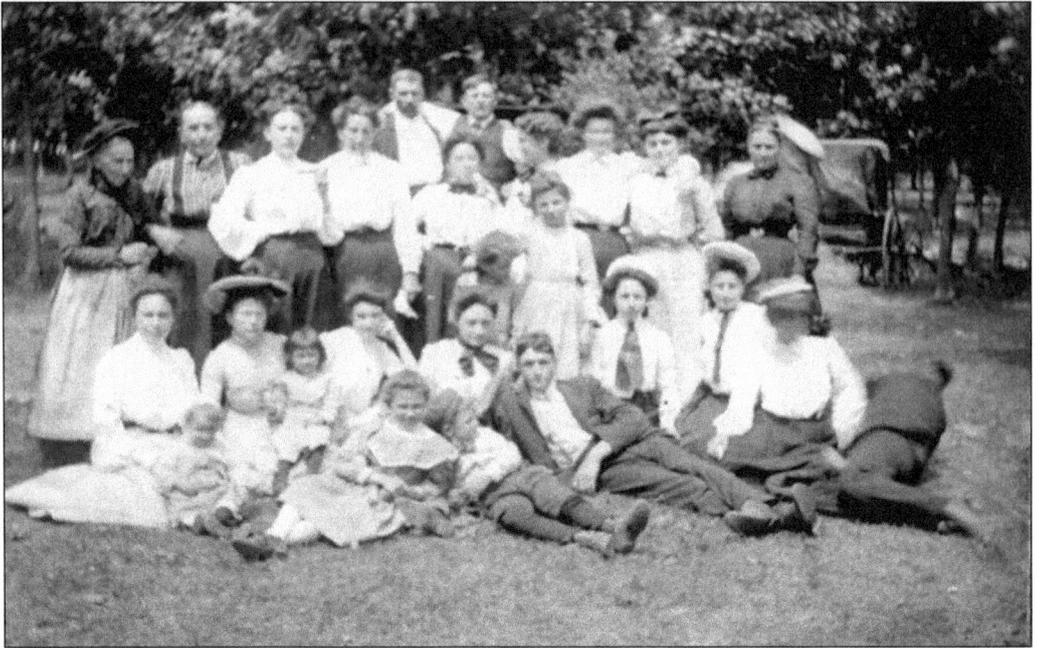

These photographs were taken about 1901, probably at picnic grounds on the Kankakee River near the mouth of Rock Creek. This area, about six miles northwest of Bourbonnais, was and still is popular for outdoor activities. Today it is part of the Kankakee River State Park. Among those pictured are members of the DesLauriers, Benoit, Bernier, Grandpré, and Senesac families.

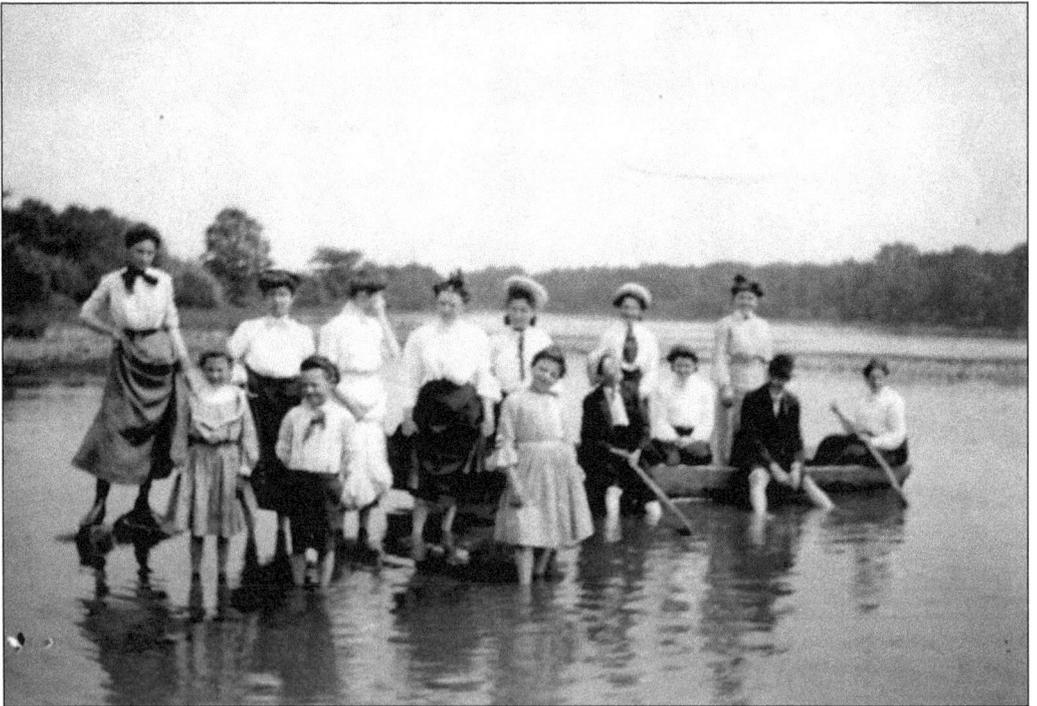

Some of the people seen in the last photograph are shown here on the Kankakee River. (AMR.)

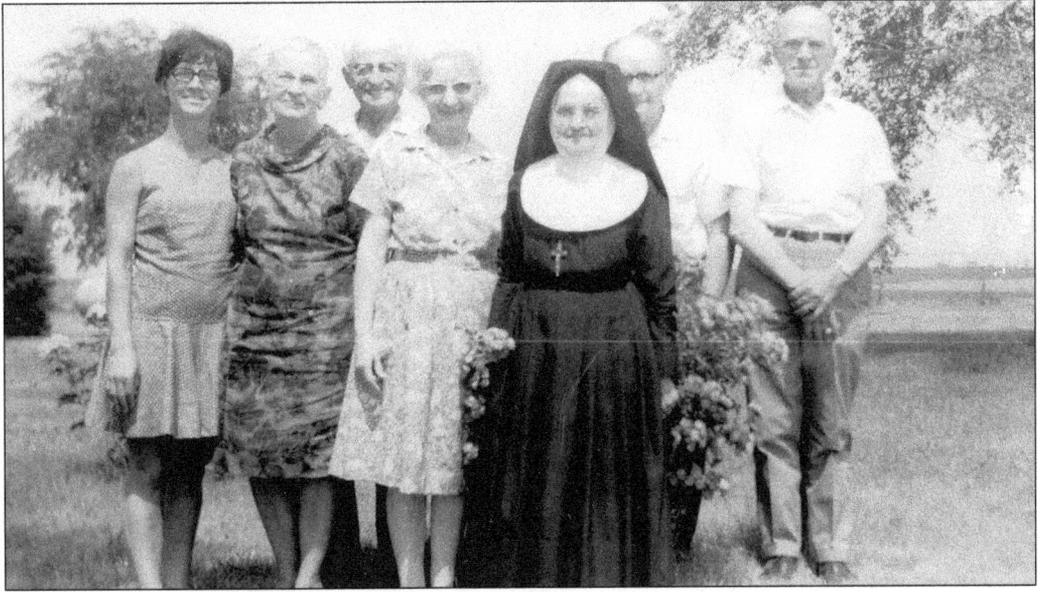

Pictured here are six descendants of Godfrey Bouchard and Emma Bouchard (née LeBeau). From left to right are Lois Provost Kirchman; Nelda Bouchard Provost; Harry Bouchard; Mildred Bouchard, Sr. Charles Borromeo (Stella Bouchard), Congregation of the Sisters of St. Joseph, Concordia, Kansas; and Roy Bouchard. Lawrence Provost is on the far right. Godfrey Bouchard was born in Chicago, his wife Emma in St. George. Godfrey's mother was Esther Des Lauriers (1830–1921); his father (1830–1906) was also named Godfrey. (Courtesy of Lois Provost Kirchman.)

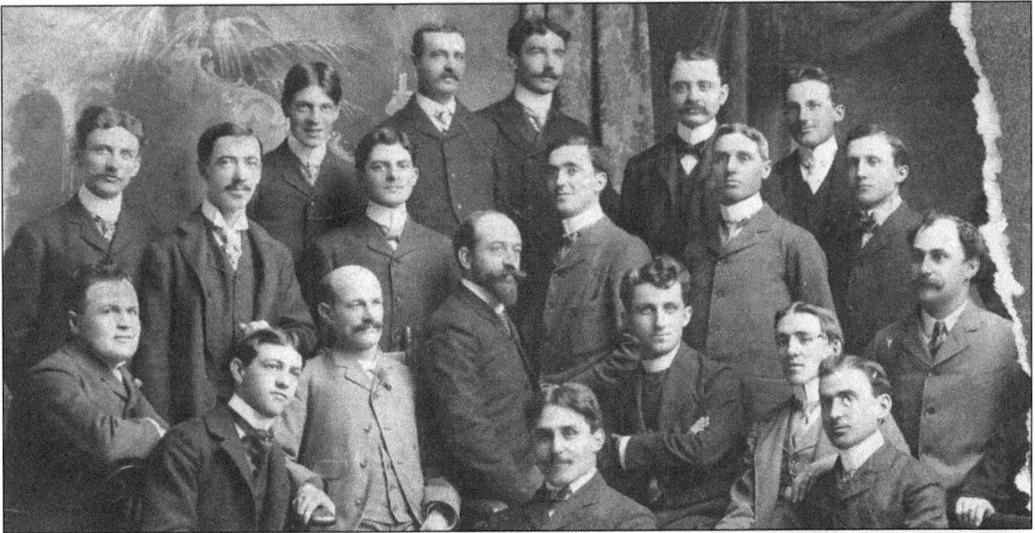

At the beginning of the 20th century, encouraged by Fr. Moses J. Marsile C.S.V., a group of young men in and about Bourbonnais and Kankakee formed a club known as Le Cercle Français, or as translated the French Club. The object of this gathering was the promotion of social relations among its members, who met nightly in club rooms in the Granger building on South Schuyler Avenue in Kankakee. Billiard and card tables offered nightly diversions for its members, while others delved into the many shelves of French books, absorbing the tales of Racine, Bossuet, and many others. Spoken French was a prerequisite for membership in this select and intriguing assembly. (Courtesy of James Fortier.)

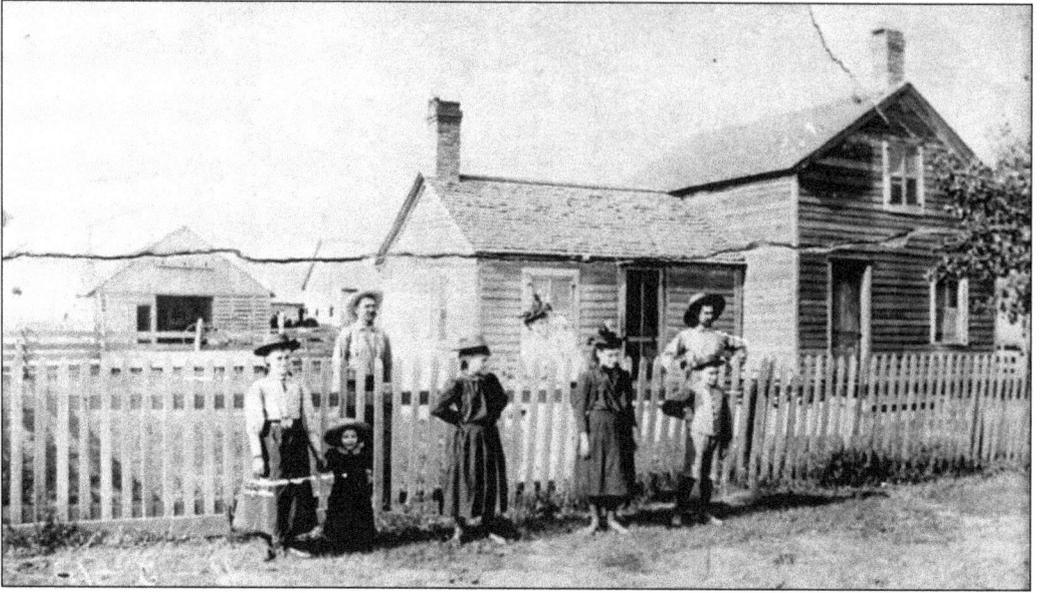

This home was built by Hubert Dupuis on land he had cleared in Bourbonnais Township. Hubert is on the left, behind the fence. He was born in 1841 at St. Jacques, province of Quebec. Dupuis married Aurelie (Orilie) LaTremouille in L'Acadie, St. Jean, Quebec, in 1842. Emil Dupuis and his wife are on the right. The children are nieces and nephews. (Courtesy of the George J. Dupuis family.)

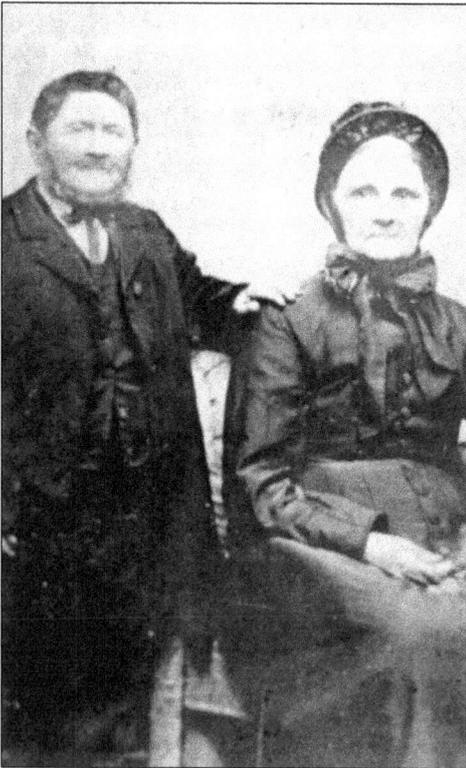

This is a wedding photograph of Joseph Dupuis and his third wife, Josephine Huneau. They were married on Sunday, June 13, 1896. He was 89. Dupuis was born in 1807 in St. Cyprean, province of Quebec. He married his first wife, Sophie Racette, in 1835, probably at St. Jacques, and they came to Bourbonnais Grove in 1854. What was unusual about Dupuis was that his height never exceeded four feet, four inches, nor did he ever weigh more than 100 pounds. The *Kankakee Times* conjectured that Dupuis was probably the smallest French Canadian of his age in the world. "His light weight made Joseph Dupuis drift into the ranks of the horse jockeys at Montreal naturally enough," said the *Times*. "For many years he rode horses and with such success that he amassed a small fortune—a fortune that depreciated somewhat but left him in comfortable circumstances for the remainder of his life." Records show that when he arrived in 1854 he purchased 360 acres of farmland. At the time of his death, he still owned some land in Bourbonnais Township. Most of the 360 acres had been divided up among his six sons. (Courtesy of the George J. Dupuis family.)

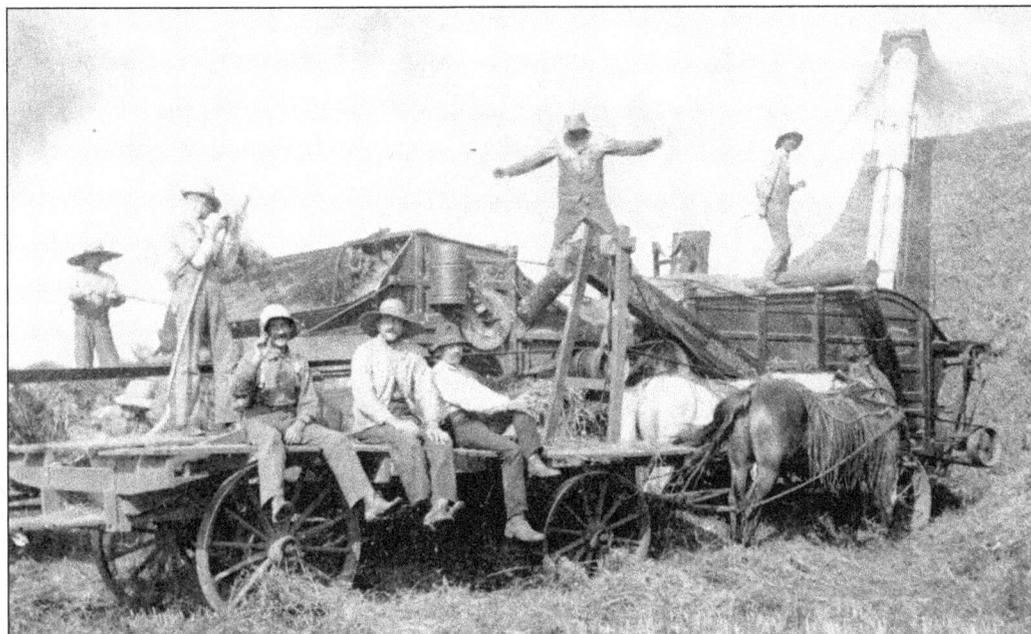

Gasoline-powered tractors came on the scene in the 1890s but were not in wide use until the first decades of the 20th century. Steam traction engines and steam-powered threshing machines were still used by French Canadian farmers of Bourbonnais Township until the 1920s. (KCM)

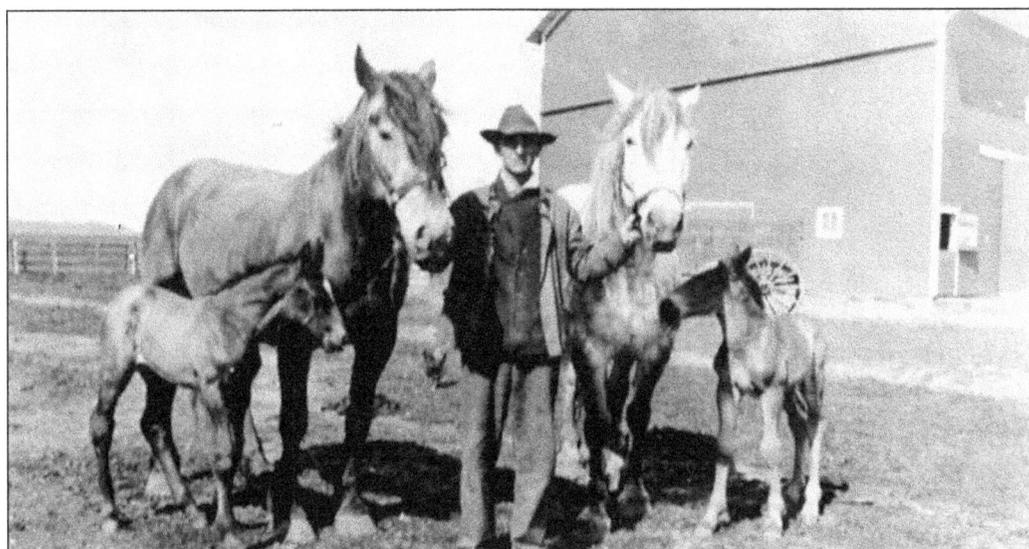

Despite new technology, horses were still valued livestock. And many of the farmers had not yet traded old Dobbin in for a tractor, or given up their buggies for automobiles. A *Prairie Farmer's Reliable Directory* of the times shows that French draft horses and Percherons were owned and bred on farms in Bourbonnais Township by Joseph Benoit, Francis X. Bergeron, Amedee Brais, Lionel and Charles Cyrier (sons of Flavier), Fred DesLauriers, Eugene Granger, Jerome Grise, Alexis Rivard, and Louis Edward Surprenant. (Courtesy of Evelyn Dupuis LeBeau)

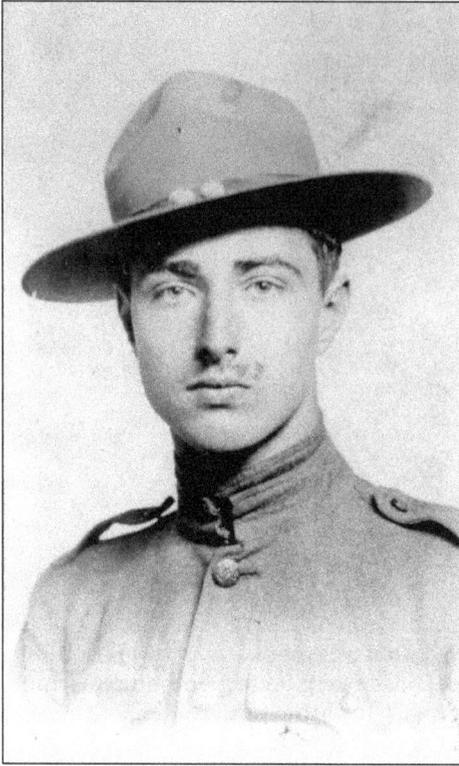

In 1904, at the age of five, Royer Joseph Arseneau and his family moved from Kankakee to Bourbonnais. His father bought the Senesac bakery on Marsile Street, across from St. Viator College. During his teenage years, Roy worked in the Arseneau Bakery. The brick bakery oven produced more than 100 loaves of bread a day. It used coke for fuel. Bread sold for 5¢ a loaf or six for a quarter. The Arseneaus made all types of pastry. In 1916, having told the recruiting officer he was 18, Roy was inducted into Company L of the Illinois National Guard. The Guard was federalized and Roy went to Texas. From there he was transferred to a bakery company and first sent to Dijon, France, and later to a small town in Luxembourg. The bakery company stayed for six months after the end of the war as part of the occupation army. Roy became the Bourbonnais postmaster in 1926, served two terms as county recorder of deeds from 1944 to 1952, and then worked for the Illinois Veterans Commission. (Courtesy of Nancy Arseneau.)

This view to the east on La Rue de l'Église (now Marsile Street) was taken before 1910. Notice the overhead streetcar wire. Maternity BVM Church and Marsile Alumni Hall are on the right. College Avenue (now North Main Street) runs left to right. (TJL.)

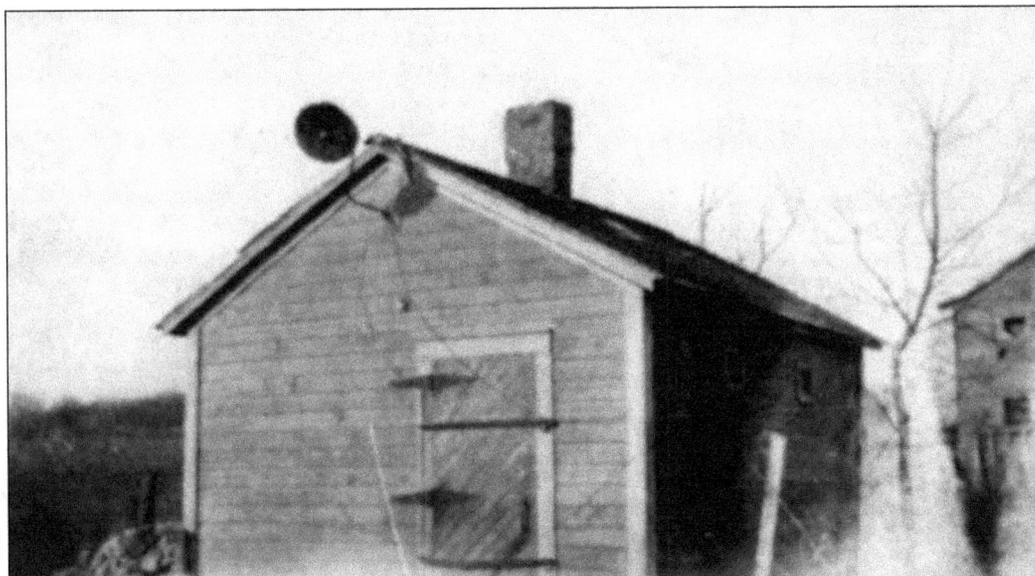

Seen here is Le Bastille, Bourbonnais's jail, as it appeared in 1919. It stood on West River Street. Built of wood, the jail was used primarily for transients and drunks. (TJL.)

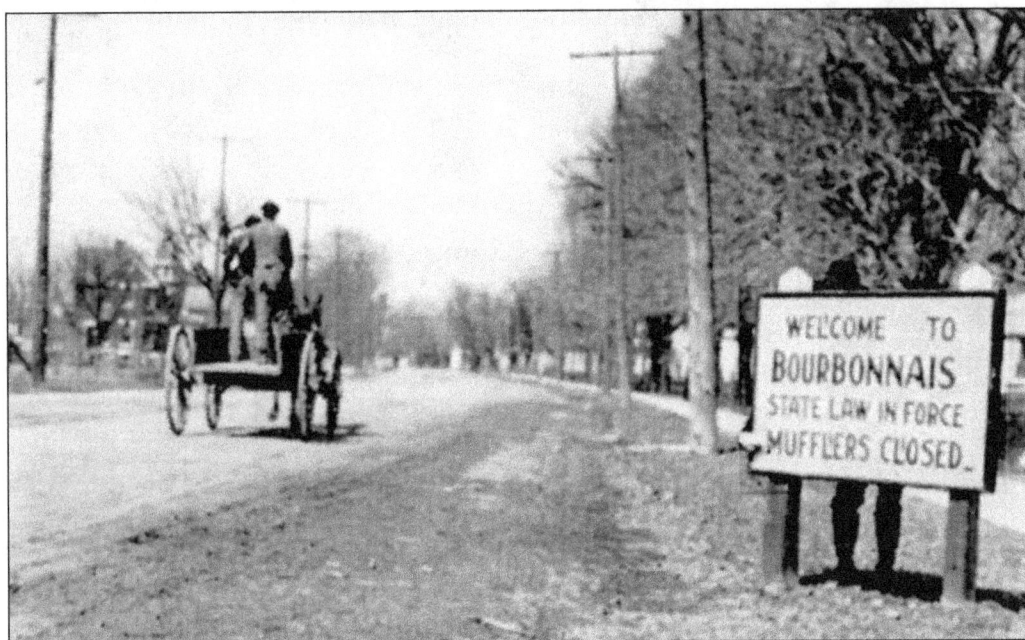

Here is a rare vintage view of South Main Street in Bourbonnais taken about 1920. Seen just to the left of the wagon is the Noel Richard home. "As we look down the street, we note the beautiful foliage of the trees, soft and hard maples, American elms, and a few oaks, which garnish both sides of the street," Adrien M. Richard recalled in his book The Village. (TJL.)

This is one of the oldest existing homes in the village. Alexis Lamontagne bought this house in 1883. Edward Brosseau, who owned the first automobile garage and was the village maintenance engineer, occupied the house in the 1920s. (AMR.)

Alexis Lamontagne, who was born in the Lake Champlain region, was a newcomer to Bourbonnais Grove in 1850. He soon met Adeline Therian, and they married in 1858. Alexis was a cabinetmaker by trade. Although records for the early years were destroyed in a fire, it appears Alexis became mayor of Bourbonnais in 1882 and probably served two terms. Recently razed, this house also belonged to Lamontagne and stood next to the one seen above. (AMR.)

This house was built in 1895 on South Main Street. The bricks used in construction are believed to have been "stone faced" with a hammer and chisel as the house was built. The original owner, Hypolite Gousset, sold the house to Noel Richard, a retired farmer, about 1912. (BGHS.)

Joseph Legris arrived in Bourbonnais Grove in 1844 at the age of 17. He was born in St. Leon, Quebec province. Legris went to the goldfields in California. He returned having amassed a small fortune, married Cleophil Sylvester, and built a small cabin in 1857. He added rooms to the home as his family grew. Legris and his sons opened two banks in Kankakee. (BGHS.)

A student of Frank Lloyd Wright's designed this house on East Marsile Street for Harvey J. Legris around 1902. The house was connected to a stable by a breezeway. Legris was the president of the American State and Savings Bank in Kankakee. The house is now owned by Olivet Nazarene University and has been renamed the Harlow E. Hopkins Alumni Center. (BGHS.)

Napoleon Houde, a local contractor, built this house. It was occupied by the Wilford DesLauriers family for many years. They owned one of the first electric cars in the county.

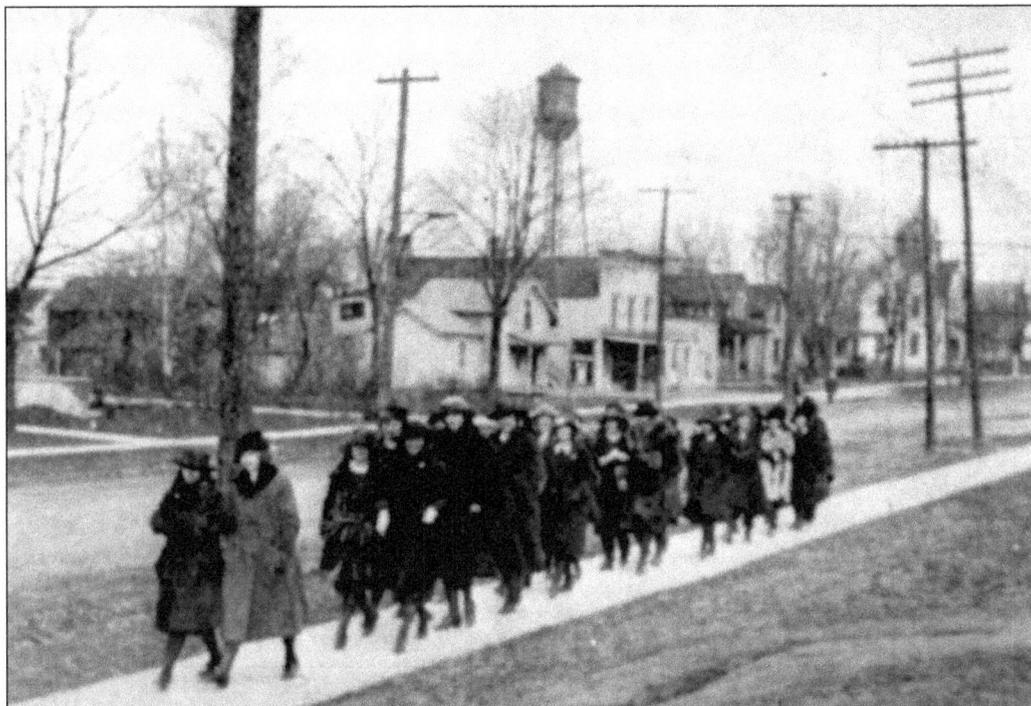

A group of students from Notre Dame Academy were photographed walking down Marsile Street in the 1920s. In the background, the village water tower, boys' school (far right), and the two-story Arseneau Bakery building (right of center) can be seen. (BGHS.)

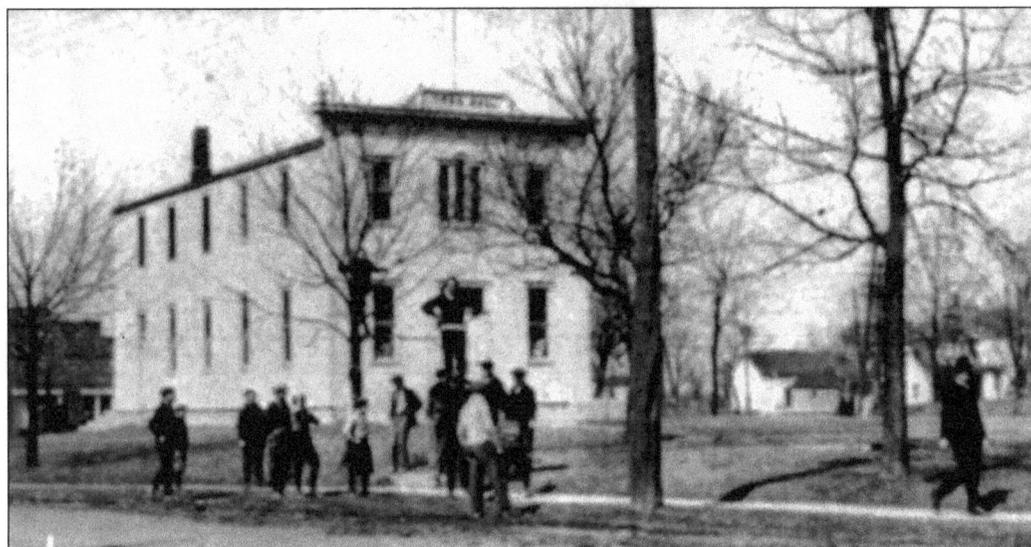

From 1895 until it was severely damaged by a tornado in 1963, this town hall building located on the village "triangle" housed both civil and social functions of village life. Prior to the building of a new municipal center, the village board met in the old Jerry Rivard store building. The town hall, "the site of many gala bazaars, card parties, box socials, dances, basketball games, spirited elections," was torn down in 1964. (BGHS.)

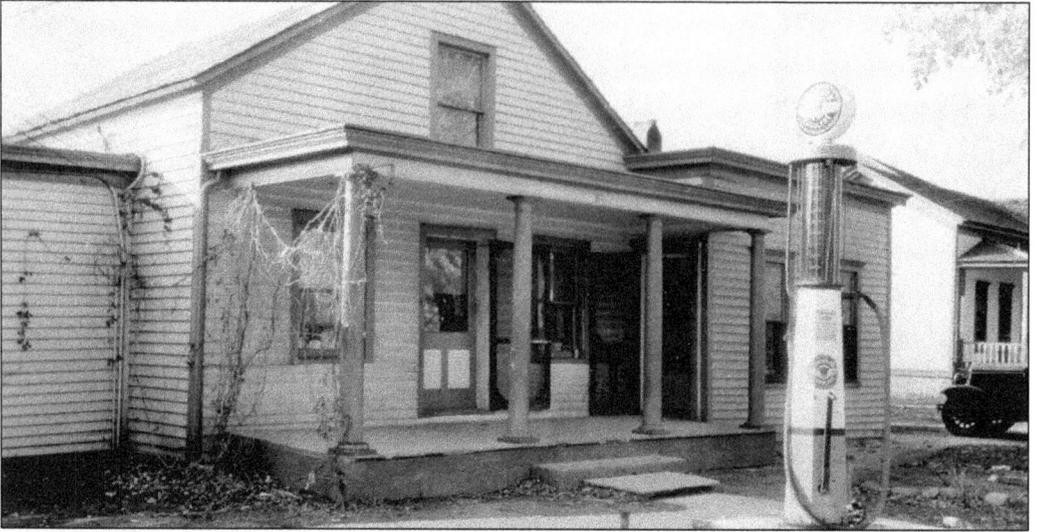

This is the original Bourbonnais Grove schoolhouse described on page 34. In 1848, a French Canadian blacksmith, Joseph Lesage, bought the log school and made it his home after school classes were moved to a new location. Additions were made over the years, and the logs were covered with clapboards. It was later occupied by Ralph and Mary Marcotte, from the 1960s to 2000. (TJL.)

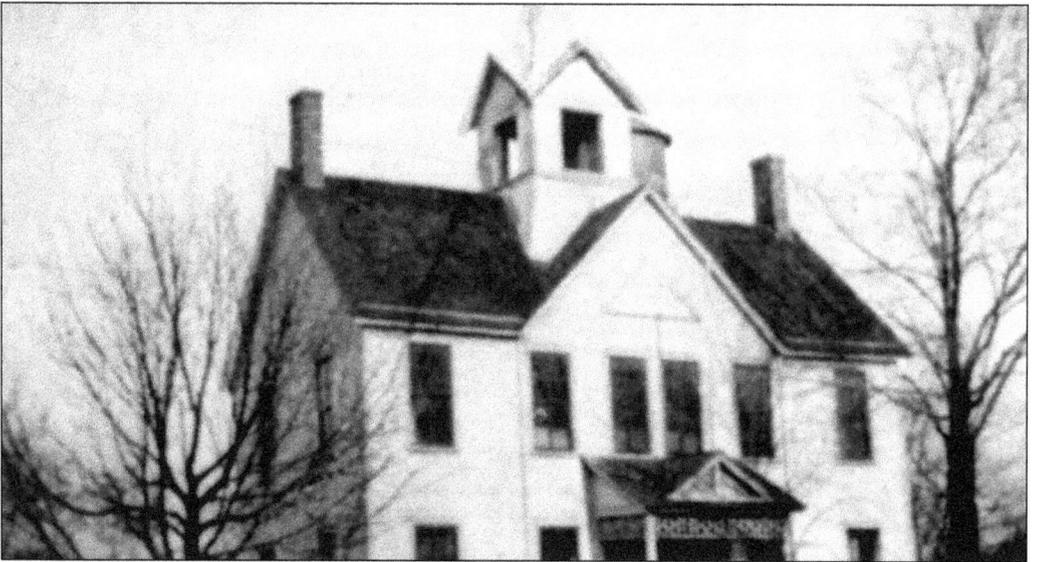

This frame two-story schoolhouse was built by the public school district in 1891. Students at St. Viator College dubbed it "Le Sorbonne." "The Viatorians taught the village boys in the school until 1918, at which time the Congregation of Notre Dame sisters accepted the job of teaching all the children of the village." This continued until 1937, when state school authorities, "anxious to improve the standard of education throughout the state, advised the school trustees to abandoned the structure and approved the consolidation of all facilities for boys and girls at Notre Dame Academy." The Notre Dame sisters maintained the coeducational school until 1956. Then a new public school was built. It was staffed with lay teachers, and the Maternity BVM Church built its own Catholic school, where the sisters continued to teach. The old school building was used for a recreation center by the school district until the 1950s. Louis Tetrault bought the property and demolished the old landmark. (TJL.)

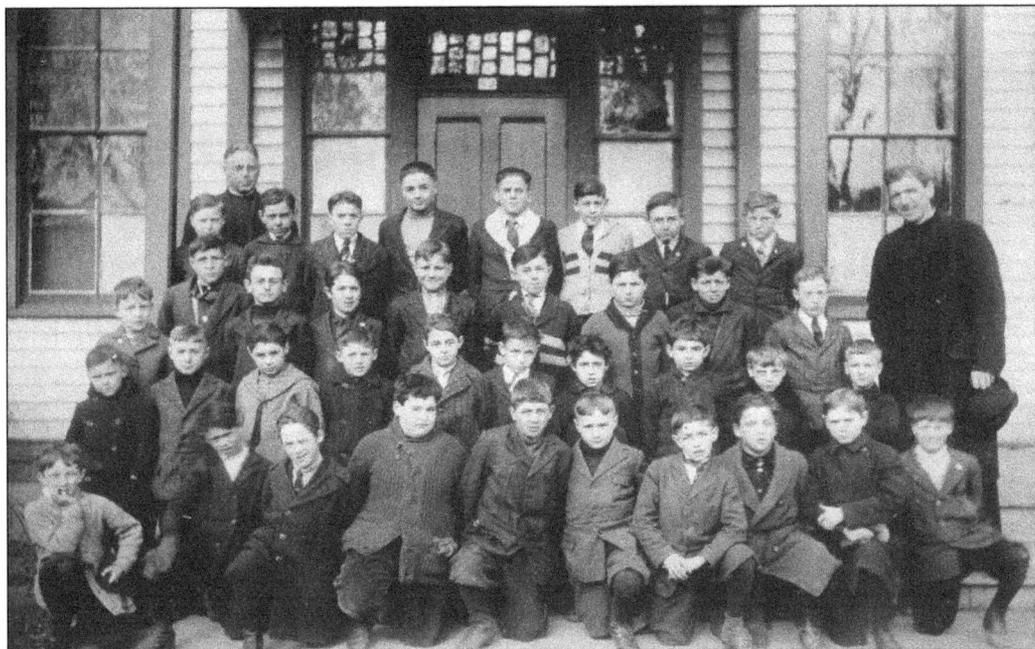

This photograph was taken at the entrance to the two-story boys school seen in the photograph on the opposite page. It was taken shortly before classes in this building were discontinued. (TJL.)

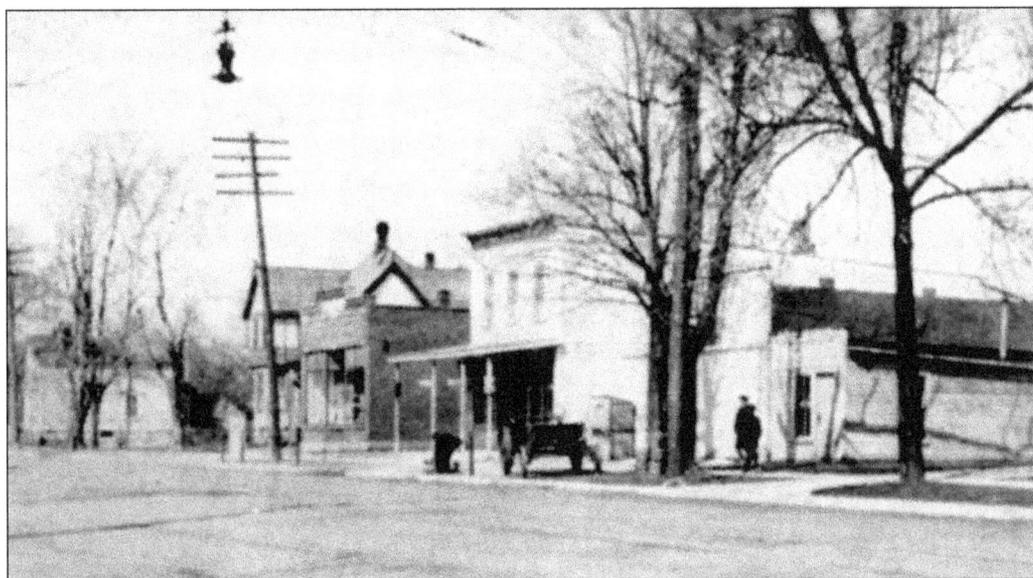

Here is a photograph of the east side of South Main Street. It was taken between 1916 and 1922. The gabled house just right of center belonged to Celestin Graveline. Graveline built the house in 1893. The building that had previously occupied that site was moved to what then was known as North Kankakee (now Bradley). There it remains today on the south side of West Broadway. The brick building, to the right of the house, is Graveline's Sanitary Meat Market. Jerry Rivard was the proprietor of a grocery store in the two-story building. (TJL.)

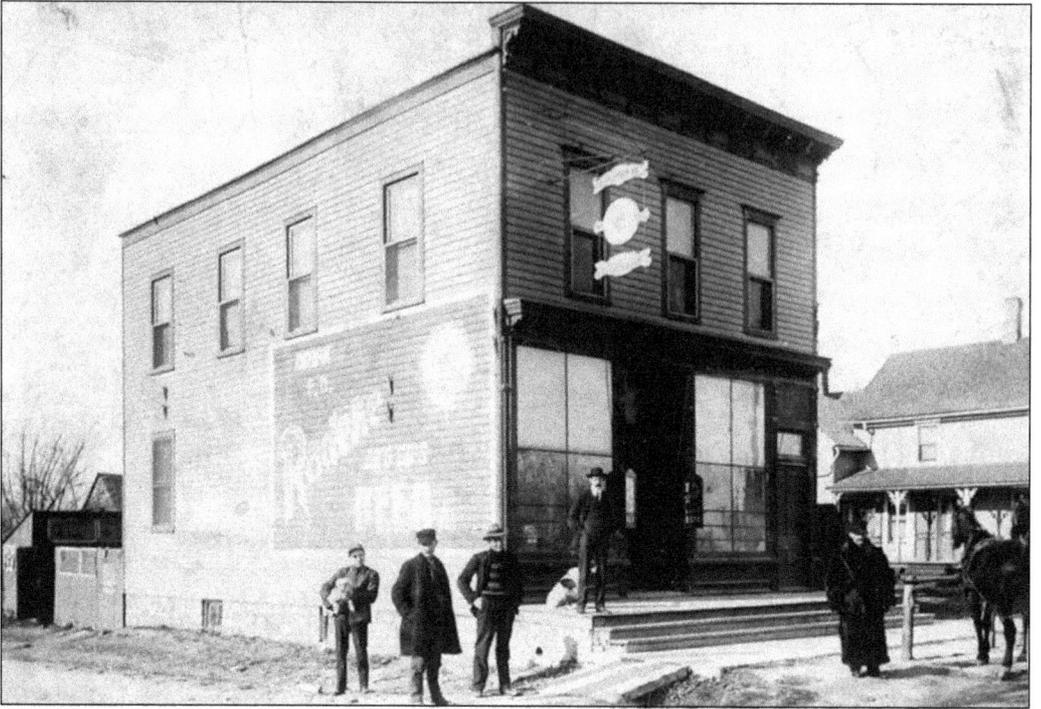

John Flageole built this building in the 1890s at the corner of North Main and River Street and opened a saloon. For several years, Alfred "Pete" Brouillette owned the building and served up locally brewed Radeke beer. In the late 1920s, Albert Landroche used the old watering hole for a grocery store and meat market. Workers razed this venerable structure in 1968. (KCM.)

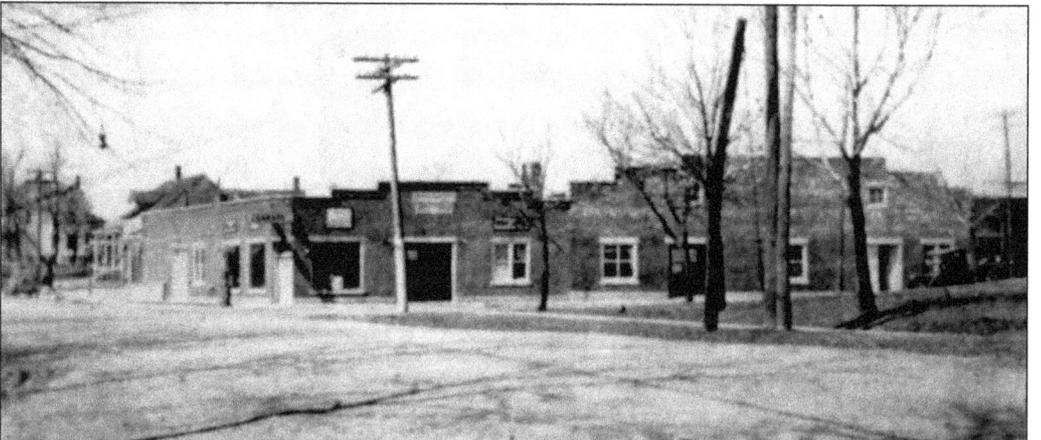

This block of buildings was built in 1916 soon after a fire destroyed the two-story wood frame Tetrault blacksmith shop. Once the new buildings were completed, the Tetrault family opened Bourbonnais's first automobile garage and automobile dealership. The family business closed in 1942, and several small businesses, including a broom factory, occupied the old buildings until they were demolished in the mid-1960s. (BGHS.)

Built in 1920 on South Main Street, this building was the village's second automobile garage. Peter Brouillette and Edward Brosseau were the proprietors. A series of small businesses later occupied the building. (AMR.)

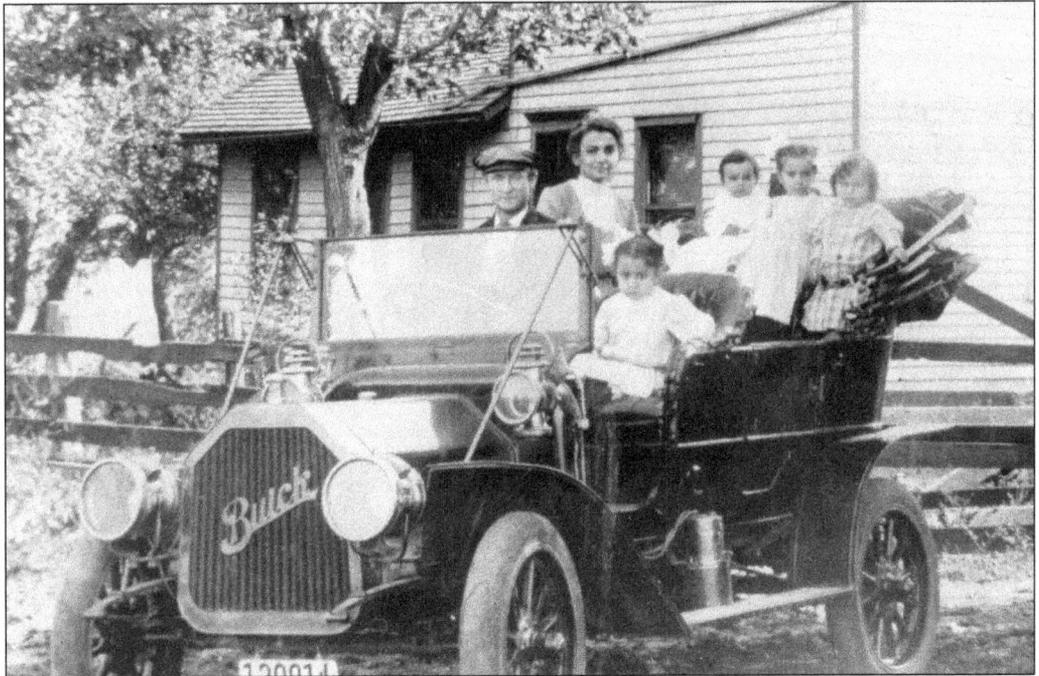

This automobile appears to be a 1910 Buick Model 10. These cars were built first in 1908. They cost about $1,000. Note that the steering wheel is on the right-hand side of the car. By the second decade of the 20th century, automobiles were a curious sight on the streets of Bourbonnais. In 1920, two automobile dealers, Pete Brouillette and the Tetrault Brothers, were intent on providing "wheels" to villagers. Here the proud owners of this Buick touring car, the Boucher family, pose for a defining photograph around 1914. (BGHS.)

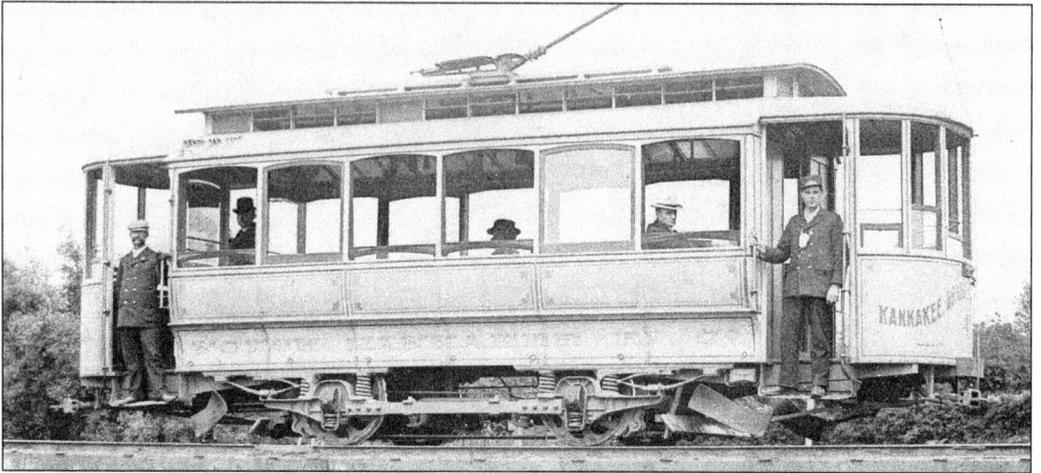

The electric streetcar came to Bourbonnais in 1894, with the formation of the North Kankakee Electric Light and Railway Company. Not only did the village have reliable transportation into Kankakee, but also electric lights. The trolley line ran from Court Street in Kankakee, down North Schuyler Avenue to the David Bradley factory in Bradley, then west on Broadway to LeVasseur Avenue (now Kennedy Drive), and north through Bourbonnais to Notre Dame Convent. The trip took a half hour each way. The fare was 5¢ each way. (KCM.)

Eugene Benoit's Liberty Laundry was located on the east side of South Main Street in Bourbonnais. He was the son of Joseph Benoit and Celina Benoit (née Lambert) and a descendent of Damas Benoit. (BGHS.)

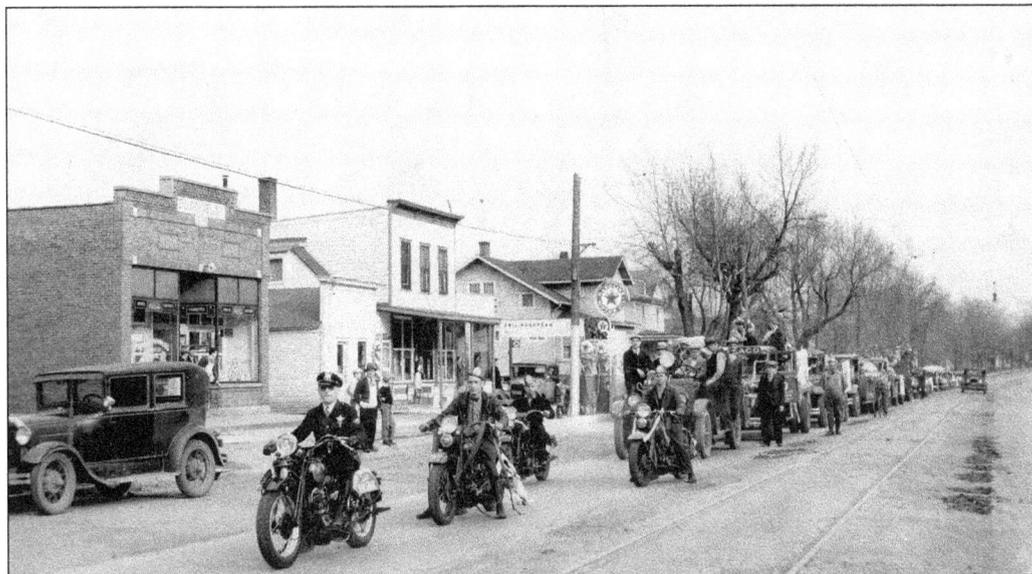

Seen here is South Main Street in Bourbonnais in 1932, when Kankakee native Lenington Small was campaigning for a third term as governor of Illinois. He had served two terms as governor, 1921 to 1929. He was not successful in being elected in 1932. Leading the procession is Kankakee police chief Gene De LaFontaine. (BGHS.)

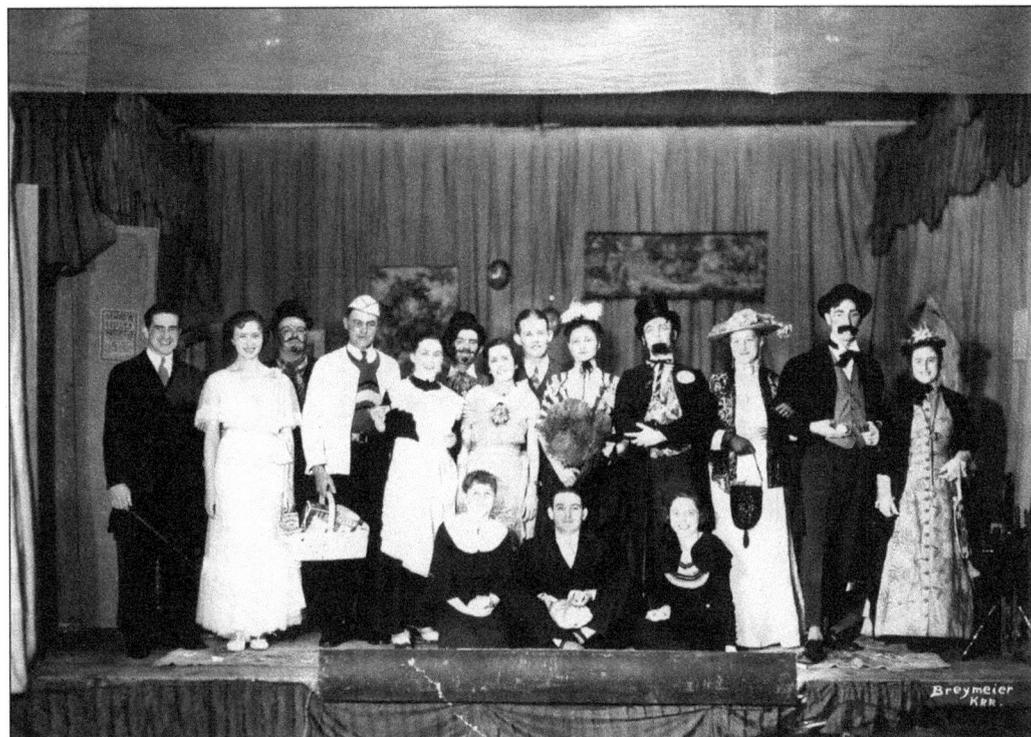

It is believed that this photograph was taken around 1933 on the stage in the old school building shown on page 74. The people are all residents of Bourbonnais. (Courtesy of Glenna Benoit.)

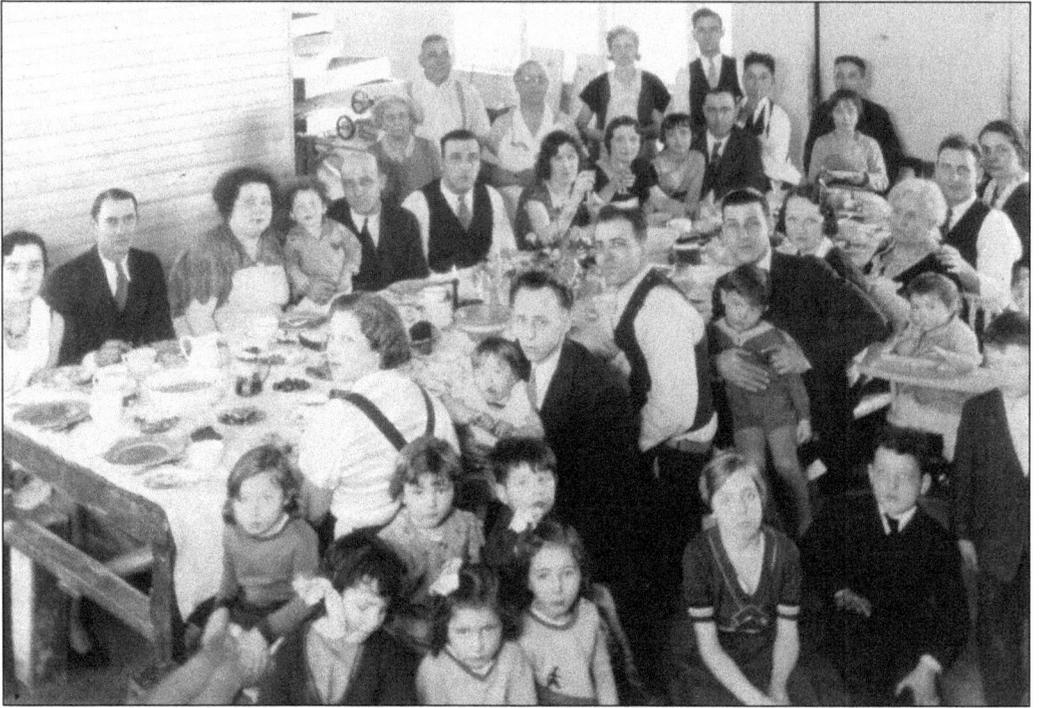

French Canadian families in Bourbonnais generally were large, and most of the pioneer families were interrelated by marriage. Here is a family gathering of the Arseneau clan. (BGHS.)

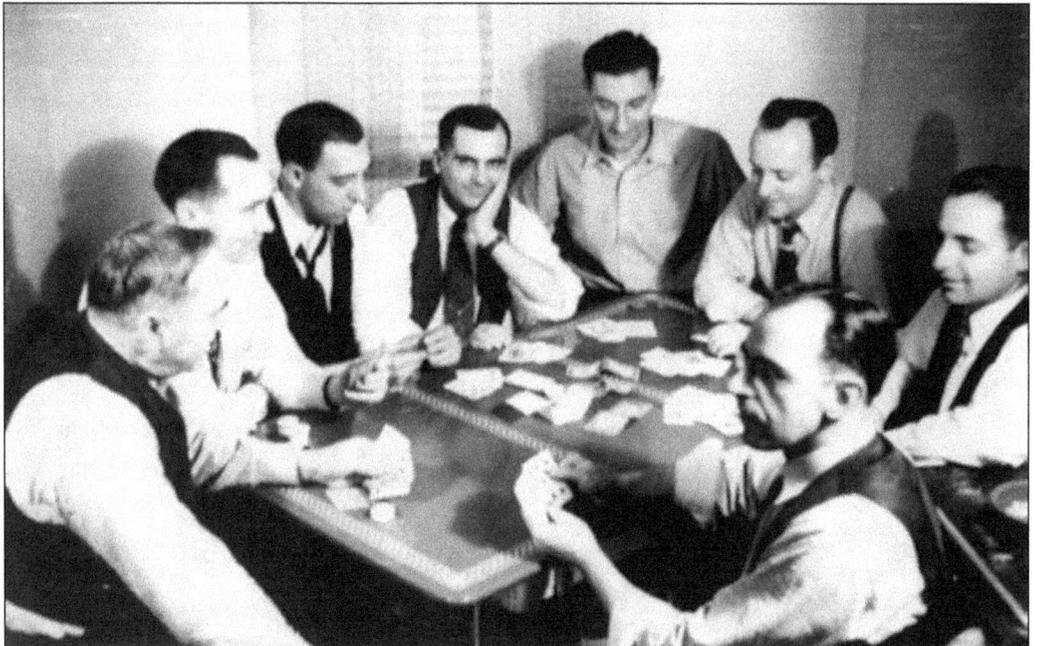

Both men and women enjoyed playing cards. There were various card parties, usually segregated as male or female. (AMR.)

When winter froze over the surface of Mailloux's slough on Frank Mailloux's farm, the young blades of Bourbonnais laced up their ice skates and grabbed their hockey sticks. In the mid-1920s, a local team called the Flying Frenchmen was organized. Many hard-fought hockey games were played between netted goals, under the existing rules of the day on that glazed outdoor arena. Seen here is one of the Flying Frenchmen dressed in official uniform. It lacked the padded protection of modern-day hockey teams. (AMR.)

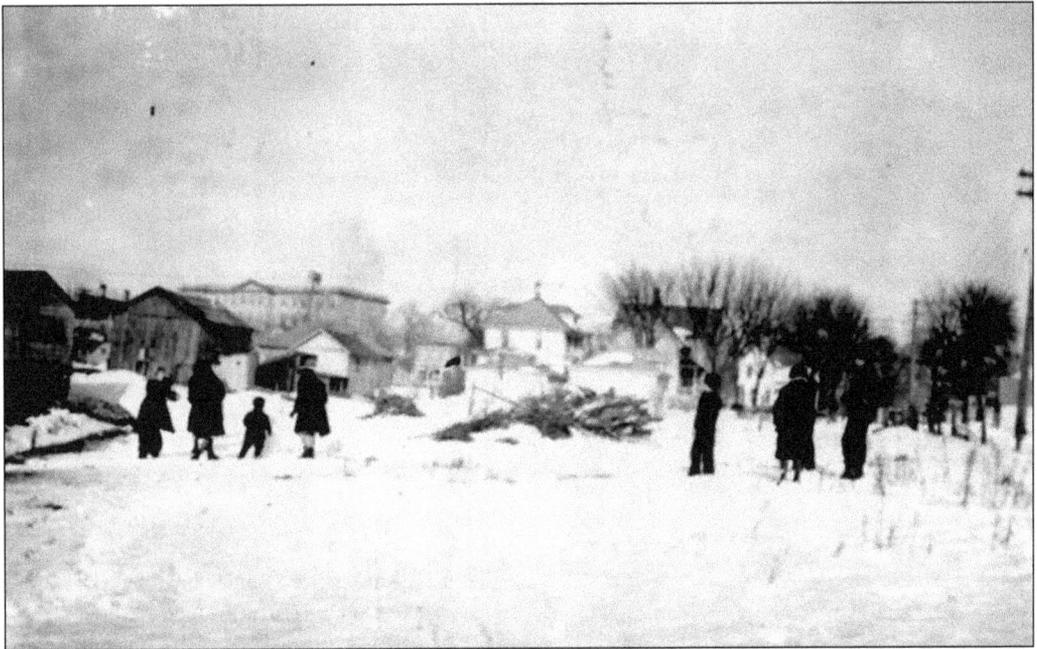

Winter offered other opportunities to enjoy sledding on the hills near the river and snowball fights in the open fields surrounding the village. In this photograph, taken on the west side of Bourbonnais looking east toward Main Street, with Marsile Hall on the horizon, it appears to be snowballs at 20 paces. (AMR.)

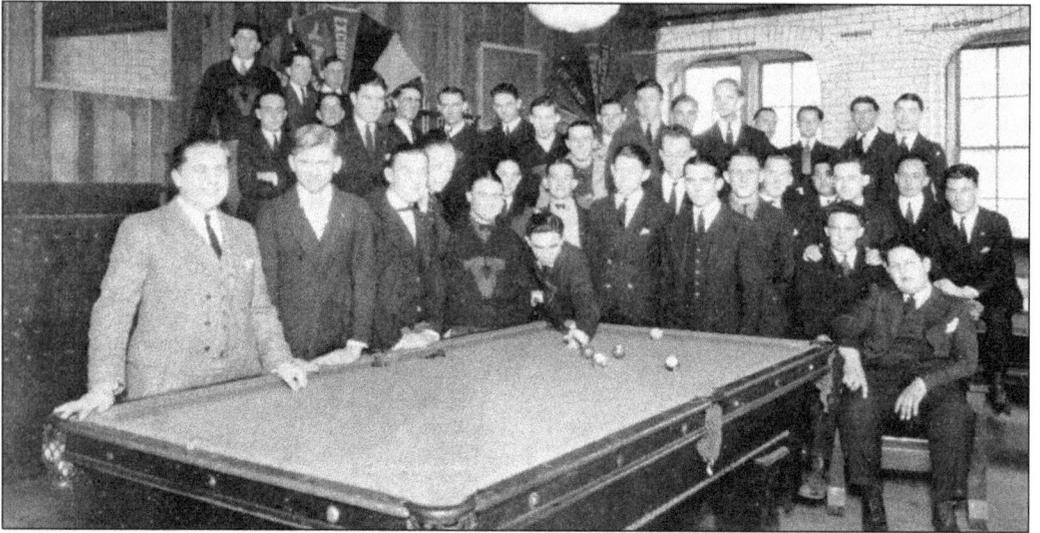

A billiard tournament seems to be in progress at the Viatorian Knights of Columbus club room. If not a tournament, this must have been a very serious game, with reputations at stake. Everyone came dressed for the occasion. (TJL.)

Is this an ersatz Oliver Hardy preparing to wrestle this trunk in a comedic performance? Or is he some bumpkin freshman dropped off a passing turnip wagon? One can only guess what has caused the expression of consternation on this young St. Viator student's face. (TJL.)

Five

MATERNITY OF THE BLESSED VIRGIN MARY CHURCH
1852–1975

Sixty years after it was dedicated, Maternity BVM Church stood rock solid in the noon sunlight on La Rue de l'Église where it still stands today. Pioneer parishioners built the church of native limestone between 1854 and 1858. The stone was hauled in horse-drawn wagons from quarries near the Kankakee River. In 1918, when this photograph was taken, the church shared the same campus as St. Viator College. A grotto dedicated to Our Lady of Lourdes is a few yards south of the church. Viatorian brother John F. Koelzer with the help of Willard Arseneau built the grotto over a period of several years, using stones carved by local residents. It was completed shortly after World War I. The grotto is maintained by parishioners. For many years, a summertime novena to Our Lady of Lourdes was held at the grotto. During the Christmas holiday season, the grotto blossomed with colorful wreaths and lights. (AMR.)

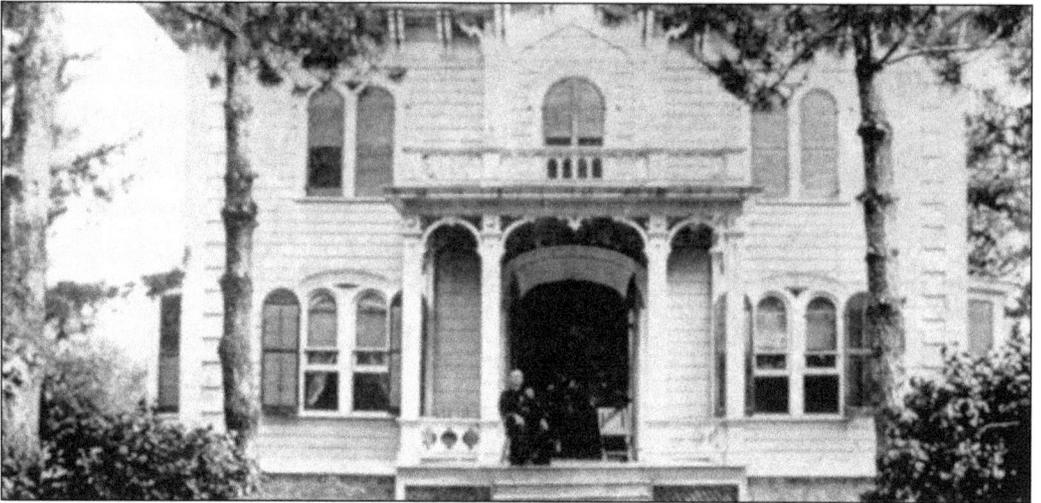

This frame Victorian Italianate villa, built in 1870, served as the rectory for Maternity BVM priests until 1952. Tales were whispered about Bourbonnais that guests—visiting priests—were reluctant to sleep in the upstairs bedrooms of the old rectory. A 34-year resident, Fr. Walter J. Surprenant, C.S.V., had long made peace with the unexplained "nocturnal spirits" who rattled around in the shadows of a moonlit midnight. When transient priests hastily checked out, Fr. "Soup" Surprenant would kindly excuse their faintheartedness. After all, he was privileged to sleep peacefully downstairs. The rectory was dismembered in 1952 and replaced by a new one built of brick. A Bourbonnais citizen used the old lumber to build a new house. The noisy spirit was said by some to only be pigeons roosting in the attic. (BGHS.)

Within Maternity BVM Church, on the north wall, there is a marble monument to Phoebe Caron, founder and first president of the Ladies of St. Anne Sodality. Today the organization is called Confraternity of Catholic Women. This c. 1928 photograph captures the faces of contemporary members of St. Anne Sodality. (BGHS.)

Taken in 1943, this picture shows the altar inside Maternity BVM Church during mass on June 20, Corpus Christi Sunday. (AMR.)

Fr. Walter J. Surprenant, C.S.V., shepherds a typical class of young people, who in 1950 have just celebrated their first holy communion. The Rev. "Soup" Surprenant was Maternity BVM pastor from 1920 to 1954. (BGHS.)

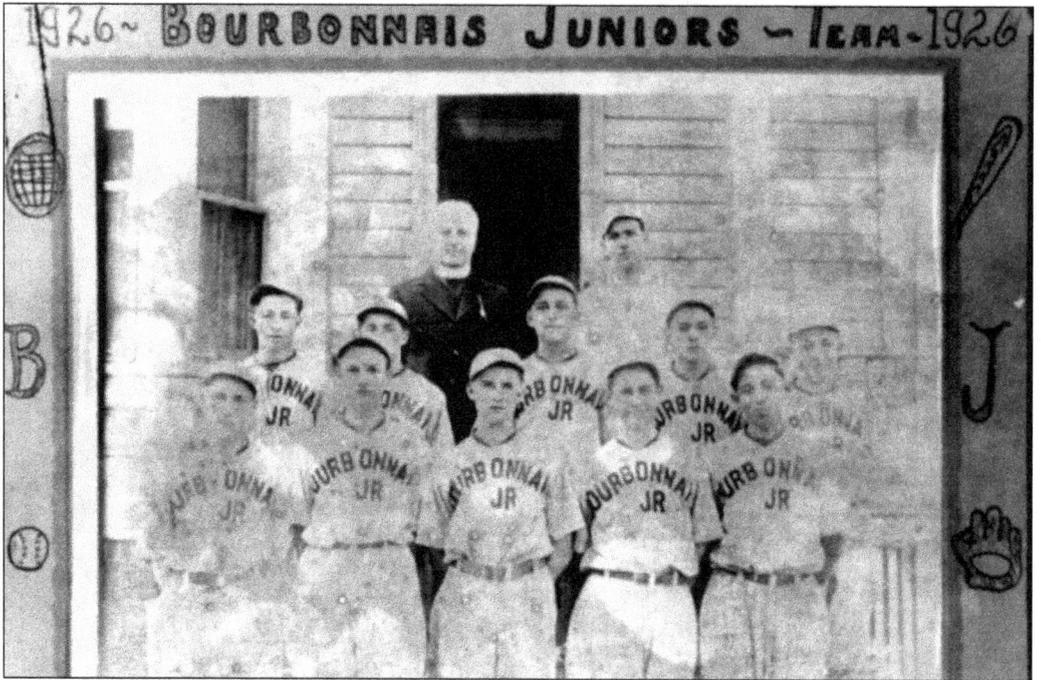

This is the Bourbonnais Juniors baseball team of 1926. Pictured are, from left to right, (first row) Anthony J. Arseneau, Adrien M. Richard, Claude Martin (captain), Alphonse Marcotte, and Raymond T. Senesac; (second row) Emerie Zace, Ambrose Loiselle, Armond Grenier, Edward (Eddie) Houde, and R. Messier; (third row) Rev. Walter J. Surprenant, C.S.V. (moderator), and Willard J. Arseneau (coach). (BGHS.)

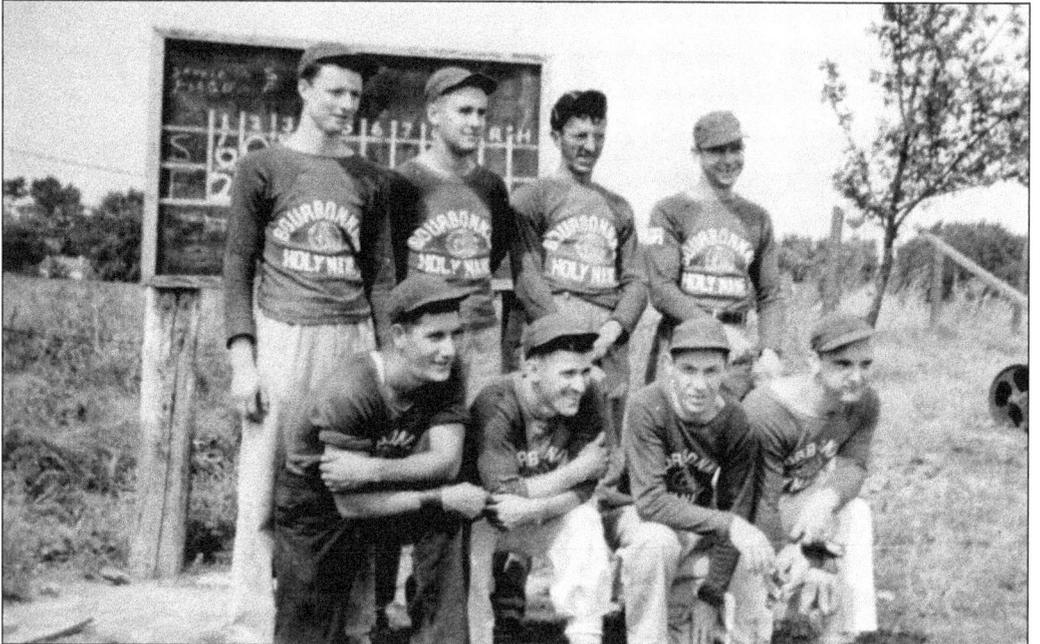

It is time out for the Bourbonnais Holy Name baseball team when a photographer turns up to take its picture. (BGHS.)

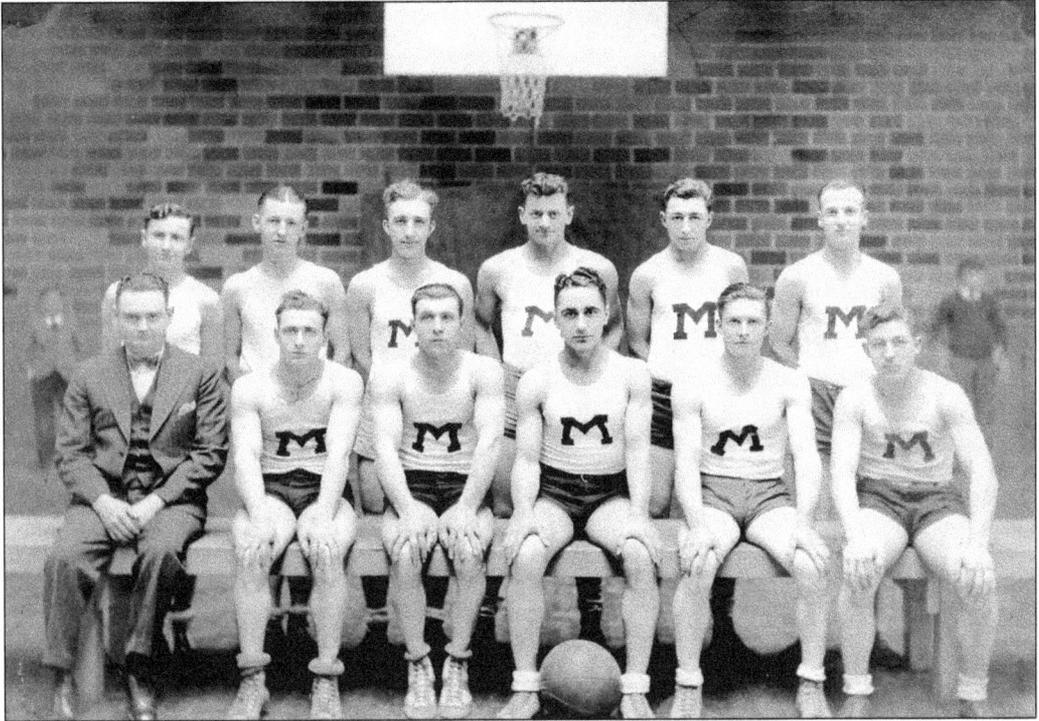

The Maternity BVM Church team is shown here in its 1940s basketball uniforms. (BGHS.)

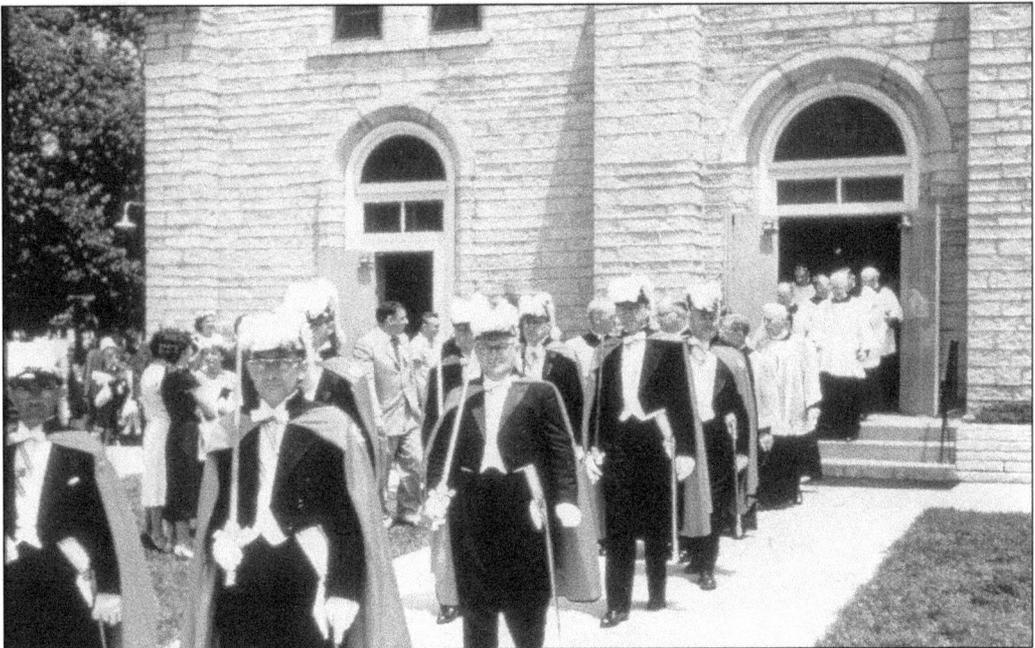

Knights of Columbus dressed in full uniform are seen here exiting the Maternity BVM Church. (BGHS.)

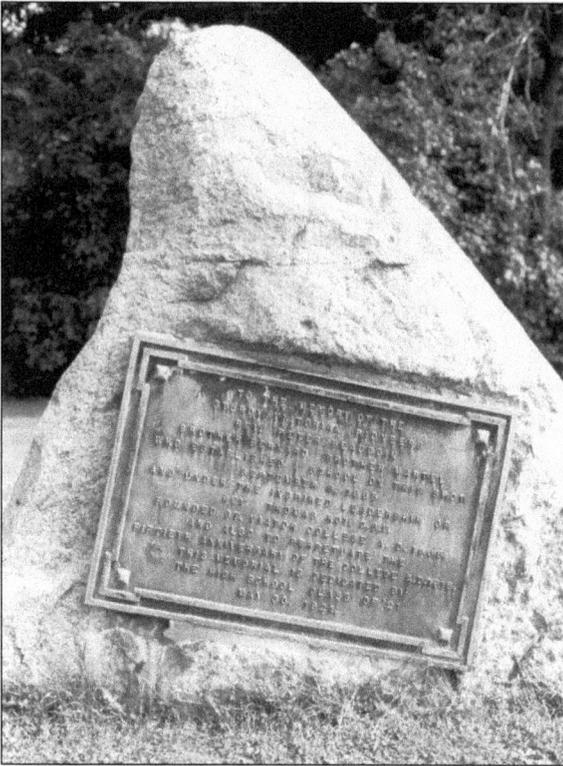

The high school class of 1921 erected this memorial to the memory of the "Rev. Peter Beaudoin, Brother Bernard, [and] Brother Martel, who established a school on this spot, September 6, 1865, and under the inspired leadership of Rev. Thomas Roy, C.S.V. founded St. Viator College A.D. 1868." It also perpetuates the 50th anniversary of the college in 1918. (THC.)

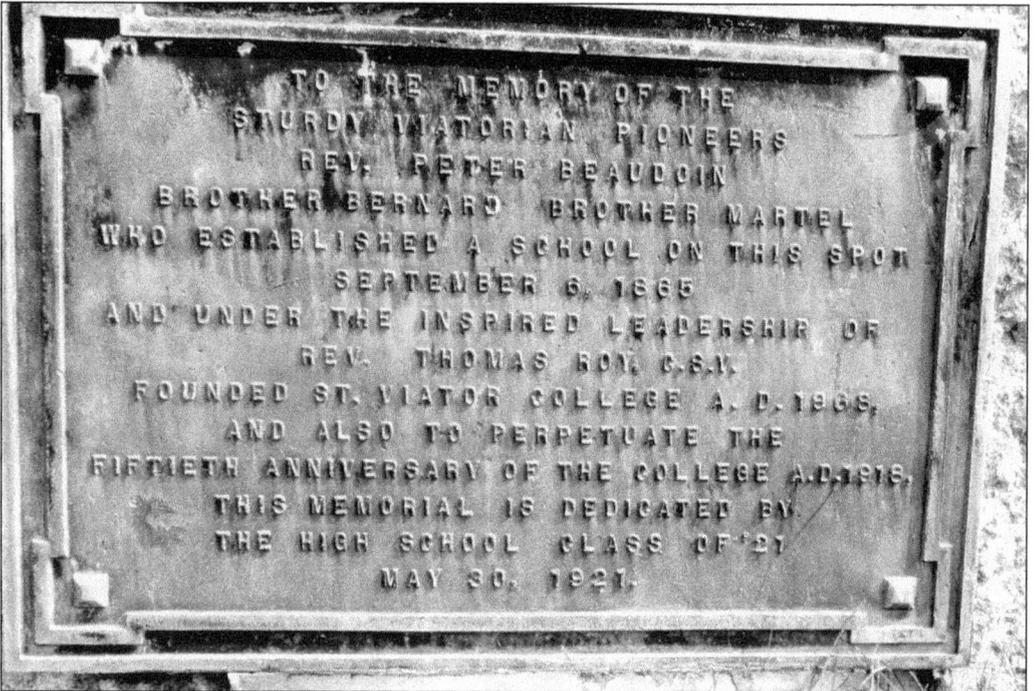

Six

NOTRE DAME ACADEMY
1862–1949

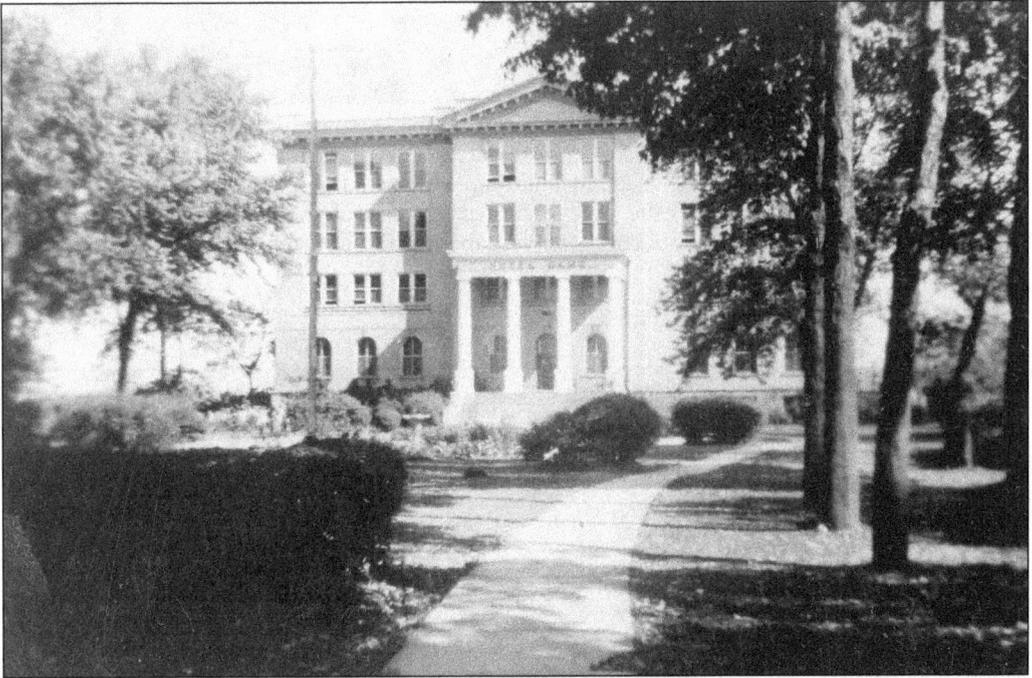

Sr. St. Marie de la Victoire, who with Sr. St. Alexis de St. Joseph and Sr. St. Alphonse de Ligouri of the Congregation of Notre Dame, came to Bourbonnais Grove from Montreal in 1860 to open a girls' academy. During the last half of the 19th century, the academy grew into a large educational institution and boarding school. In 1906, a decision was made to replace the old Notre Dame Academy (pictured on page 45) with a modern building. In the late winter of 1909, the academy accepted a bid from Bourbonnais contractor Philip Houde to construct a four-story, cream-colored brick building (above). Frederick E. Legris donated land, and ground was broken on March 14, 1909. July 23, 1910, marked the move to the new building. Student boarders arrived on September 11. In October, workers demolished the wings of the old academy and moved the center of the building to the college grounds to be used as the college's infirmary. (Courtesy of Cecile LaMarre Enright.)

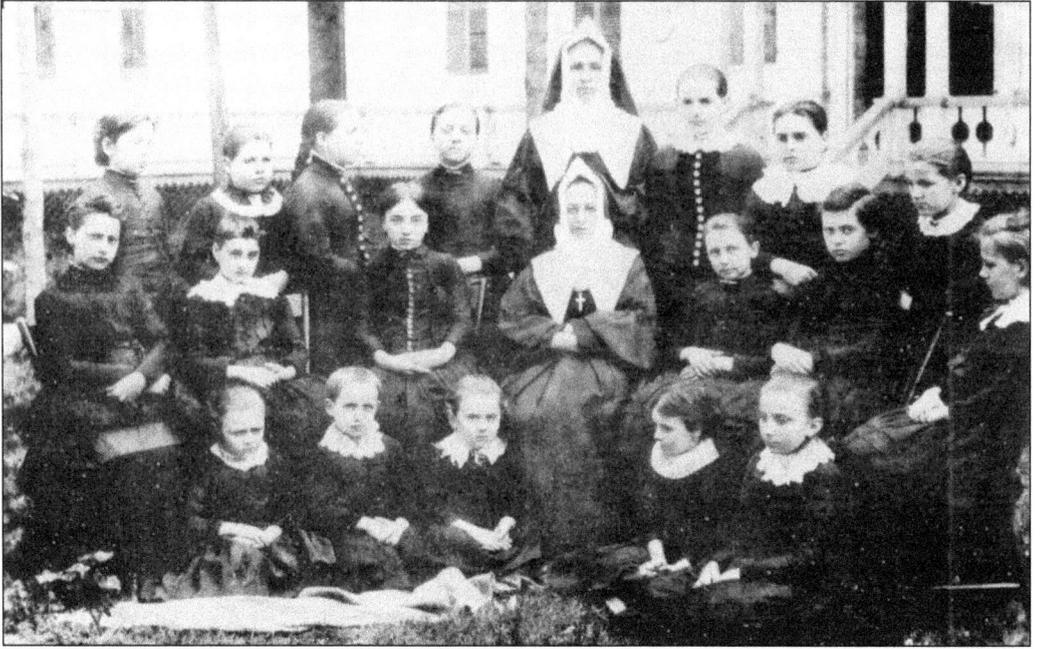

These children who boarded at the old Notre Dame Academy were photographed along with two sisters of the Congregation of Notre Dame about 1900. Although the boys and girls attended different schools they lived in the academy building. The seated nun appears to be Sr. St. Marie du Cénacle. On March 4, 1900, she was appointed superior of the academy. The number of students attending Catholic school that year was about 160. (Courtesy of Congregation of the Sisters of Notre Dame.)

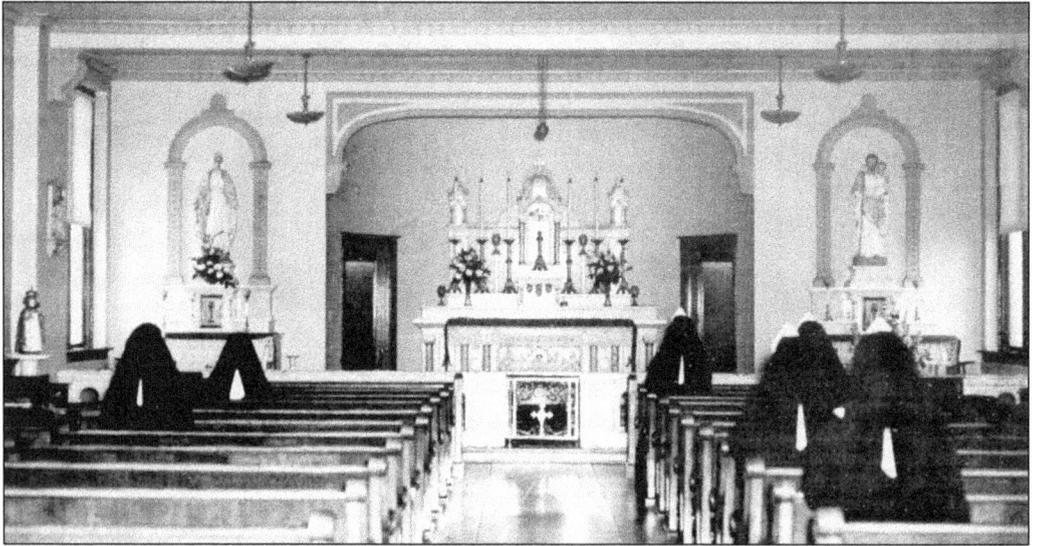

The new academy building, completed in 1910, incorporated this chapel on the main floor. Two statues, Joan of Arc and St. Michael, donated by the parents of one of the nuns, stood outside the chapel entrance. (Courtesy of Congregation of the Sisters of Notre Dame.)

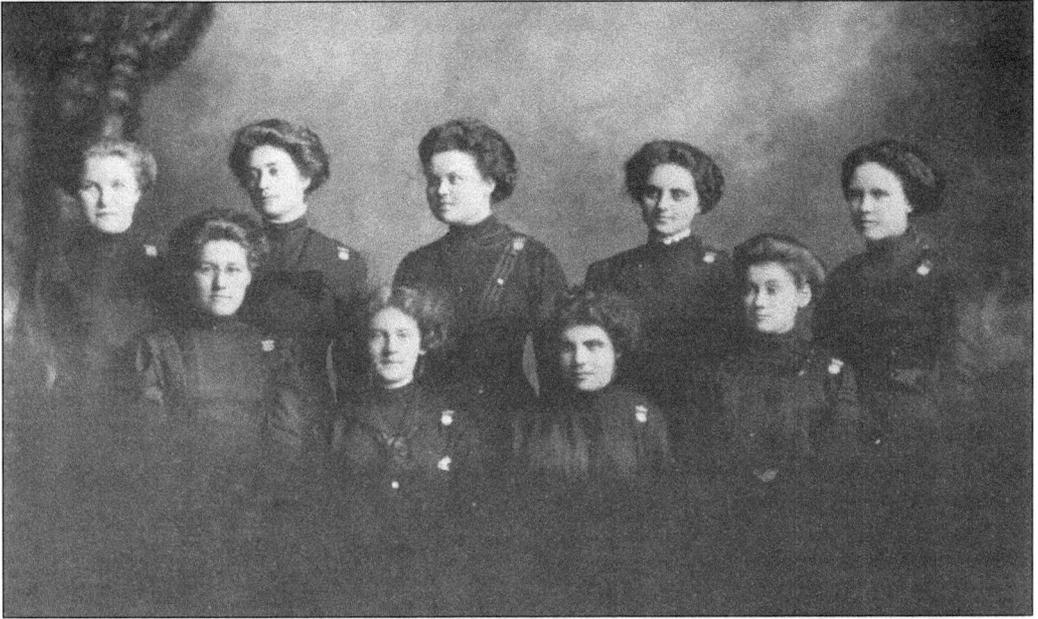

Nine young women, Lucie Breault, Catherine Clark, Theresa Cronin, Bernadette Graveline, Blanche Kelly, Marie Lane, Kathleen Mallaney, Geraldine McEvoy, and Bernadette Messier, were the academy's graduating class of 1910. This was the last class to graduate from the old convent building. That year also marked the 50th anniversary of the founding of the school. (Courtesy of Congregation of the Sisters of Notre Dame.)

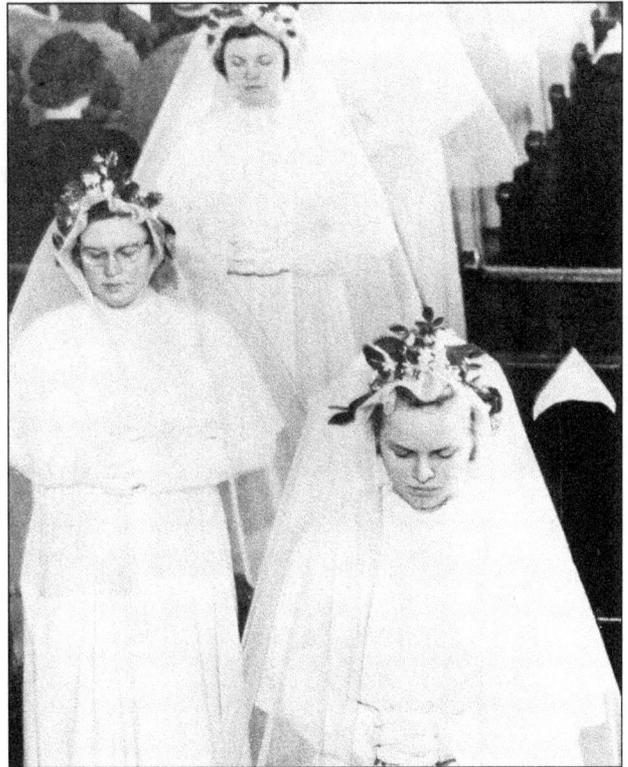

Novices to the Congregation of the Sisters of Notre Dame wearing their white bridal dresses were photographed about the mid-1950s in the aisle of Maternity BVM Church. In 1953, the Notre Dame Convent in Bourbonnais had been chosen as the site of the first American novitiate of the Congregation Sisters. Twenty-two "novitiates were welcomed by rejoicing sisters of the convent". Historian Adrien M. Richard commented that the "near century of sacrifice by the hundreds of inhabitants of the Bourbonnais mission" had not been in vain. (Courtesy of Congregation of the Sisters of Notre Dame.)

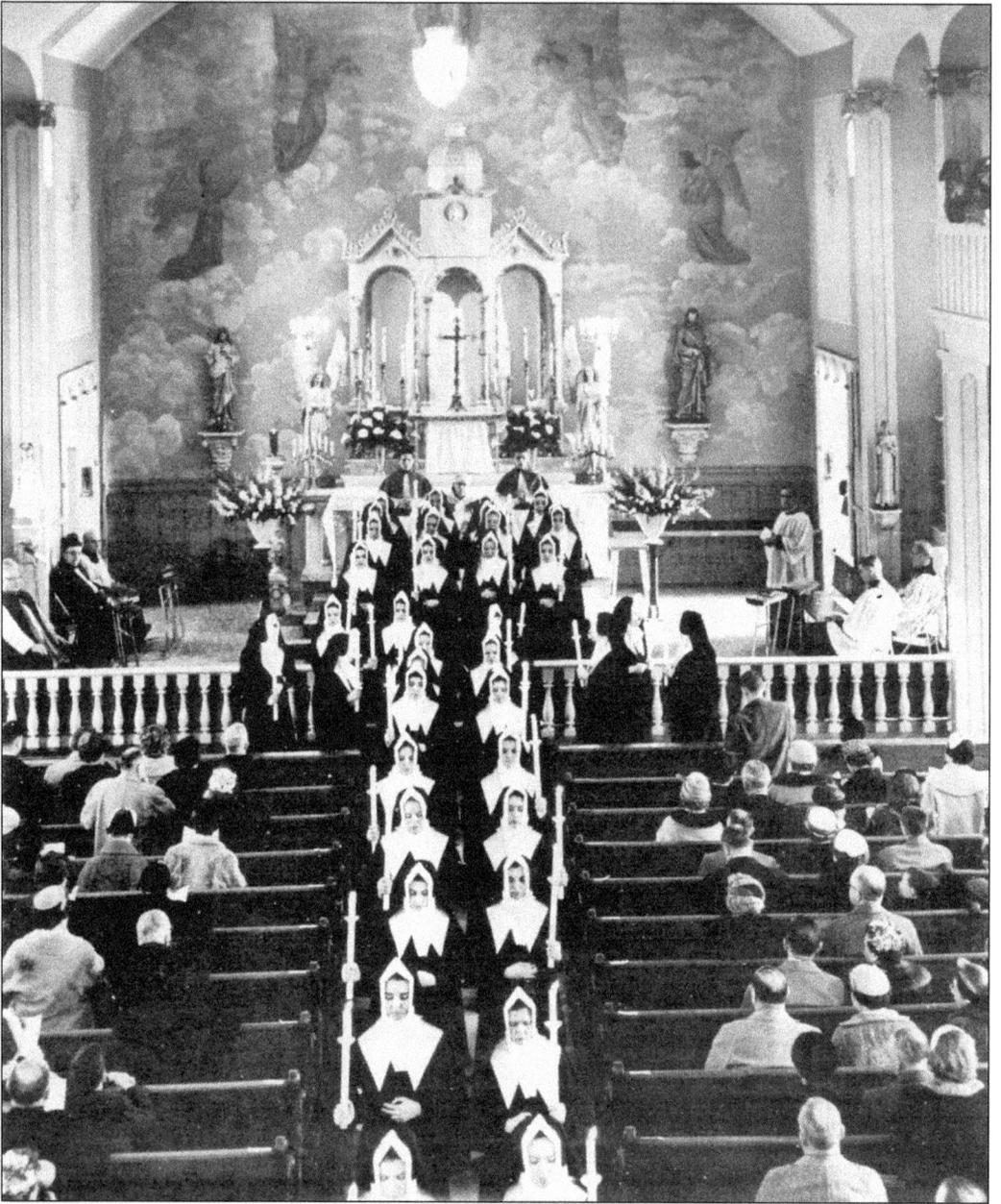

Newly consecrated Sisters of the Congregation of Notre Dame, now brides of Christ, having taken their final vows of obedience, chastity, and poverty, are seen leaving the altar in Maternity BVM Church. (Courtesy of Congregation of the Sisters of Notre Dame.)

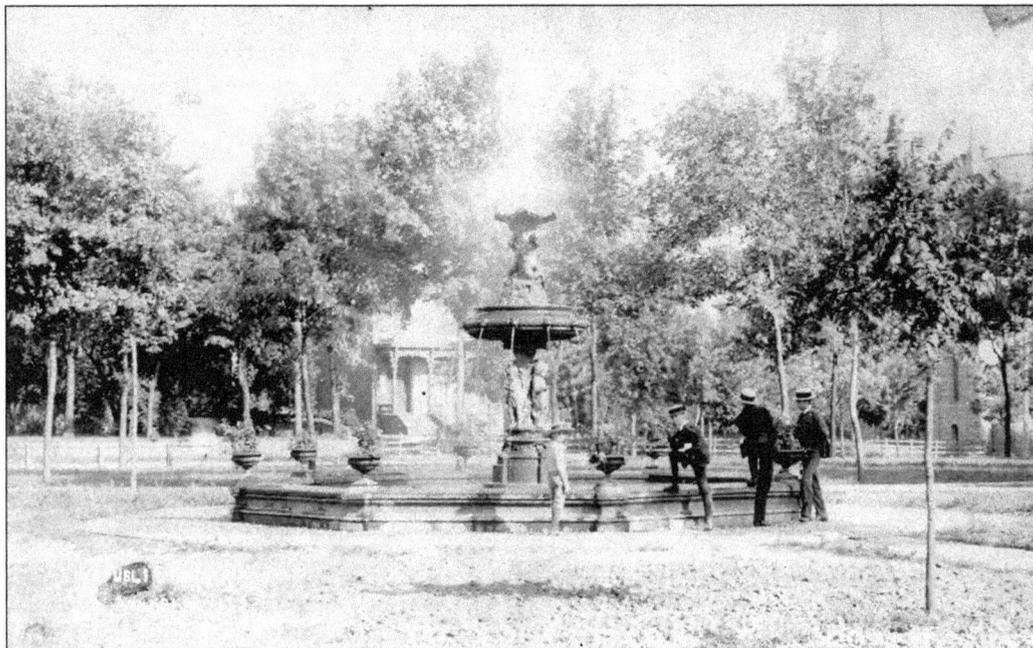

These are two photographs of the same fountain. The picture above shows the fountain in its original location on the northeast corner of the Kankakee County Court House grounds. The picture below shows the same fountain, missing the statue that once adorned the top, after it was moved to the convent yard in 1911. It had been sold to the sisters for $10. (Above, KCM; below, AMR.)

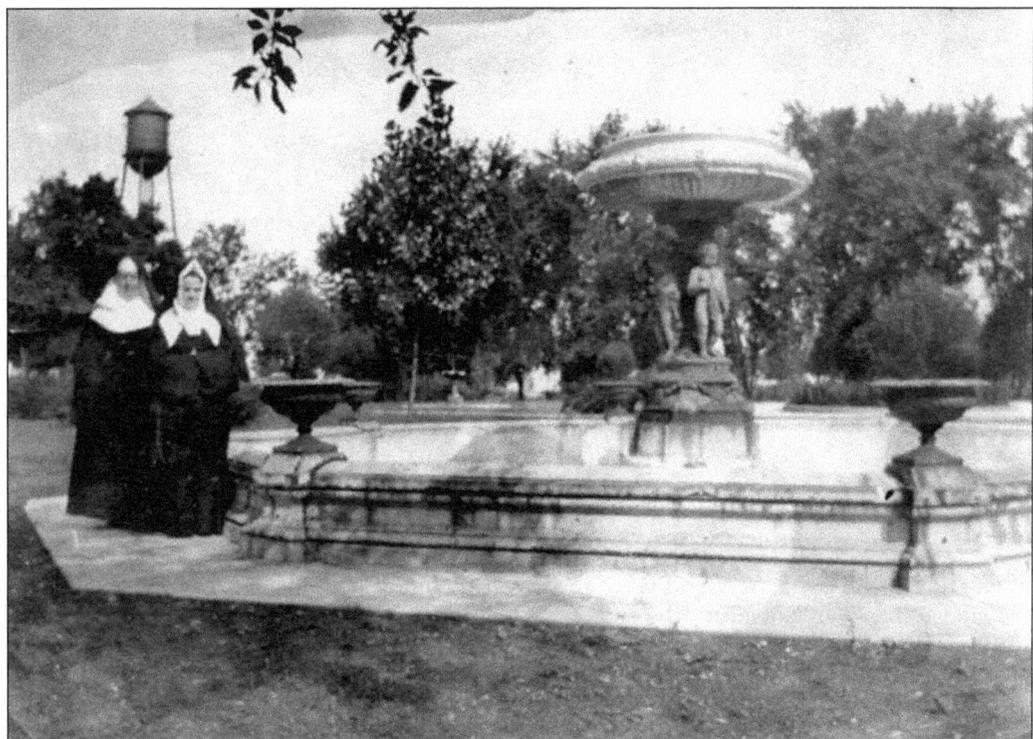

Of course, it was not all prayers and piety at the academy. There were plays, dances, and parties. Singing, music instruction, and art classes insured students got a well-rounded education. This is a photograph of the 1955 graduating class. (BGHS.)

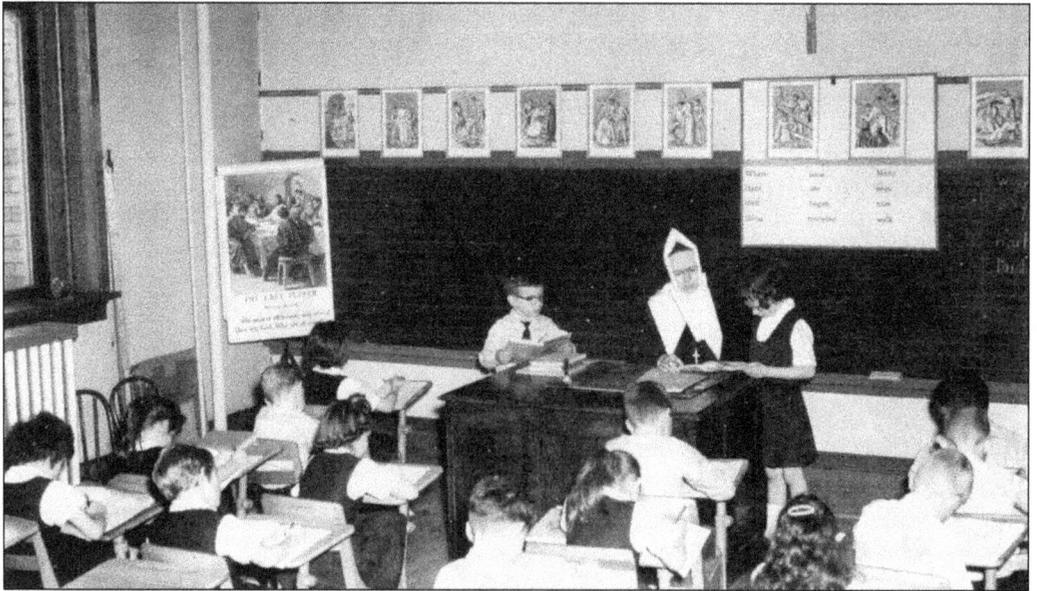

In July 1955, Bourbonnais residents voted in an overwhelming majority for a new public school in the village. The mandate meant the end of Notre Dame sisters teaching public school children. Up to that time, all children, Catholic and Protestant, were in a tax-supported school taught by nuns, brothers, and priests. Now, for the first time, the clergy would teach in a Bourbonnais parochial school, "where crucifixes, statues and holy water" would be a part of the classroom. (Courtesy of Congregation of the Sisters of Notre Dame.)

Seven

ST. VIATOR COLLEGE

1865–1938

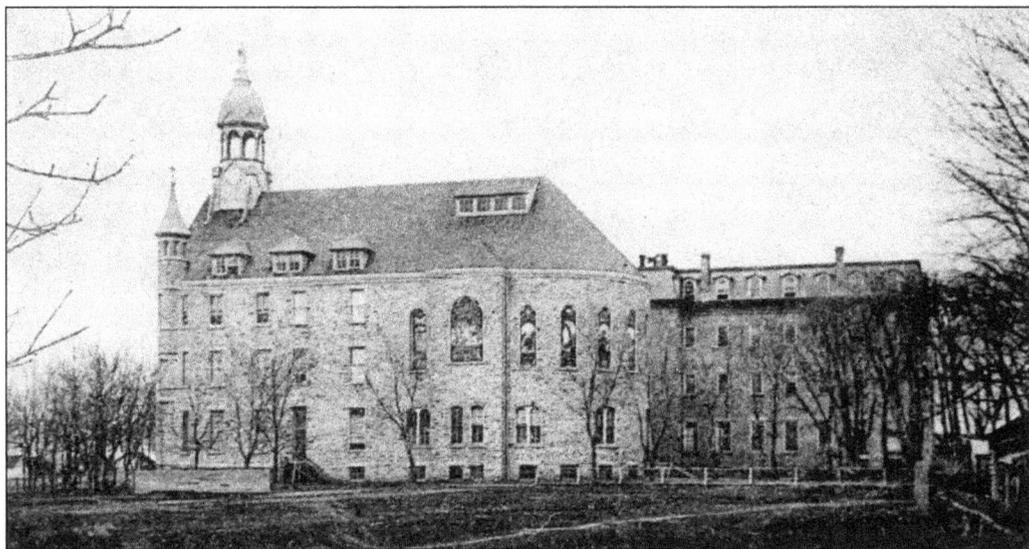

St. Viator College grew over the years from a boys' school in a two-story public schoolhouse in 1865 to an impressive complex of buildings by 1900. During the 1868 fall session, Fr. Thomas Roy added to the grade school and commercial departments courses in French, Latin, philosophy and mathematics. By 1870, a course in vocal and instrumental music was given and a theological department opened. That year, ground was broken for a new stone building. The Illinois state legislature granted St. Viator College a university charter in 1874. Specialists in the fields of English literature, science, theology, and philosophy contributed to a curriculum that would produce graduates the caliber of Bishop Bernard J. Sheil, auxiliary bishop of Chicago and founder of the Catholic Youth Organization; archbishop of Syracuse, New York, Fulton J. Sheen; Francis J. Sheridan, playwright; the Rev. Harris A. Darche, the most decorated marine of World War I, who was awarded medals by the French and American governments for bravery under fire; Illinois governor Samuel Shapiro; and many other outstanding men in business, law, and medicine. (TJL.)

These two photographs of St. Viator students and faculty were taken on glass negatives around 1900. Some of the buildings destroyed in the 1906 fire are in the background. Uniforms were worn by the school's Reserve Officers Training Corps members. (ONU.)

This image of young ladies dressed in their Sunday best is on one of the glass negatives. Were they visiting the college, or were they students at nearby Notre Dame Academy? Those questions have no answers, but it must have been a special occasion for the photographer. The negatives, once the property of a St. Viator student or one of the faculty, survived the fire and were found by an Olivet Nazarene University staff member in one of the St. Viator College buildings built after 1906. (ONU.)

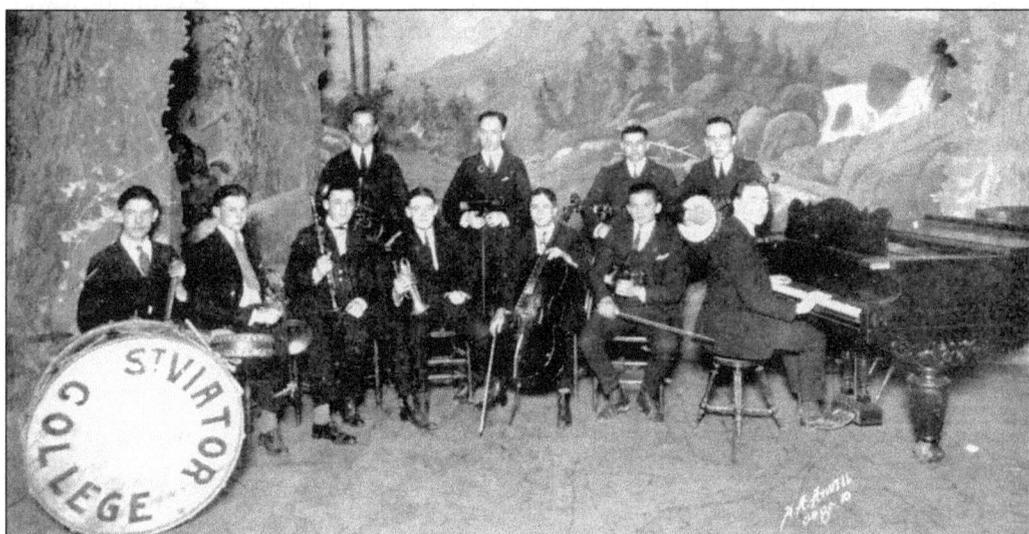

The St. Viator College orchestra gathered on stage for a school concert during the 1921–1922 school year and had their yearbook picture taken. (BGHS.)

On the evening of February 21, 1906, residents of Kankakee became aware of an increasingly bright glow in the northern sky. Ten miles to the north, people in Manteno were drawn out into the moonlit winter night to wonder at the pale orange light flickering on the southern horizon. Soon the news came by telephone—"St. Viator College is burning!" Students attending a basketball game in the new gymnasium rushed out onto the campus to be confronted with a dormitory engulfed in fire, a fire that spread rapidly to the grand Roy Memorial Chapel. Students, priests, and some Bourbonnais residents ran into the chapel in a desperate effort to rescue statues, books, fixtures, and the rich furnishings. There existed no defense for the roaring flames. There was no organized fire department in the village, and a hastily summoned bucket brigade from Kankakee was driven back by the heat. The heat was so intense it cracked the windows in the Arseneau Bakery across Marsile Street from the college campus. The morning sun revealed only the gymnasium had been spared the conflagration. Of the rest of the buildings, "Nothing but the stone walls remained standing in smoldering embers and rubble, as the labor of so many religious in the past forty years was now wiped out." The source of the fire was never officially determined. Before the ashes had cooled, planning for a new college began under the leadership of college president Fr. Moses J. Marsile. (BGHS.)

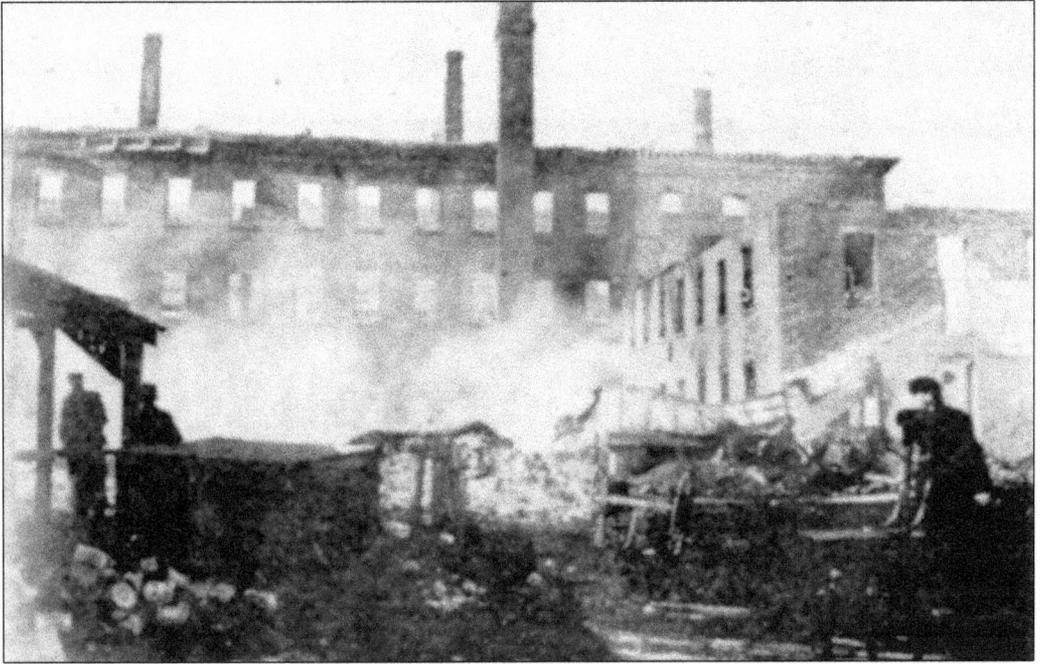

Seen here are the smoking ruins of the old boys' school and the first college building (Roy Hall), built of native limestone by the Viatorians during the years of 1869 to 1874, the morning after the fire. Senior and junior student dormitories occupied the top floor, and study halls, classrooms, a library, a science hall, and a museum were on the second floor. The first floor contained rooms for students and a billiard hall. (BGHS.)

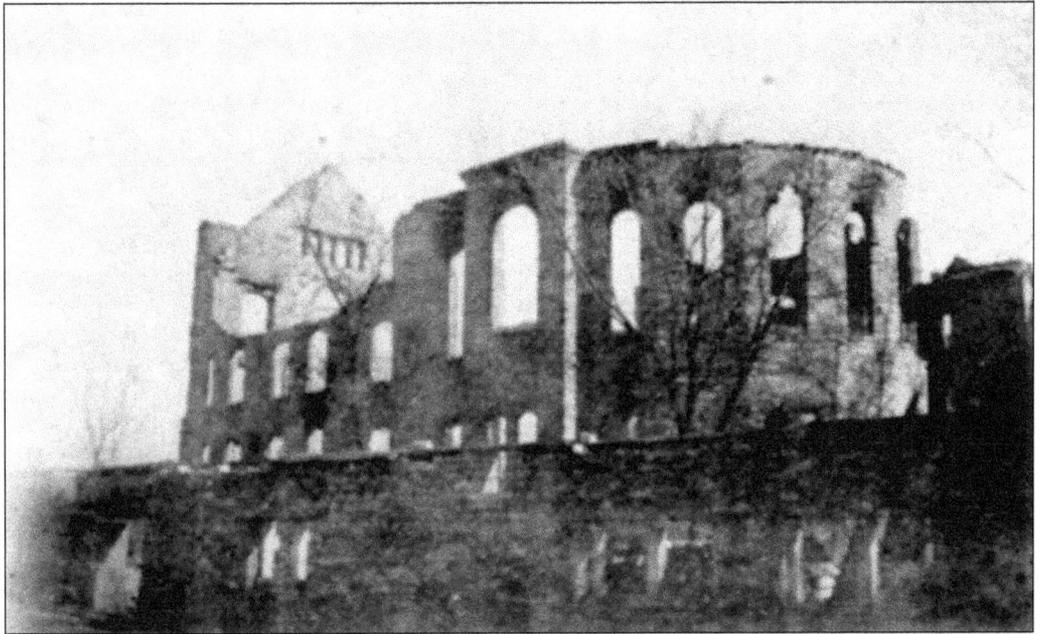

This is all that was left of the magnificent Roy Memorial Chapel on the day following the fire. College alumni built the Byzantine-style chapel as a memorial to the Rev. Thomas Roy, C.S.V., in 1889. (See photograph on page 95.) (BGHS.)

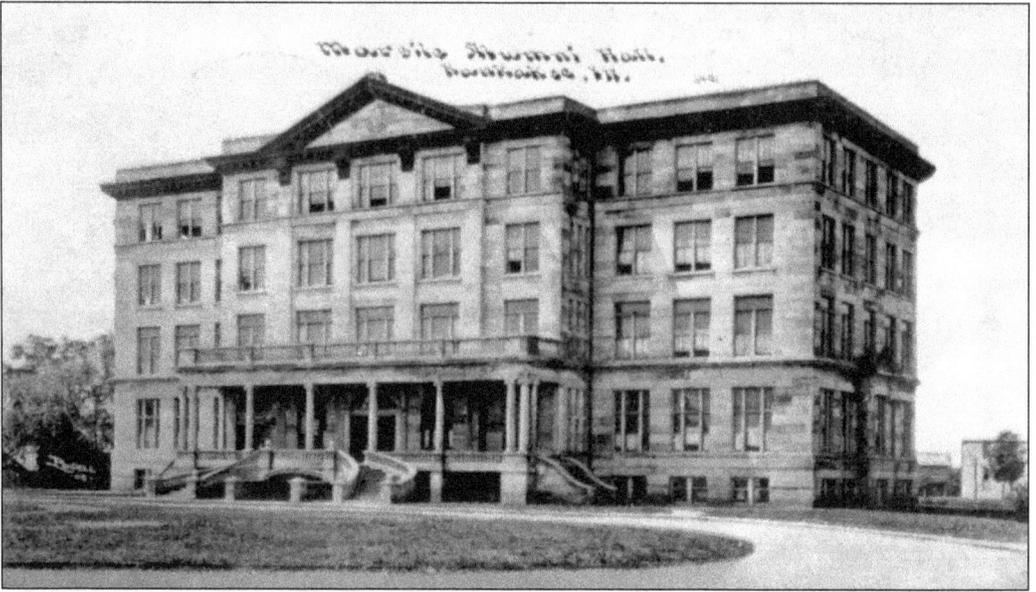

Stone block by stone block, building by building, the construction of a new college progressed. Contributions from alumni and friends, even from Andrew Carnegie, spurred on the work of reconstruction. A dormitory named for Fr. Thomas Roy, a heating plant, and an administrative building, all put together with Bedford stone soon were spread out around an imaginary circle. The administrative building honored the college president, the Rev. Moses J. Marsile, by being christened Marsile Alumni Hall. (BGHS.)

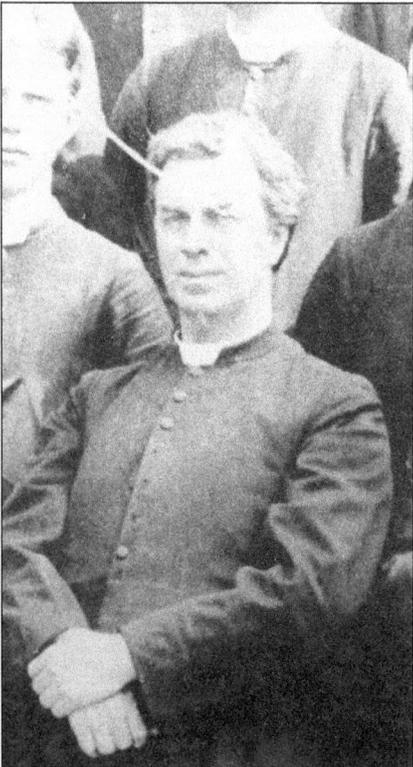

Moses J. Marsile (center), having entered the Novitiate of the Clerics of St. Viator at the age of 16, came to the college in September 1871 as a teaching brother and became head of the department of French literature. Marsile took his final vows as a priest in 1875. While vice president of the college, he published about 50 of his poems in a volume titled *Epines et Fleurs* (Thorns and flowers). Marsile had an international reputation as a man of letters. Some called him "the poet laureate of old Bourbonnais." He wrote more poems, prose, and operettas and received the French Academy's Triple Palm for literary merit, its most prestigious award. Marsile held the presidency of St. Viator College for 35 years, rector of St. Mary's Church in Beaverville for 10 years, and was pastor at Maternity BVM parish for one year (1918–1919). (BGHS.)

Eight

OLIVET NAZARENE COLLEGE
1939–1975

By 1925, St. Viator College had fully recovered from the devastating fire of 1906. The village and college looked forward to a bright future. This photograph shows the St. Joseph Infirmary at left, the science building and power plant at center, and on the right, the gymnasium. On January 26, 1926, a blaze of unknown origin consumed the school's gymnasium building. It had been the only edifice to survive the 1906 conflagration. Built in 1901, the building, besides containing a gymnasium, also housed the school kitchen, dining hall, auditorium, music rooms, billiard room, and bowling alleys. Movies were shown in the auditorium on Saturday nights. Plans were drawn up to rebuild on a grand scale, pledges were made, and debts incurred. By 1929, a new gymnasium and a dining hall stood on the campus. As the economic crisis became acute during the 1930s, the college debt grew beyond the school's ability to amortize its obligations. The creditor insurance company demanded payment of $300,000 plus accrued interest. The college eventually succumbed to the riptides of the nation's protracted financial depression and closed its doors in August 1939. The demise of St. Viator College set the small community of 600 French Canadian Roman Catholics back on its heels, and what would come was even more alarming. (BGHS.)

2½ Million Dollar Campus

From simple beginning, Olivet has grown to great proportions. The entire populace, some 1000 students, 70 faculty members, scores of workers, and many friends live on or near the campus in Greater Kankakee, which once knew the tribe of the Pottawattamies.

Olivet is a co-educational, Liberal Arts, Christian college, with the motto "Education with a Christian Purpose." Its equipment is superior; 108 acres of campus and playing fields, a fine library, well equipped laboratories, chapel, attractive dormitories, and one of the finest physical education buildings in the Middle-west.

Olivet offers twenty-four departments in liberal arts from which to choose. Complete degree programs are available in various fields of learning.

Expenses are moderate. A limited number of scholarships are offered and students are assisted in locating employment.

OLIVET NAZARENE COLLEGE
HAROLD W. REED, Th.D., D.D., President
Kankakee, Illinois

A small college in Olivet had been destroyed by fire. At first it was only a rumor circulating through Bourbonnais and then a fact: a Protestant Church of the Nazarene would reestablish its college on the St. Viator campus. The insurance check for the burned Olivet College, $195,000, allowed the Nazarenes to gain possession of St. Viator's 40 acres and six buildings. By 1944, they were able to pay off the remaining mortgage. "The years to follow saw unfortunate misunderstandings repeat themselves," wrote historian Adrien M. Richard, "causing at times to have lines drawn, and resulting in rent feelings and relations. Fortunately, the years of association have mellowed hearts and today [1975] with changing times, customs and mores, the faithful of both faiths have fused their combined civic efforts with other denominations that have since made their home in Bourbonnais." Olivet's Pres. A. L. Parrott and Prof. Linford A. Marquart recognized they were "strangers in a strange land." Marquart said, "Frankly and honestly my objective was to get acquainted with the people and learn about the community. . . . So I had to learn a lot. Gradually I began to find out that Bourbonnais had a unique history. . . . I found that as the strangeness wore away the people were friendly and cooperative." Marquart became one of the founders of the Bourbonnais Grove Historical Society. (THC.)

As Olivet students began to fill the old St. Viator campus, the buildings that once carried the names of prominent Catholic clergymen were renamed. Marsile Alumni Hall became Burke Administration Building, for Edwin Burke, a longtime chairman of the Olivet Board of Trustees; Roy Hall became Chapman Hall, for Dr. James B. Chapman, an early leader of the Nazarene Church. (KCM.)

102

This building originally was the center section of the old Notre Dame Academy. It is pictured on page 45. At the time the new academy was built in 1910, this section, renamed St. Joseph Hall, was moved to a new location. The Viatorians used it as an infirmary, and patients were tended by the Sister Servants of the Holy Heart of Mary. The Nazarenes changed the name to Walker Hall, for Dr. Edward F. Walker, a former college president. Walker Hall housed members of the Olivet Nazarene College faculty. The 1963 tornado left the building in shambles, and it was torn down. (BGHS.)

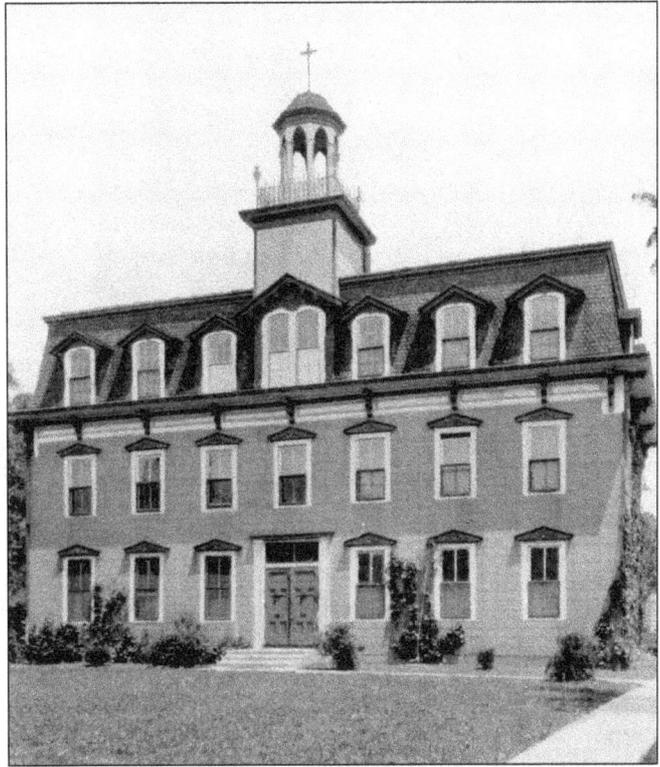

The St. Viator dining hall, built in 1926, became Olivet Nazarene College's Birchard Field House, and the old gymnasium became Birchard Gymnasium. The buildings were named for Clayton Birchard, a former student athlete and later professor of the college. Prior to the building of the Ludwig Center, Birchard Field House served as a dining hall and cafeteria. The college remodeled Birchard Field House in 1968 to accommodate Miller Business Center and renovated the gymnasium in 2003. Dr. Howard V. Miller was an early church leader. (ONU.)

Nesbitt Hall, the women's dormitory, was added to the Olivet Nazarene College campus in 1959. It is named for Mary Nesbitt, the first Olivet teacher. She began teaching in 1907. The new dormitory housed 150 women.

Named for Dr. Sylvester T. Ludwig, this million-dollar student center came to the Olivet Nazarene campus in 1966. The Ludwig Center building is the site of student and faculty dining. It also is a gathering place for social activities and other campus functions.

The Strickler Planetarium was built in 1966 on the Olivet campus. It is named after professor of biology Dwight J. Strickler, who taught for 40 years. The planetarium, the only facility of its kind in the area, is operated under the direction of the college "for the educational improvement of the community and the educational zone of the Church of the Nazarene." (BGHS.)

If weather permits, Olivet holds graduation ceremonies outdoors on the lawn north of the Strickler Planetarium. Seen in the background are the Reed Hall of Science and Observatory. Reed Hall is named for former college president Harold W. Reed (1949 to 1979). Reed Hall and the Strickler Planetarium were built in 1966. (ONU.)

One of the first new buildings to appear on the Olivet campus was Williams Hall (left), a women's dormitory. It was built in 1951. Another women's dormitory, Nesbitt Hall, is seen in the distance. (ONU.)

On their way to class, these female students of Olivet Nazarene find an appreciative audience seated on the steps of Chapman Hall for Men. Formerly Roy Hall, it is one of the St. Viator College buildings erected as a dormitory in 1906. (ONU.)

It was not a particularly warm day on Wednesday, April 17, 1963. The temperature was in the low 70s with a southwesterly wind. The sky was mostly overcast, not the kind of day that one might expect a violent storm. But at 4:10 p.m., the U.S. Weather Bureau issued a warning that a tornado was moving east at about 40 miles an hour. However, radar at the Chicago Weather Bureau and the Illinois State Water Survey in Champaign had detected to the west of Kankakee a "pendent" or "hook" echo as early as 3:43 p.m. Soon the tornado had crossed the Kankakee River. The local newspaper later reported, "The storm moved into Indian Acres where the fatality occurred [in a destroyed mobile home]. It [then] appeared to lift and travel over the south edge of Arrowhead Hills and Park Villa subdivisions, still heading east." Next it turned from a slightly northeast track to a southeasterly one. This direction took it directly to Olivet Nazarene College. From there its path was deflected to slightly southeast. The photograph was taken by the author at the time the funnel cloud was moving through the college campus. (THC.)

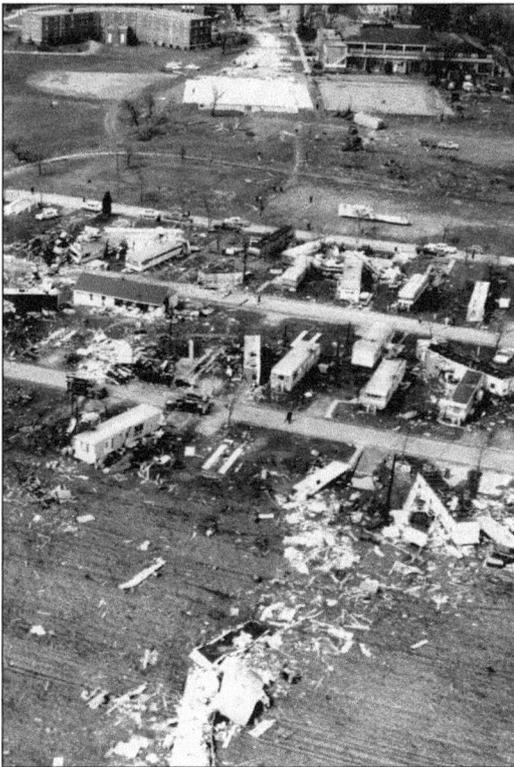

The tornado roared through the center of Bourbonnais. It damaged several houses along its path, and the old town hall on the village triangle suffered heavy damage. Trailerville, on the east side of Olivet Nazarene College, received a direct hit by the tornado. The trailer village had grown from temporary quarters required by enrollment of GI Bill students at the end of World War II. The storm struck a community of mobile homes housing families of Olivet students, mostly young couples. One resident, as he rushed out of his trailer, turned and saw it lifted off its foundation. "It just exploded in the air," he said. (TJL.)

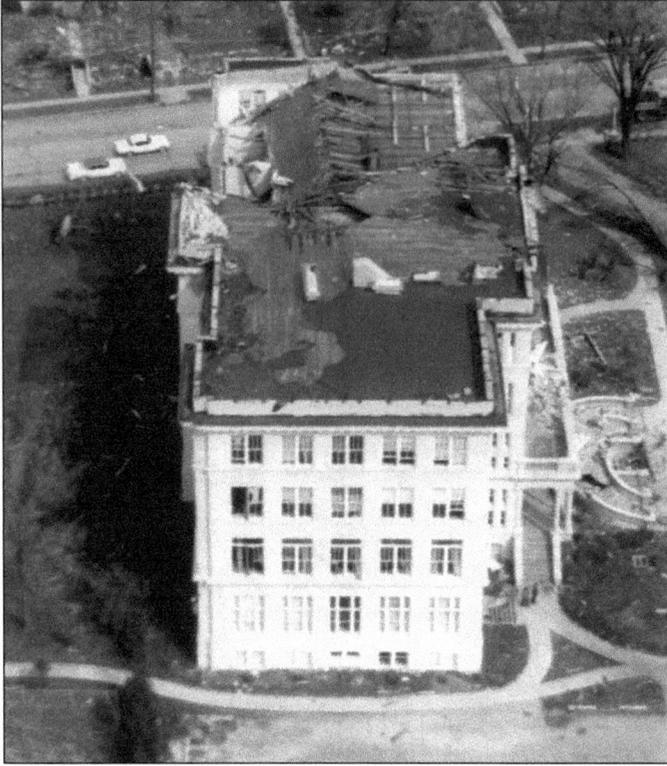

The 1963 tornado damaged much of the third floor of Burke Administration Building on the campus of Olivet Nazarene College. (TJL.)

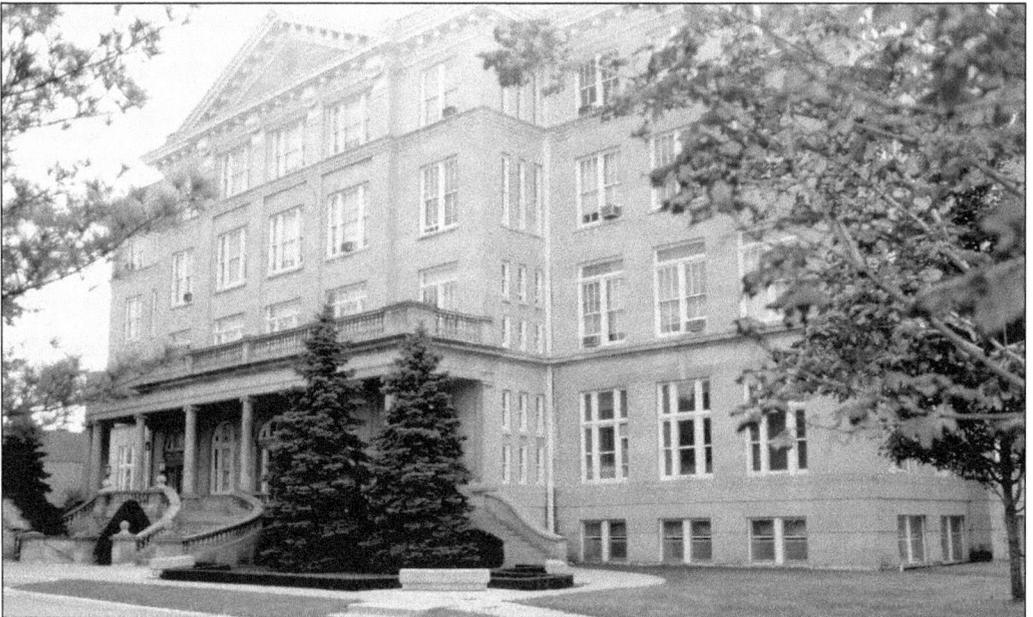

The damage was soon repaired and Burke (originally St. Viator College's Marsile Alumni Hall) remains today as an historic landmark in the community of Bourbonnais, and a reminder of those St. Viator clerics who instituted classical educational tradition in what then was a rural village of French Canadians. On October 24, 1986, Olivet Nazarene College became Olivet Nazarene University. (THC.)

Nine

POSTWAR BOURBONNAIS
1945–1975

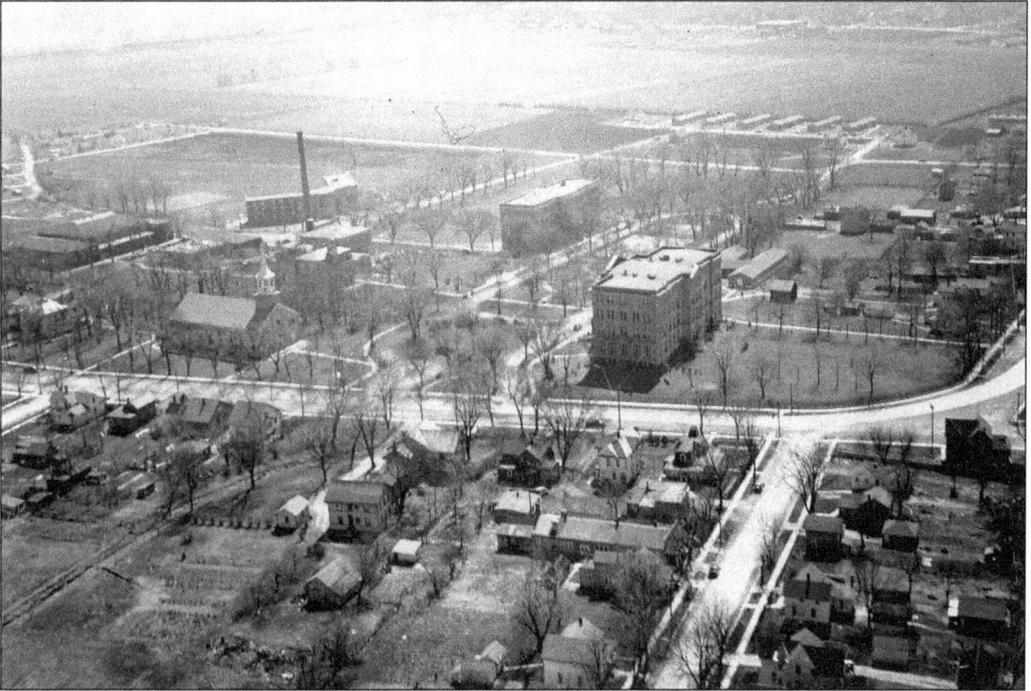

In February 1990, Bourbonnais director of public works John Latham shared his recollections of Bourbonnais in the 1950s with Jennifer Hays Huggins, reporter for Kankakee's the *Daily Journal*. Latham admitted that he had once expected Bourbonnais to remain a small town, "kinda like Mayberry," but a subsequent population explosion stifled that anticipation. Historian Adrien M. Richard wrote that from the time of incorporation in 1875 until 1940, village population hovered around the 600 figure. Ten years later, the population stood at about 1,000. Children were still being taught by Catholic clergy in the public school. A bond referendum in 1956 financed the first modern school in School District No. 53. It was named Robert Frost. The new Maternity BVM Catholic School opened in late October 1961. Village population approached 10,000 in 1975, as Bourbonnais prepared to celebrate 100 years of incorporation. There were new schools, new churches, a new bank, and ever expanding subdivisions. (ONU.)

It is a Sunday in June during the mid-1940s. Members of Maternity BVM parish are celebrating the Feast of Corpus Christi with a procession. A religious tradition in the Roman Catholic Church since 1228, this observance began in Bourbonnais Grove in 1841 with the establishment of St. Leo's Chapel. Processions were discontinued in the late 1940s. (AMR.)

Standing along South Main Street in Bourbonnais in the early 1970s are buildings that housed Graveline's Sanitary Meat Market (left) and the Rivard grocery store. During the 1930s, the Rivard building became part of the Royal Blue franchise chain of groceries. (TJL.)

The Tetrault home still stood at the intersection of South Main and Marsile Streets in the 1970s. In the 1800s, it had been the home of Dr. Louis Pierre Monast. Monast had married Noel LeVasseur's daughter, Carrie. The Monast home was built near the one LeVasseur had built of brick in 1837. Villagers believed that part of LeVasseur's original log cabin existed inside the walls of Tetrault's house. No evidence of that was found at the time the house was demolished in 2001. (THC.)

Members of the College Church of the Nazarene held their first services in this newly constructed church building in 1954. It is located on the college campus, on Olive Street, a block east of South Main Street. (BGHS.)

Philip Houde built this house in 1909. After living in it for nine years, the Frederic J. Richard family sold it to the Prairie family. Leonard Delonais bought the house in the 1960s. He remodeled the exterior and opened a business called the Wedding Center. Delonais made several additions to the house but preserved the original interior light oak flooring and woodwork. Olivet Nazarene College bought the property in the late 1980s and demolished the house. (BGHS.)

This was the only surviving horse barn within the village limits. At the time Olivet Nazarene College bought the property, the barn was razed. Originally built by Philip Houde in 1909, the barn had one horse stall, a hayloft, and room for two buggies. The Richard family used one buggy for everyday chores and another fancier model on Sundays. With the advent of the automobile, Richard kept two cows in the barn. The Prairie family, later owners, kept their automobiles in the barn until they sold the property to Leonard Delonais. (BGHS.)

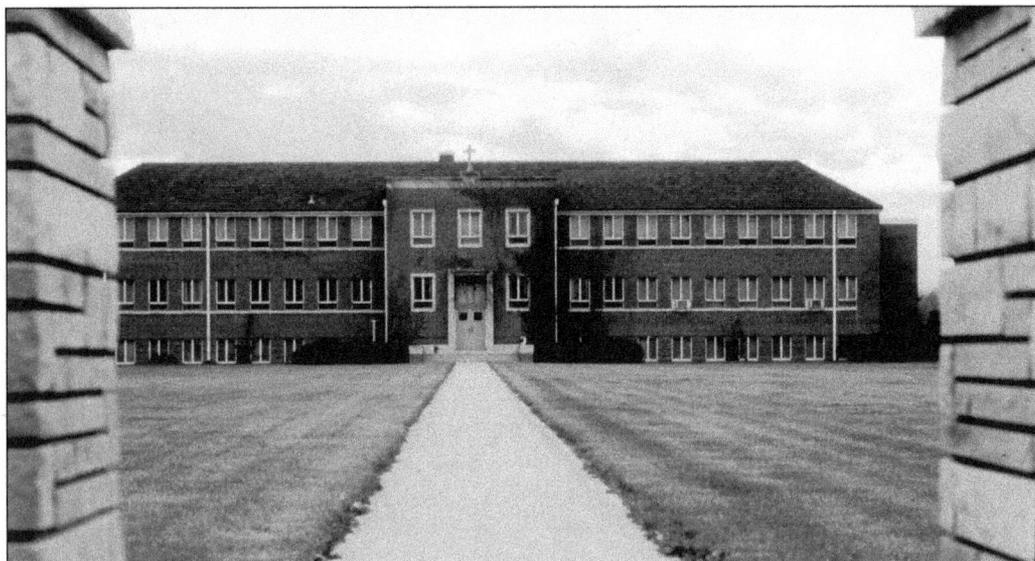

Construction of this building was delayed for 20 years by litigation and challenges to a will. Finally, in June 1952, the construction of the Albert Fortin Villa was completed. Fortin had bequeathed his estate to the establishment of a home for orphaned children. The home would be run by the Dominican Sisters of Springfield, Illinois. Food and lodging were available for children of any race or religion who became a burden on a surviving parent or were victims of a broken marriage. (BGHS.)

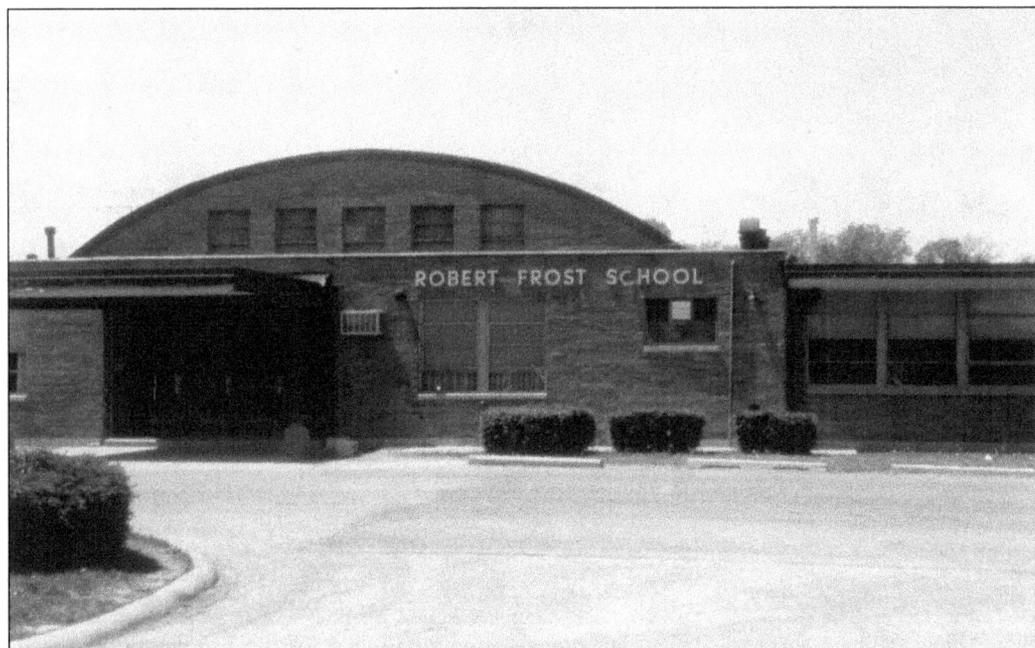

Robert Frost elementary public school opened its doors for the first time in September 1956, enrolling 272 students. (BGHS.)

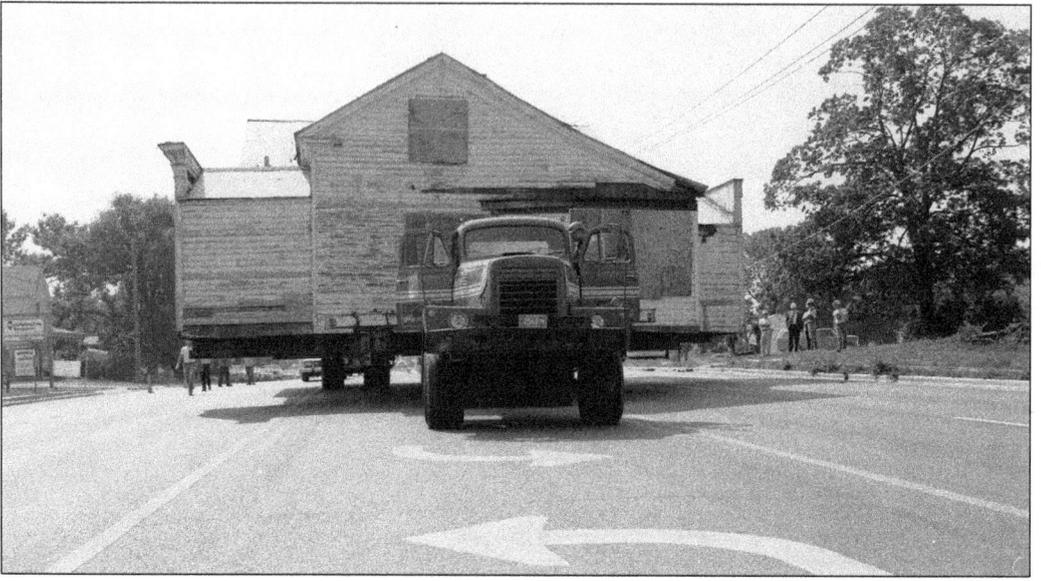

June 20, 1986, was moving day for the old George R. Letourneau home. Ray Odel pulled the house off its foundation and began the three-quarter-mile trip to a lot on Stratford Drive East, where it would take up permanent residence as the headquarters of, and a museum for, the Bourbonnais Grove Historical Society. By noon, the Letourneau house sat on wood cribbing that would hold it until a new foundation was built. (THC.)

Slater Field, built in the early 1970s, became the home ball field for the Bradley-Bourbonnais Little League. The field was named for John W. Slater, who served as Bourbonnais mayor from 1969 to 1973. (BGHS.)

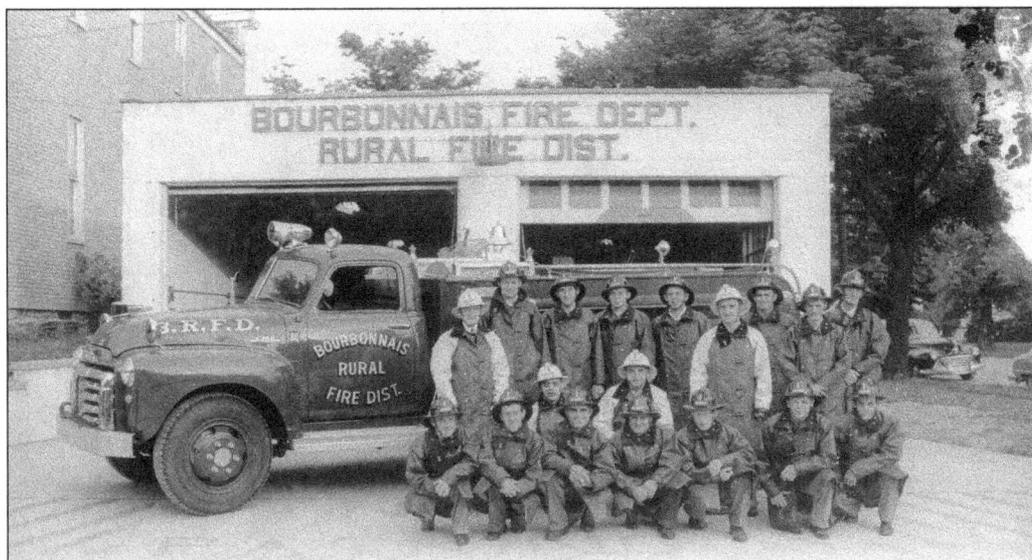

The Bourbonnais Fire Department purchased this new GMC fire truck in October 1965. It held 1,000 gallons of water and was equipped with a two-way radio. (TJL.)

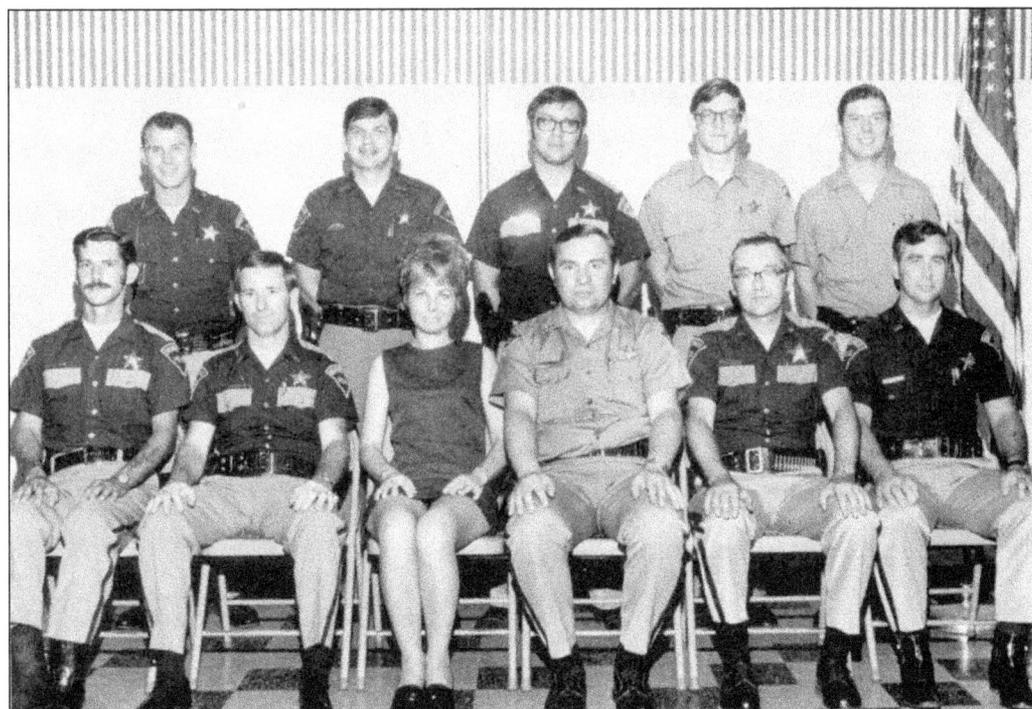

Members of the Bourbonnais Police Department appear in this 1972 photograph. New uniforms were issued that year. Seated in the center is police chief Larry Hildebrand. (THC.)

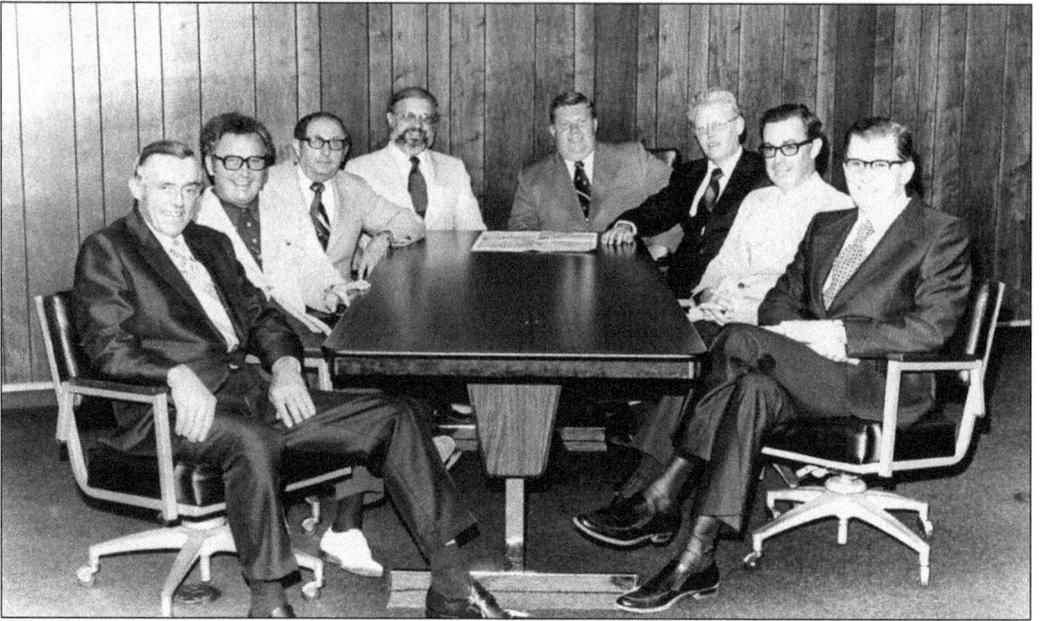

These are board members of the new Bank of Bourbonnais that was chartered in late 1974. Seated from left to right are Dr. Odgen Phipps, Vernon Ruder, Leonard Delonais, Clarence House (president), Paul Lovell, Thomas Nutting, Bob Bell, and Willis Maltby. (BGHS.)

In the late fall of 1972, contractors completed the long awaited new Bourbonnais Municipal Center. With 11,000 square feet of floor space, the building stood on three acres of land on North Main Street. The building's architect was John H. Larson. At that time, John W. Slater was president of the board of trustees. Jay LaMore, Jerome Coyne, Albert LaFine Jr., Ernest Mooney, William Golding, and Thomas Frederick were trustees. (BGHS.)

116

Ten

POSTSCRIPT
TALES OF ANOTHER DAY

Standing next to a welcoming sign on the village limits of Bourbonnais is Carroll Shaubaunia Bourbonnais. He came to the village in 1986 from California to visit for the first time a community that bears the name of his ancestors. Bourbonnais is a family name that originated during the late 1600s, at the time François Brunet, a recent arrival in Villa Marie (Montreal) from France, added the name of his native province, Bourbonnais, to his surname. He became known as François Brunet "Le Bourbonnais." In 1832, Carroll's great-grandfather, François Bourbonnais Sr., a free trader and client of the American Fur Company, his Potawatomi wife, Catish, and their family had settled in a tract of timber called Bourbonnais Grove. Carroll and his wife, Lula Bourbonnais (née Maddox), were married in 1932. The trip east to Illinois was part of the celebration of their 54th wedding anniversary. Lula was from Fort Worth, Texas, and Carroll, a member of the Citizen Nation Potawatomi, was born and raised near Tecumseh, Oklahoma. During the dust bowl days, Carroll and his wife moved to California. (THC.)

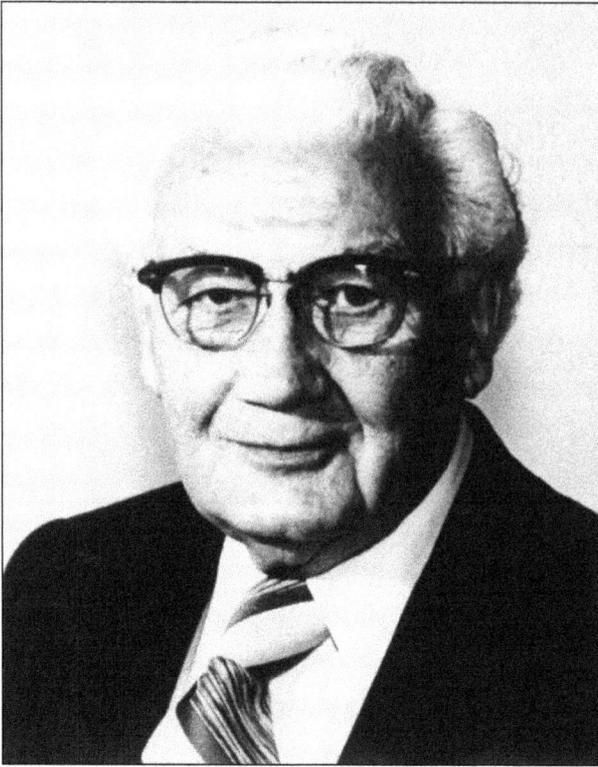

Prof. Emeritus Linford Marquart of Olivet Nazarene College is a charter member of the Bourbonnais Grove Historical Society and one of its founding members. He was head of the college's history department before retiring. It was Professor Marquart who, during a discussion of the amount members of the society should pay for dues, handed over a $5 bill to cofounder Adrien M. Richard, thus paying the first dues and settling the issue. (THC.)

Adrien M. Richard and Anne Richard (née Raymond) contributed the period furnishings for a bedroom in the restored George R. Letourneau Home Museum in Bourbonnais. Adrien, a lifelong resident of Bourbonnais and a magna cum laude bachelor of arts graduate from St. Viator College's 1929 graduating class, became the unofficial village historian after retiring from the Roper Corporation in 1972. He organized the Bourbonnais Grove Historical Society in 1975, the year the village celebrated its 100th year of incorporation. (BGHS.)

Seen here are the George R. Letourneau home, machine shed, and barn on the original farmstead site. The photograph was taken in the early 1970s. (THC.)

This is the Letourneau barn and milking parlor as it appeared just before the Bourbonnais Fire Department burned it down during a training exercise. The house would have met the same fate had not the Bourbonnais Grove Historical Society and many concerned citizens convinced village officials the house needed to be saved as an historic landmark. (THC.)

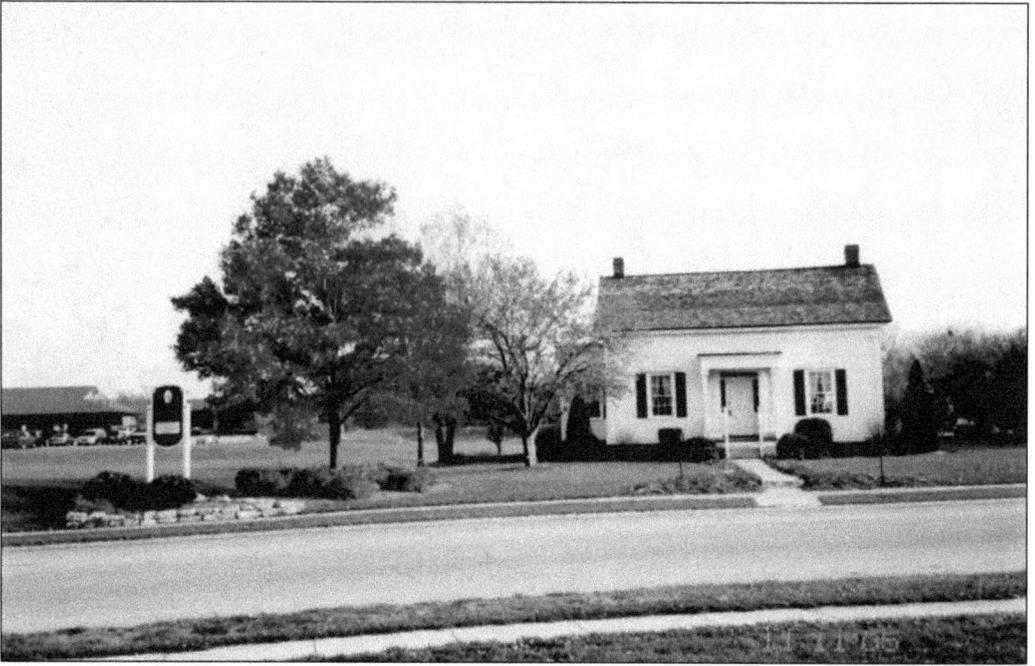

The George R. Letourneau Home Museum is shown after it was moved to a new location, on the Adrien M. Richard Heritage Preserve, and restored. (THC.)

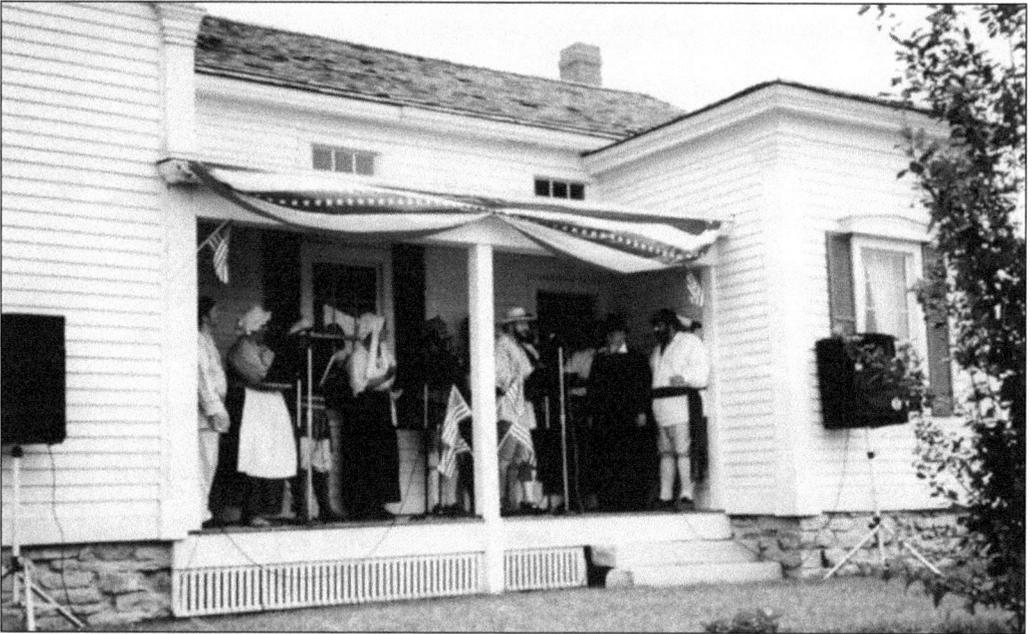

On July 4, 1989, the Bourbonnais Grove Historical Society celebrated the 100th anniversary of the French Canadian settlers' manifesto declaring that they would no longer recognize St. John the Baptist Day as their official patriotic holiday, but instead from then on celebrate the Fourth of July. It was reported in the July 11, 1889, *Kankakee Gazette* that the French Canadian citizens of Kankakee County had gathered at Graveline's Grove to celebrate that "purely patriotic" holiday. (THC.)

A few years after the formation of the Bourbonnais Grove Historical Society, Olivet Nazarene College set aside the Viatorian Room in Ludwig Hall as a small museum of St. Viator College memorabilia. This photograph was taken the day the room was dedicated, February 6, 1984. Seen here are, from left to right, Adrien M. Richard, Anne Mae Laffey, Fr. George Auger, Fr. James Crilly, and Dr. Joseph Nielson. (BGHS.)

Members of the Bourbonnais Grove Historical Society gathered in the Viatorian Room in 1989. Pictured are, from left to right, (first row) Mary Louise Bertrand, Anne Richard, Adrien M. Richard, and Dr. Joseph Nielson; (second row) Duane Bertrand, unidentified, Dorothy Schmidt, Fr. James Crilly, Fr. Thomas Langfeld, Theresa Gifford, Judy Ponton, and Ken Ponton. (BGHS.)

The Durham-Perry farm's 170 acres of land still contain a few remnants of the original Bourbonnais Grove timber and is contiguous with the south line of Bourbonnais village limits. The 1840s barns and 1860 house are maintained by the Bourbonnais Township Park District. (THC.)

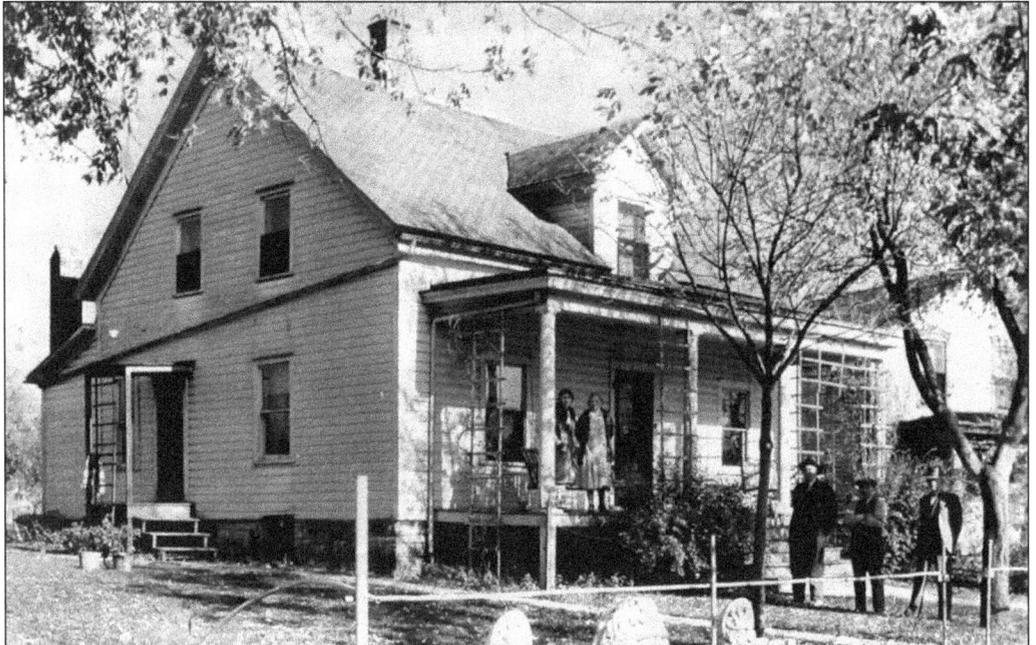

This house is said to be one of the oldest in the village of Bourbonnais. It contains within its walls, according to local tradition, part of either Noel LeVasseur's cabin or half of his old trading house. Henry Roy moved this house from its original site to this location on North Main Street. Merrill Beique bought the house in 1916, and it was later owned by Prof. Dwight J. Strickler of Olivet Nazarene College. (KCM.)

The old Joseph Legris home has been rehabilitated and still stands on its original site on South Main Street. (THC.)

Henry Roy built this house on North Main Street in 1904. After living in the house with his family for 10 years, Roy sold it to Louis Drolet. Drolet's son, Leon, installed the village's first transmitting radio station, 29AYY, in the house. Osmand Trudeau bought the house in 1938. It remains one of the village's landmarks. (BGHS.)

In 1979, the Bourbonnais Grove Historical Society erected this memorial to Noel LeVasseur facing the old village triangle. The monument contains some of the bricks believed to have been used in building his home in 1837. The house stood in the area seen in the upper right-hand corner of this photograph. (THC.)

Every year Bourbonnais holds a Friendship Festival near the end of June. A big part of the festival is a series of parades that travel up Main Street to Gosselin Park. The largest parade is on Sunday afternoon. Several years ago, this float was entered into one of the Sunday parades by the Bourbonnais Grove Historical Society. (BGHS.)

On September 26, 1978, the faculty of Olivet Nazarene College led by Dr. Leslie Parrott, college president (to the right of the sundial), and the Rev. Robert Carey, C.S.V., pastor of the Maternity BVM Church (left) returned three artifacts, a sundial, a theologian's bench, and a home plate memorial from St. Viator College to the church grounds. The sundial is a gift of the St. Viator class of 1917. A plaque on the sundial names the class graduates, including the Rev. Fulton J. Sheen, who was class treasurer. (BGHS.)

Seated on the theologian's bench are Fr. George Auger, C.S.V., Maternity BVM associate pastor, and Dr. Ottis Sayes, chairman of the Department of Religion and Philosophy of Olivet Nazarene College. (BGHS.)

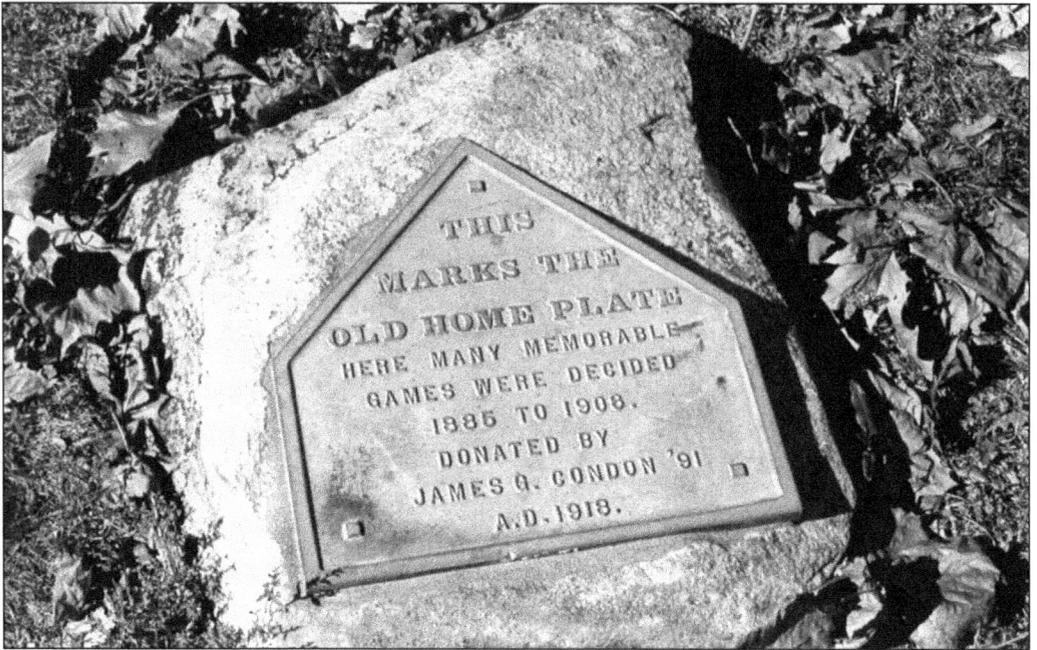

The home plate memorial is a gift of the St. Viator class of 1918. It originally marked the site of the old St. Viator ball diamond. The construction of Roy Hall and Marsile Alumni Hall after the fire of 1906 made the location of the ball field unusable. It was remembered that many memorable games were played on the site between 1885 and 1906. (BGHS.)

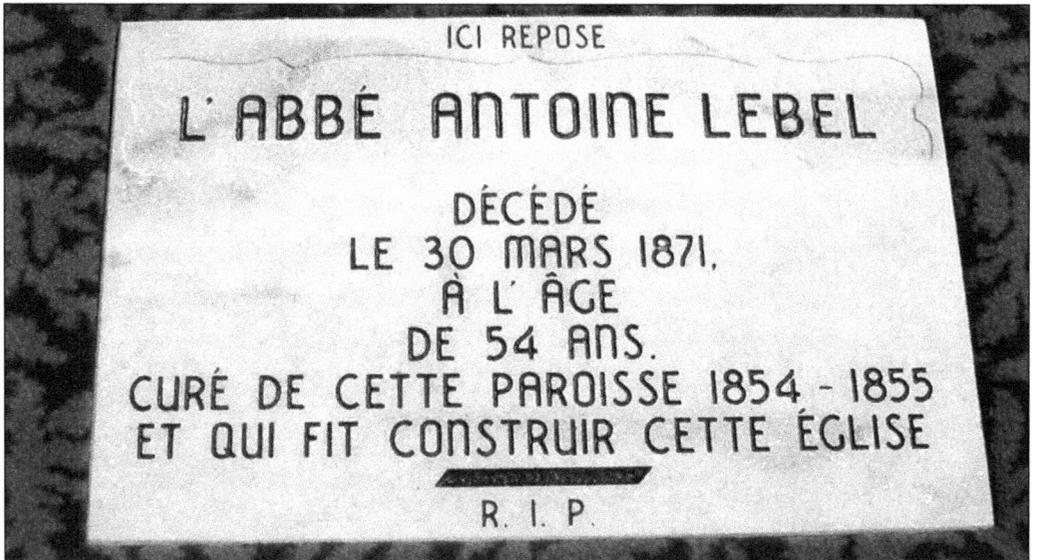

ICI REPOSE

L'ABBÉ ANTOINE LEBEL

DÉCÉDÉ
LE 30 MARS 1871,
À L' ÂGE
DE 54 ANS.
CURÉ DE CETTE PAROISSE 1854 - 1855
ET QUI FIT CONSTRUIR CETTE ÉGLISE

R. I. P.

Following a traditional European custom, there are at least three burials beneath the floor of Maternity BVM Church. The burial of Rev. Isadore Antoine Lebel was only recently discovered by Eric A. Derr. It was Father Lebel who drew up the plans for the new church building in 1854. To the left of the main altar is the burial place of Sister St. Ignace, a Sister of the Congregation of Notre Dame. Fr. Leon Boisvert, a Cleric of St. Viator and a native of Bourbonnais Grove, is buried to the right of the main altar. He is the first Cleric of St. Viator to die in the United States. (THC.)

SELECTED BIBLIOGRAPHY

Burroughs, Burt E. *Burt E. Burroughs Annotated: The Story of Kankakee's Earliest Pioneer Settlers*, with an introduction and notes by Vic Johnson. Kankakee, IL: Lindsay Publications, 1986.

Byrns, William P., William Seil, and Donald L. Wasson. *Days Gone By: A Pictorial History of Kankakee County*. Kankakee, IL: Kankakee County Bicentennial Commission Heritage '76 Committee and Illinois Graphics Inc., Bloomington, IL, 1975.

Johnson, Vic. *Presidents of the Bourbonnais Village Board, 1875–1997*. Bourbonnais, IL: Bourbonnais Grove Historical Society, 1997.

Juniors and Seniors of St. Viator College. *Viatome*. Vol. I. Bourbonnais, IL: St. Viator College, 1922.

Kankakee Centennial Association. *1853 Kankakee Centennial 1953*. Kankakee, IL: Kankakee Centennial Association, 1953.

Kantrowicz, Edward R. "A Fragment of French Canada on the Illinois Prairies." *Journal of the Illinois State Historical Society* LXXV, no. 4 (Winter 1982): 263–276.

Lebel, Gerard. C.SS.R. "François Brunet dit Bourbonnais," in *Nos Ancêtres*, Vol. 15. Translated by Joan Linneman. St. Anne de Beaupré, Quebec: La Revue Sainte-Anne de Beaupré, 1981.

Richard, Adrien M. *Notre Dame Centennial: A Century of Devotion*. Bourbonnais, IL: Congregation of the Sisters of Notre Dame, 1960.

———. *The Village: A Story of Bourbonnais*. Bourbonnais, IL: Centennial Committee of Village of Bourbonnais, 1975.

———. *Tales of Another Day*. Bourbonnais, IL: Privately published manuscript by Adrien M. Richard, 1986.

Senesac, Rev. Elder A., C.S.V. *Centennial Anniversary of the Church of the Maternity of the B.V.M.* Bourbonnais, IL: Church of the Maternity of the B.V.M., 1947.

The Senior Class of St. Viator Academy. *The Voyageur*. Vol. III. Bourbonnais, IL: The Academy of St. Viator, 1927.

The Senior Class of St. Viator Academy. *The Voyageur*. Vol. 43, no. 5. Bourbonnais, IL: The Academy of St. Viator, 1926.

The Senior Class of St. Viator Academy. *The Voyageur*. Vol. IV. Bourbonnais, IL: The Academy of St. Viator, 1929.

Visit us at
arcadiapublishing.com

...